Looking and Listening

Looking and Listening

Conversations between Modern Art and Music

Brenda Lynne Leach

ROWMAN & LITTLEFIELD
Lanham • Boulder • New York • London

Published by Rowman & Littlefield
A wholly owned subsidiary of The Rowman & Littlefield Publishing Group, Inc.
4501 Forbes Boulevard, Suite 200, Lanham, Maryland 20706
www.rowman.com

Unit A, Whitacre Mews, 26-34 Stannary Street, London SE11 4AB

British Library Cataloguing in Publication Information Available

Library of Congress Cataloging-in-Publication Data

Leach, Brenda Lynne.
 Looking and listening : conversations between modern art and music / Brenda Lynne Leach.
 pages cm
 Includes bibliographical references and index.
 ISBN 978-0-8108-8346-8 (cloth : alk. paper) — ISBN 978-1-4422-4131-2 (pbk. : alk. paper) — ISBN 978-0-8108-8347-5 (ebook)
 1. Art and music. 2. Jazz in art. 3. Music—20th century—History and criticism. 4. Art, Modern—20th century. I. Title.
 ML3849.L42 2015
 780'.07—dc23

 2014021094

Printed in the United States of America

For Mom and Dad, who made a home filled with
love and creative possibilities, with love and gratitude

~

Contents

~

Foreword

Jessica Hoffmann Davis, EdD

The arts are languages that speak to us in many voices: those of the artists, the audiences, and the symbols (the brushstrokes, gestures, musical notes) that frame the understanding expressed in each work. In producing and finding meaning in art, we participate in a conversation perpetuated throughout history and time, across continents and cultures, individuals and nations. The arts speak to us, and we speak through art.

There are many interpretations of art as a spoken language—reflections, for example, on the difference between the quantitative preciseness of musical notes and the qualitative density of visual images. Are there meanings that visual art conveys that cannot be expressed in music? Or do we find artistic counterparts, for example, in the graceful slowness of a "lento" tempo in music and the elongated images in a languid work of visual art?

When the various arts address the same theme, do their different expressions enrich each other and/or articulate meaning exclusive to their respective realms? Do the various arts in fact speak to one another? Do artist creators look across their respective domains for inspiration or provocation?

In the 1984 Broadway musical *Sunday in the Park with George*, composer Stephen Sondheim recreated in music the artistic process of expressionist painter George Seurat. Maestro Brenda Leach, whose treasures await the reader here, speaks of art's "isms." In that realm, with staccato tempo and repetition of words, Sondheim affords firsthand experience of the up-down painted colored dots of pointillism (a technique developed by Seurat).

Music giving new meaning to visual art—the painter's process finding visceral expression in musical performance. When I first saw *Sunday* on

Broadway, I was astonished to see the audience rise to its feet for a standing ovation after the first act. Two women behind me were clapping and weeping, and one said to the other, "I have no idea what's going on here, but I've never been so moved in my life."

In that statement, the emotional audience member spoke to the mystery and power of the creative process to which Sondheim had so deftly introduced us. The combination of the enormous visual representation of Seurat's painting that was the stage set and Sondheim's exquisite score had combined to create an experience that neither domain (visual art or music) could have attained on its own.

Do the various languages of art speak not only to but also through one another? To what extent are music and visual art untranslatable and exclusive to their own sets of symbols and space? And to what extent do they inform and inspire each other, introducing a collective voice that is greater than either voice on its own?

These are fascinating issues that take our view of art as language on to a new plane. Which creators are artistically multilingual, and what do they do with their interest and skills? And toward what end? These questions have been on the mind of Brenda Leach, a musical virtuoso in her own right, at least since her studies at Harvard University, where we met in the program in the arts in education that I founded and directed. In the pages that follow, in language that is artfully clear and engaging, Leach introduces us to the conversation that persists between modern composers and visual artists.

Believing, as I do, that the arts lead us not to discrete answers but to open-ended questions, Leach crosses the boundaries between music and visual art and invites us into the fascinating dynamic that persists between the two. In introducing us to equivalencies in the two languages of art, she provides us with biographical portraits of artists who have bravely crossed the boundaries of different symbol systems and awakens us to a new and exciting terrain of questions that promise to enrich our sense of discovery and joy.

This book is a treasure, replete with insight and challenge, analytic prowess, and a rich sense of historical veracity. Traveling with Brenda Leach across the topics and territories of modern music and visual art, we find ourselves more informed in each area and more aware of the possibilities for cross-fertilization.

This book is about connections, those that flourish between artists and their own work and between the work of artists in different domains. Experiencing these connections on every page, we expand our ways of seeing and hearing and thinking. We become boundary breakers like the artists we meet here, and we realize that moving forward, along with the rest, we will be sensitive to the harmonizing that is possible across the languages of art.

Acknowledgments

I have wanted to write this book for a long time. As a teenager learning to play the great contrapuntal organ works of J. S. Bach, I loved the feeling of this brilliant music in my fingers and toes, the balance and interplay of the many lines and their place within a grand structure, the exciting rhythms, and the "color" I would give it by my choice of timbre—musical color. The sheer sound of these elements in combination was transcendent. I also wondered even then what such music might look like in the hands of a visual artist. I imagined a "visual transcription" at first, and then I thought about all of the various elements that were shared in the visual arts. As my experience with both music and art developed and broadened, I became fascinated by this "conversation" between the art forms. I thank my editor, Bennett Graff, for encouraging me to write this book.

There are many people to thank for their help in making this project possible. I extend heartfelt thanks to the wonderful librarians at Bay Path College, who were so helpful in locating sources I needed. I spent many hours during summer months doing research in the Dickinson College Library, and I appreciate the open door extended to me. I am grateful to the Earle Brown Foundation for providing archival materials and for the photograph used in this book.

I am most grateful for my family, friends, and colleagues for their support along the way. They have been enthusiastic as sounding boards and readers of various drafts. To my siblings, who offer both anchor and fairy dust; to my nieces and nephew, who constantly remind me how to live a creative life; and to my mother, whose love, wisdom, and generosity is abundant and ever present, I say thank you!

~

Introduction

"Many a long winter evening can be devoted to discussing the relation-ship between painting and music."

—Dave Brubeck Quartet 1996

The great American composer Aaron Copland wrote in his now-classic *What to Listen for in Music,* "Listening is a talent, and like any other talent or gift, we possess it in varying degrees. I have found among music lovers a marked tendency to underestimate and mistrust this talent, rather to overestimate it" (Copland 1957, 12). The same might be said for *looking* at art. All too often in museums, visitors walk through the great halls of art, read the wall text, glance briefly at the work of art, and then continue on to the next wall text. Wall texts serve the important purpose of offering the visitor interesting information about the work, the artist, and the context in which the work was born. However, viewers frequently do not realize how much they bring to the experience. Everyone has art and music in their lives whether they realize it or not. That art can be music heard on the street, graffiti on urban buildings, or creations of childhood. So why is it so daunting for many people to enter a museum or concert hall when, in fact, we all have experience with art simply by being alive?

Over the years I have known students, concertgoers, and people from the general public who say that they feel "intimidated" and believe there is a base of knowledge or some secret code they need to know before they can engage in the experience of the arts. At the same time, I have discovered from years

of teaching and lecturing that those same people who feel intimidated really do see a lot in art and hear a lot in music. Some think that they need some sort of "permission" to value their own observations. Often what is missing is the vocabulary to express what they see and hear and the time to make meaning of the experience. Certainly engagement in art and music can be enriched by gaining knowledge about the works, their creators, and the time and place in which they were created. And this can and should be a lifelong adventure. But a desire to engage is the crucial first step, and often that first step of engagement is done with the heart rather than with the brain.

A likely first response to a work of art or a piece of music will reflect judgment. "I like it!" "I hate it!" Both responses are fine. But a good question to follow is, Why? Does the work remind you of something from your own experience? Does it bring you joy? Does it make you remember something from your own life? Does it create a positive or negative emotional response? Does it challenge you? Does it make you think about something in a different way? Does it help you to understand something in a new way? These are among the many questions that are triggered when engaging with the arts. By participating in this inquiry with the art, viewers and listeners find that the arts are far more than decorative objects or experiences of entertainment value.

As a viewer or listener considers a work of art or music in the context of his or her own experience, that personal experience may include another art form. Perhaps a person has a strong comfort level with visual art but less with music. By thinking across disciplines, one might find that an open door in visual art might open a window to music.

My hope is that, through this book, readers will consider connections made here and make new ones on their own. In some cases these connections are specifically named by the artist or composer, in some cases the connection is implied, and in other cases the connection is made through interpretation. I hope that viewers of art and listeners of music will engage in a relationship *with* the arts and will develop their own connections and questions. Bring your questions; bring your doubts; bring your ideas; and, most importantly, bring yourself to the arts.

Approach to Connections

This book is about connections. No artist exists in a vacuum. Artists and composers are connected to the world around them; to artistic lineage from which they come; to other art forms; to other artists; and to history, politics, society, change, and all of life. The connections made in this book are snapshots of particular points of intersection and should not be interpreted as

sweeping generalizations about the creative work of any artist. The work of all artists and composers discussed here developed throughout their lifetimes and as such changed and evolved.

Each chapter in this book focuses on a connection between a specific art work or groups of works and a musical composition or groups of works. The connections are made in different ways. In some cases paintings were created as a response to a specific musical composition, as in Arthur Dove's paintings on George Gershwin's *Rhapsody in Blue*. Other connections high-light musical reflections done in response to visual art, as in Dave Brubeck's *Time Further Out: Miró Reflections* and Gunther Schuller's music on the art of Paul Klee. In these cases, direct works were named by the artist and musician respectively. In some cases, a creative response to one's work resulted in friendship and long-term discourse, as in the case of Arnold Schoenberg and Wassily Kandinsky. In 1911, Kandinsky heard a performance of music by Schoenberg, which inspired the artist to respond through painting. It also marked the beginning of a long-term friendship, exchange of letters, and shared thoughts on each other's work.

Connections are also made in looking at and listening to the work of artists and composers for whom art was a vehicle for political or social state-ment. In the murals of Diego Rivera, we witness history. Similarly in some of the music of Carlos Chávez, the listener is invited into the story of other cultures through sound. In some works by Stuart Davis and Romare Bearden, the viewer can almost hear jazz and the story it tells.

Other connections are made as a way of looking at ways elements of style can carry across artistic disciplines. The parade of "isms"—impressionism, cubism, minimalism, for example—began in the world of art. How were ideas of impressionism in painting carried into music? Is there such a thing as cubist music? How is the idea of minimalism executed in art and in music? Artists and composers often shrug at such labels, however the consideration of the overarching ideas of various styles can serve as a place to start. Ele-ments identified in such labels are often literal in one area and metaphorical in another, but that can be part of what is interesting in considering such an approach.

Chronology—Important Decades

The connections made in the following chapters focus on the art and music of Europe, Mexico, and the United States in the twentieth century. With the late nineteenth century and turn of the twentieth century, we explore French impressionism in painting and also in music, as well as atonal,

expressionistic works in Germany and Austria. The step into the new century in the United States is led by developments in jazz and the ways in which it was heard in music and seen in painting. In the music of Aaron Copland and Roy Harris, we hear the spirit of the new modernist era expressed in the music of these American classical composers. From the roaring twenties to the Harlem Renaissance, we see and hear the blossoming of art and the sounds of the immensely popular and quickly developing music of jazz. We also explore developments in abstract art, kinetic art, conceptual art, and minimalism.

The works of the artists and composers discussed also reflect an ever-changing society. From the works of Monet and Debussy in fin-de-siècle France to the early-twentieth-century art and music of Schoenberg and Kandinsky and the early cubist works of Braque and Picasso, we witness change in Europe. The art of Rivera and the music of Chávez give voice to a postrevolution society in Mexico. The music of blues and ragtime of the 1890s usher in not just a new century but also a new type of music that is uniquely American and born of the African American experience. A rapidly changing United States was also reflected in the art of Georgia O'Keeffe and the music of Aaron Copland, who captured the spirit of both rural and urban America.

As the twentieth century moved forward and the "modern" turned to "postmodern," artists across disciplines experimented with old ideas and created new techniques, approaches, and concepts. In doing so, they pushed the boundaries of what is considered art and what is considered music. John Cage explored the sounds of everyday as Robert Rauschenberg made art from objects of everyday. Such composers as Terry Riley and artists like Sol Le Witt experimented with what could be made from limited material—how much could be made from how little? Important collaborations were born in the work of people like Cage, Rauschenberg, and choreographer Merce Cunningham and in the work of Aaron Copland and Martha Graham.

Style

Elements of Style in Art and Music

The term *style* used with regard to the arts refers to the way in which characteristic elements are used in combination with one another. In painting, these characteristic elements might include color, composition, brushstroke, tone, and texture. In music, they include melody, rhythm, timbre (tone color or distinguishable essence of sound), dynamics (degree of loudness and softness), harmony, texture, and form. When comparing a painting with a musical composition, one might examine the use of "color" (literal in visual

art, metaphorical in music) in order to make observations about its role in determining a possible shared style.

Shared Elements

Like visual art and music from centuries past, modern music and art share key elements but frequently in a way that is especially vivid, intense, and dramatic. Major political and social changes in the twentieth century were a natural prompt for subject matter in the arts. The words *line, shape,* and *color* are literal in visual art and have musical counterparts in *melody, phrase,* and *timbre.* In music, rhythm is what happens between beats; visual rhythm leads and directs the eye. The word *texture* suggests the sense of touch, which is apparent in art. Similarly, the notion of texture in music suggests layers of sound. While repetition, variation, and pattern help create order and structure to the eye, timbre, rhythmic patterns, as well as melodic and harmonic sequences do the same for the ear. In combination they create the form or structure of the work.

Texture and Color

For Russian-born artist Wassily Kandinsky, abstract art was very much like music. In his many writings, he frequently addressed the topic of music in relation to visual art. His painting *Fugue* uses a literal musical form as the title. Music is often described by texture—monophonic (a single line), homophonic (more than one yet rhythmically similar lines), and polyphonic (many lines functioning independently). In music, a fugue is always polyphonic, that is, comprised of two or more lines, each of which introduce the subject (a brief melodic or motivic phrase), which is developed and expanded through counterpoint. While Kandinsky's painting is not intended to be a literal visual representation of a fugue, it does suggest a busy texture—a "chorus of colors" as Kandinsky called it.

The notion of color in art and music has been considered on many levels. As a visual artist uses color in a multitude of ways, so does a composer when working with sound—timbre. Most people can imagine the colors red, yellow, or blue. So, too, can many imagine the sound of a flute, a trumpet, or a violin. The ways in which artists and composers make choices and juxtapose and intensify "color" is important to visual and musical compositions. Some artists have gone so far as to define *color music,* in which specific colors are emotionally linked with specific sounds.

The characteristic use of these key elements is most certainly shaped by social, political, and intellectual developments of the time. When certain trends infiltrate multiple art forms at a specific time in history or in a specific geographical location, the art of a time and place invites such inquiry.

Creating across Disciplines

Composers Who Painted

Creativity has a way of migrating. Although an artist may become "known" for a specific art form, it is not unusual to find that this person has an interest or proclivity in another art form. For example, Arnold Schoenberg earned his place in history because of his impact on the world of musical composition. His work encompasses stylistic change from the nineteenth to the twentieth century. The body of work over his lifetime includes compositions that echo the fading nineteenth century, atonal music, neoclassical music, serial compositions, and even a couple of pieces that reflect his interest in jazz.

Schoenberg also painted. His work in the visual arts was most prolific between 1908 and 1915, when he was closely aligned with the "expressionist" school. The composer turned to painting when he believed he could not express what he wanted to in music. Many musicians, painters, and writers creating expressionist art were in close communication. Many of these artists explored abstract concepts by experimenting with color, form, and dissonance. Schoenberg did this in both music and painting.

Some people may be surprised to learn that Gershwin also painted. His song repertoire has become the sheer definition of "American" song. From Tin Pan Alley to Broadway and Hollywood, his songs have come to define an era. He also wrote major works, such as *Rhapsody in Blue* and the opera *Porgy and Bess*. In addition to his enormous body of musical compositions, he also painted important people in his life.

Painters Who Made Music

For artist Paul Klee, music was a lifelong passion. He played the violin and was a regular concertgoer. At points in his young life, he considered whether to pursue a career in art or in music. Many of his paintings reflect his interest in music. Whether through subject matter, the inclusion of literal symbols from musical notation, or through the belief that music and visual color were capable of transcending the human senses, music was an important source of inspiration. He loved classical music and had a particular fondness for Mozart. Like some of the music of Mozart, some of Klee's paintings suggest childlike play, lightheartedness, and humor.

From Art to Music and Music to Art

When Joan Miró painted an abstract work in 1925, who would have thought it would inspire a jazz album? Dave Brubeck devoted an entire album to music that he said was inspired by Miró's painting. The musician wrote notes about his musical "reflections" and shared a glimpse into his creative process.

In the life and work of Stuart Davis (1892–1964), we find a visual art-ist who found creative inspiration in many things, from the architecture of emerging skyscrapers to fast travel on new modes of transportation, and land- and seascapes of Gloucester, Massachusetts . But it was jazz in particu-lar that had an enormous influence on his work. He connected deeply with this music from the early days of jazz, including the blues and ragtime, to the jazz age of the 1920s, to the big-band swing of the 1930s. Davis not only painted jazz as subject, but more importantly, he also transposed musical ele-ments into the visual. What does jazz look like? How can abstract painting be a counterpart to jazz?

Perception/Interpretation/Making Meaning

Also important is the place of individual perception of art and music. Writer Jeanette Winterson wrote, "Art takes time. To spend an hour looking at a painting is difficult" (Winterson 1995, 7). Painter Georgia O'Keeffe devel-oped this idea boldly in her paintings of flowers. She wrote,

> A flower is relatively small. Everyone has many associations with a flower—the idea of flowers. You put out your hand to touch the flower—lean forward to smell it—maybe touch it with your lips almost without thinking—or give it to someone to please them. Still—in a way—nobody sees a flower—really—it is so small—we haven't time—and to see takes time, like to have a friend takes time. If I could paint the flower exactly as I see it no one would see what I see because I would paint it small like the flower is small. So I said to myself—I'll paint what I see—what the flower is to me but I'll paint it big and they will be surprised into taking time to look at it—I will make even busy New Yorkers take time to see what I see of flowers. (O'Keeffe 1976, 23)

Art takes time and music requires time. Listening to a piece of music from beginning to end requires real time—time to listen, hear, and make meaning. How is our experience looking at art impacted when we listen to music at the same time? Does our experience with one art form influence our experience with the other? Drawing upon collections of great museums in the United States and Europe, this book explores these questions by pairing specific visual works with musical compositions.

Organization of the Book

The book is organized into three parts, each of which considers the con-nections made in a different way. Part I focuses on visual artists who were inspired by music. Given that many of them were working in the first part

of the twentieth century, we find that jazz was a big influence, not only on American artists, but on Europeans as well.

The second section considers musical compositions that were written as a result of influence from the visual arts. For example, Dave Brubeck derived innovative approaches to rhythm and meter from a painting by Joan Miró. Composers like John Cage, Morton Feldman, and Earle Brown considered philosophical questions and reconsidered the notion of form—What is form? Is it changeable? Who determines what it is?

Finally, the third section explores more general connections that can be considered through the ways in which composers and artists have addressed political and social change. Chapters in this section also look at ways in which styles that were defined in the field of visual art have been considered in music. Each chapter in this book stands by itself, so they can really be read in any order.

An Invitation

Many connections are possible. Some are stated by the artist and/or musician; other connections are made by the listener/viewer. Some of the connections made here are of a specific moment in time in the work of the composer/artist. Some may have been intended by the artist/musician; other times the connection is made by the observer/listener. Bring your curiosity to the art and music and, in doing so, create your own questions and connections.

PART I

PRELUDE

Artists Respond to Music

The five chapters that form part I tell the story of artists whose work was inspired by music. In the art of American painters Stuart Davis, Romare Bearden, and Arthur Dove, as well as such European artists as Piet Mondrian, we discover not just musical inspiration but also a specific style of music—jazz. Not only was the excitement of a young century at play, but this new century also ushered in a new style of music that was distinctively American. Prior to this, music of the United States was borrowed, usually from Europe, or it was composed in a style of existing music. As the nineteenth century turned to the twentieth century, the spirituals, marches, blues, and ragtime music of the old century formed the building blocks for jazz, which was born in the United States in the twentieth century. The freshness of this music, along with the stories it told, was irresistible to many visual artists, both in the United States and beyond. Jazz was, after all, dance music—energetic, vibrant, and imbued with a fresh sense of freedom. The new sounds and tonal colors created by instruments in the early jazz bands, along with bold rhythms and improvisation, inspired painters to explore these ideas in their work. From the influence of Earl Hines on the work of Stuart Davis to the influence of Gershwin's *Rhapsody in Blue* on Arthur Dove and the power of boogie-woogie music over European artist Piet Mondrian, we find the sounds of one art form speaking to another.

As the United States saw the blossoming of jazz in the early twentieth century, artists in Germany and Austria were exploring a side of art that was based on the dissonance of the human condition. Composers, such as Arnold

Schoenberg, broke away from long-established traditions, as did visual artists of the time. In the chapter on Schoenberg and Kandinsky, we explore how the lives of these two artists intersected at a specific junction—a concert of music by Schoenberg that inspired Kandinsky to create a powerful visual counterpart.

~

Stuart Davis and the Art of Jazz

On the upper left side of the painting called *American Painting* (1932–1951) by artist Stuart Davis (1892–1964) appears an excerpt of lyrics by jazz great Duke Ellington: "It don't mean a thing if it ain't got that swing." In the life and work of Stuart Davis, we find a visual artist who found creative inspiration in many things, from the architecture of emerging skyscrapers to fast travel on new modes of transportation, to land- and seascapes of Gloucester, Massachusetts, to music—jazz! Jazz had an enormous influence on his work. It should be no surprise that an American modernist painter connected deeply with the new and distinctively American music known as jazz.

Stuart Davis was one of many painters who were inspired by jazz. American artists, such as Archibald Motley (1891–1981) and Aaron Douglass (1899–1979), both major figures of the Harlem Renaissance, used images of nightlife and jazz culture in some of their paintings; Motley's works *Stomp* and *Nightlife* depict such energy. Romare Bearden (1911–1988) would come to "paint the blues," as he said, in major series of works, such as "Of the Blues." The stories he told through paintings and collage were in many cases some of the same stories told through the language of jazz.

The Birth of Jazz

At its core, jazz is connected to freedom—the freedom to express emotion, the freedom to tell one's story, the freedom to create. The roots of jazz can be traced back to multiple sources, including field hollers, work songs, and

complaint songs of the earliest slaves brought to the United States from Africa. These songs were powerful forms of emotional expression and communication. Raw, spontaneous, and deeply honest, this music told stories—stories of individuals that became shared stories of many. These early musical expressions impacted Negro spirituals of the nineteenth century. Songs, such as "I've Been 'Buked," "Fix Me, Jesus," and "Wade in the Water" to name just a few, had themes of angst, sorrow, praise, faith, and hope. They were freely created in moments of yearning, working, and sharing.

Spirituals were written in verse form through which they conveyed stories of struggle, perseverance, and hope for a better day. These stories were developed through multiple stanzas or verses, sometimes punctuated with a refrain that echoed a theme or message in each verse. The style of these songs reflects the emotions they conveyed. They were originally sung a cappella (without instruments), and they often incorporated "call and response" between groups. Call and response involves a musical dialogue in which a lead singer sings a melodic phrase, to which another singer or group responds in song. As in a verbal conversation with moments of talking and listening, communication is at the core of call and response. The slurs and glides of the human voice help to express not just words but also the emotion behind them—often a sense of yearning or cry.

Jazz also had roots in European music and in marches, especially those of the late nineteenth century. Early marches helped support the movement of groups, particularly soldiers. Composed in duple or quadruple meter, they have strong, regular accents on beat one and regular phrases to organize the physical movement of the march. In the nineteenth century, such bandleaders as John Philip Sousa, who was known as the "March King," became popular in leading these ensembles that made music for patriotic expression and later for concert performance. These bands were typically comprised of woodwind instruments, brass instruments, and percussion instruments. Band music of this era was rooted in the harmonic conventions of European music, and it had clearly defined structures. Works, such as Sousa's "Stars and Stripes Forever," were composed in a form that relied on clearly marked sections called *strains*, *trios*, and *breaks*. The combination of repeated sections, called *strains*, contrasting with sections characterized by reduced instrumentation and the famous piccolo solo of the trio and the "surprise" of the famous trombone breaks helped to create interest and excitement among listeners.

In the 1890s, jazz developed in both instrumental music and in vocal music. It can be traced back to instrumental ragtime music of the 1890s and also to the vocal blues. Originally improvised, ragtime piano music is known for its lively, syncopated rhythms; angular intervallic leaps; and role as en-

tertainment in smoky saloons and bordellos. Ragtime music was not even acknowledged as "real music" in its early days. Early ragtime music developed in St. Louis and Sedalia, Missouri, and it later took hold in other parts of the country. It became popular through the work of musicians like Scott Joplin and his music, such as "Maple Leaf Rag." As ragtime started to be notated, that opened the door for its publication, which began around 1900. After that, ragtime became a regular part of vaudeville and Broadway musicals in the early twentieth century.

The early twelve-bar blues that began in the rural South was a distinctive vocal style that was derived, in part, from spirituals. This involved a vocalist singing over a repeated chord progression in three four-bar phrases—AAB. This strict formula allowed the singer to tell the story through repeated verses in which the words would change but the harmony and form would stay constant. Through this structure, the music was at the service of the words. Singers could improvise over this defined harmonic pattern while telling their story in song. The most common accompanying instrument was the guitar. If the words did not complete the four-bar phrases, the guitar would "fill in" in order to keep the rhythm, harmony, and structure consistent. These "filled-in" passages came to be known as *riffs*. Some of the earliest published blues include W. C. Handy's "Memphis Blues" and "St. Louis Blues," as well as Jelly Roll Morton's "Jelly Roll Blues." Artists, such as Ma Rainey and Bessie Smith, brought the blues to new levels of creative expression.

Ragtime music and the blues led the way in developments in early jazz. This new music, sometimes referred to as New Orleans jazz because of its roots in this culturally diverse city, was created by small ensembles that played instruments that had been used by patriotic bands. This collection of "leftover" instruments, including clarinets, trombones, cornets, trumpets, and banjos, was transformed by musicians into a new style—jazz. Improvisation was at the core of this New Orleans style in which melodies were embellished by various solo instruments.

After World War I, jazz began to be recorded, and it was played on the radio, which meant it reached a larger audience. The Jazz Age of the 1920s took hold, and by the middle of that decade, the phrase *hot jazz* was used to described the intensity of this music—particularly the element of improvisation. Louis Armstrong and his Hot Five and Hot Seven bands of the twenties became jazz classics. His Hot Five Band was made up of lead instruments—trumpet, clarinet, and trombone—backed up by a rhythm section. Influenced by the blues, ragtime, and Sousa-era bands, these jazz bands of the 1920s were defined by the virtuosic skills of the players, which allowed

for extensive improvisation. The lead instruments often improvised "collectively," building to a "hot" high point.

Paul Whiteman, who was referred to as the "Jazz King," was a great arranger who came to prominence in the 1920s. Early jazz had been strongly associated with dance and entertainment. Through his arrangements and interest in what is now referred to as "symphonic jazz," people began to listen to jazz as well as dance to it. Symphonic jazz merged jazz styles into the traditional color and form of symphonic music, resulting in a new approach that found voice in works like Gerswhin's *Rhapsody in Blue*, which was premiered in the 1920s by Paul Whiteman's orchestra, with Gershwin himself at the piano. This concert took place in a concert hall, which was a new venue for this style of music. It introduced jazz to a wider audience, and it helped jazz as a style to gain acceptance in the broader world of music.

Developments in jazz happened quickly. Small bands and combos grew from around eight or nine instruments, including clarinet, cornet, trombone, tuba, banjo, bass, guitar, drums, and sometimes piano, to "big bands," which were large ensembles made up of brass, woodwind, and rhythm sections. As the ensembles grew in size, arrangers became important, and they started writing specifically for these "big bands." This ushered in the Swing Era of the 1930s, which gained great popularity as dance music and entertainment. Jazz moved north to cities like Chicago and New York City. Big band/Swing Era giants, such as Duke Ellington, Count Basie, and Benny Goodman, gained unprecedented popularity in the United States due, in part, to developments in the recording industry. Duke Ellington brought together some of the best jazz musicians of that time, and as a bandleader, he created new sounds in jazz through rhythmic innovations and by blending instruments in new ways. Because the big bands were larger than those combos of earlier New Orleans jazz, the focus turned to technical virtuosity within "arrangements" over the element of spontaneity found in earlier jazz.

In the 1940s a new style of jazz known as *bebop* developed. This called for smaller ensembles, which allowed a return to the extensive individual improvisation that had been at the core of early jazz. Such artists as Miles Davis (trumpet), Art Tatum (piano), Dizzie Gillespie (trumpet), and Charlie "Bird" Parker (tenor sax) became major figures in the world of jazz. The shift away from the big band sound of the 1930s back to smaller combos gave musicians a way of returning to improvisation. A soloist could improvise extensively as long as it fit into the established chord progressions. Musicians of the 1940s also introduced elements of dissonance and unusual harmonies that were new to jazz audiences. By this point jazz had moved away from music for dancing to music for listening. Bebop led the way to "progressive

jazz" in the music of artists like Dave Brubeck, Gil Evans, Stan Kenton, and Thelonius Monk. Many more types of jazz would emerge in the second half of the twentieth century.

Gunther Schuller, the prolific American composer, educator, writer, and conductor, coined the term *third stream*, which refers to a "new" type of music that combines elements of both jazz and classical music. In a lecture, he spoke about the aspect of storytelling in all jazz, not just vocal jazz. He said,

> The true jazz artist . . . is generally trying to tell a story, trying to make a personal statement, trying to say something on his instrument that has perhaps not been said before in just such a way. The true jazz artist is creative not just in the on-the-spot invention of musical statements, that is, *his* choice of notes, shapes, phrases, rhythmic figures, but also creative in the way he approaches his instrument. He does this often in ignorance or defiance of the orthodox training methods by which classical players learn their instruments. . . . He used whatever tonguing and articulation his ear commanded him to use and in the process invented articulations, phrasings, and rhythmic configurations never heard before. (quoted in Fisk 1997, 441–42)

Stuart Davis

Stuart Davis was born in Philadelphia to artist parents who had both studied at the Pennsylvania Academy of Fine Art. His mother was a sculptor, and his father became an art editor at the *Philadelphia Press*. They possessed a sense of free spirit and entrepreneurialism. At the age of just fifteen, Davis left high school and went to study at the Robert Henri School of Art in New York City. As a young art student, he lived his life beyond the traditional artist studio and in the fabric of urban American life. He frequented dance halls, saloons, and dive bars. His teacher, Robert Henri, had progressive ideas about making art, and he encouraged his students to sketch impressions of these experiences in urban life. In his autobiography, Davis reflected on these days, saying, "Coleman and I were particularly hep to the jive, for that period, and spent much time listening to the Negro piano players in Newark dives" (quoted in Hills 1996, 28).

As a young artist, Davis worked as an illustrator for magazines, including *The Masses*, which was a socialist magazine started in 1911 that explored edgy and progressive ideas. At that point in time, the idea of what it meant to be modern was in and of itself a radical idea. Some of Davis's sketches of ragtime music being played in the saloons of Newark appeared in this magazine. The spontaneity of the music making resonated with Henri's ideas about spontaneity in art.

As a modern American painter born in the late nineteenth century, Stuart Davis admired the work of European artists Piet Mondrian and Fernand Léger, both of whom also were intrigued by American jazz. Davis was also influenced by cubism, particularly the works by Pablo Picasso and Georges Braque. He was also taken with works by postimpressionists, such as Henri Matisse and Paul Gauguin, whose work he had been exposed to while exhibiting his own at the International Exhibition of Modern Art held at the Sixty-ninth Regiment Armory in New York City (known as the 1913 Armory Show).

The Armory Show is considered to have been one of the most important art exhibits held in the United States. The show featured the work of 300 artists, including paintings by contemporary American artists as well as foreign artists. The section featuring foreign artists showed the evolution of modern art with paintings by artists from Goya to Courbet, impressionists to postimpressionists, Kandinsky to Picasso. The most controversial work at the show was Marcel Duchamp's (1887–1968) *Nude Descending a Staircase, No. 2*, which was met with outrage and harsh humor. The work was influenced by early cubism in the fragmented approach to the figure. However, there is a strong sense of movement in the work—the fragmented planes appear like multiple photographic exposures repeated to give the impression of the figure moving down the staircase. More than 250,000 people attended the show, and while it was controversial, it brought modern art to the interest and attention of the American public.

Stuart Davis considered this show to be a turning point in his career. He reflected on the exhibit, saying,

> I was enormously excited by the show, and responded particularly to Gauguin, Van Gogh, and Matisse, because broad generalization of form and the non-imitative use of color were already practices within my own experience. I also sensed an objective order in these works which I felt was lacking in my own. It gave me the same kind of excitement I got from the numerical precisions of the Negro piano players in the (Newark) saloons, and I resolved that I would quite definitely have to become a "modern" artist. (quoted in Hills 1996, 29)

Davis himself exhibited five watercolors at the Armory Show.

Davis was also very interested in contemporary American urban life—from the colorful gas station to a local storefront to a pack of cigarettes to a taxicab to music. He was drawn to everyday America and everything in it that was new and vibrant. He was intrigued with words, not just what they

meant, but especially the way they looked. He noted that people see and hear words every day and that these words are powerful. However, he saw words as more than a group of letters; to him letters were shapes to be developed in paintings. Davis noted that, after all, letters are physical shapes. He said, "In choosing words I find that the smallest idea is equal to the greatest. I've used insignificant words and drawn insignificant objects because at times these were all that were at hand. By giving them value as experiences and by equating great with little, I discovered that the act of believing was what gave meaning to the smallest idea" (quoted in Kuh 2000, 52).

One can find similarities in jazz. Early jazz bands were comprised of old instruments, essentially left over from nineteenth-century bands. Alone, each instrument might have been considered insignificant. The basic chords of a jazz chart can be seen as insignificant before coming to life through the interpretation and improvisation of the musicians. Perhaps the process of giving meaning and life to the "smallest idea" is also a driving force in jazz.

Davis spoke of the great influence of jazz on his life, even naming his son after the jazz artists George Wettling (drummer) and Earl Hines (pianist). He said, "For me at that time jazz was the only thing that corresponded to an authentic art in America. . . . For me—I had jazz all my life—I almost breathed it like air" (quoted in Kuh 2000, 53). As a young man in the 1910s, Davis became acquainted with early jazz firsthand in the bars of Newark, New Jersey. Before jazz was even taken seriously in the broader musical world, Davis listened to this music, in part for inspiration for his creative work in the visual arts.

Some of his works from this period use jazz as a subject of contemporary urban life. He painted ragtime and early jazz musicians playing in saloons, and he used not only the visual imagery of New York City and the 1920s hot jazz scene but also the nervous energy and hectic pace that were becoming part of the essence of the new American urban life. In 1940 Davis reflected back on this time, writing,

> Earl Hines' piano playing has served me as proof that art can exist, since 1928, when I heard his playing in a Louis Armstrong record, "Save it pretty mama." . . . Earl Hines represented to me the achievement of an abstract art of real order. His ability to take an anecdotal or sentimental song and turn it into a series of musical intervals of enormous variety has played an important part in helping me to formulate my own aspirations in painting. (quoted in Hills 1996, 127)

Listen to "Save It, Pretty Mama," Louis Armstrong with Earl Hines, https://www.youtube.com/watch?v=_aBnzoEcwuk&list=PL52EBB9 817AE8A193.

Look at *The Blues*, 1925, Stuart Davis, http://joshuaabelow.blogspot. com/2010/10/blues-1925-stuart-davis.html.

Listen to "The Yellow Dog Blues," 1925, Bessie Smith (vocals), https:// www.youtube.com/watch?v=JVL24i38F2s.

Influence of the Swing Era

By the 1930s, as swing music swept the United States, Davis became more interested in depicting not just the sights of jazz but also the *sounds* of jazz through the use of line, color, and shape. A key work from this era is Davis's *Swing Landscape* from 1938. As a struggling artist, Davis qualified for employment through Roosevelt's Works Progress Administration (WPA) Federal Art Project, which was part of the New Deal. Under this program the government commissioned artists across media to create art for public buildings. Davis became involved in designing murals for this program; among the murals he painted were those for Radio City Music Hall in New York (1932) and the New York World's Fair (1939).

Davis was also one of twelve artists chosen to paint murals for the Williamsburg Housing Project in Brooklyn, New York. His painting depicts waterfront images of Gloucester, Massachusetts, the small New England town he visited during summer months. Ironically, the piece was never installed in Brooklyn and is now at the Indiana University Museum of Art. This work marked a shift away from a painting depicting the making of jazz to a "swing-influenced" painting of the Gloucester, Massachusetts, waterfront. However, this work is characterized by a style that utilizes lines, shapes, and colors to suggest the essence of swing as part of American popular culture.

Look at *Swing Landscape*, 1938, Stuart Davis, http://www.iub.edu/~iuam/ online_modules/picturing_america/_img/009.jpg.

Listen to "Cavernism," 1934, Earl Hines, http://www.youtube.com/ watch?v=3X9Zu2X7JXE.

Listen to "It Don't Mean a Thing if You Ain't Got That Swing," 1932, Duke Ellington and His Orchestra, http://www.youtube.com/ watch?v=-FvsgGp8rSE.

Davis said,

> I have always liked hot music. There's something wrong with any American who doesn't. But I never realized that it was influencing my work until one day I put on a favorite record and listened to it while I was looking at a painting I had just finished. Then I got a funny feeling. If I looked, or if I listened, there was no shifting of attention. It seemed to amount to the same thing—like twins, a kinship. After that, for a long time, I played records while I painted. (quoted in Cassidy 1997)

In the 1940s, Davis attended all-night jam sessions, and he met many of the leading jazz artists of the time. As he continued to create in the 1940s and '50s, he conveyed the feelings and expressions of jazz in his work through the use of abstract images that suggested sound and rhythm. His work from this period was a sort of visual translation of American life as evidenced by the popularity of jazz, which was sweeping the country. Davis often articulated specific connections between his art and jazz. For example, with regard to his painting *Hot Still-Scape for Six Colors—7th Avenue Style* from 1940, he said,

> It is composed from shape and color elements which I have used in painting landscapes and still-lifes from nature. Invented elements are added. Hence the term "Still-scape." It is called "Hot" because of its dynamic mood, as opposed to a serene or pastoral mood. Six colors, white, yellow, blue, orange, red, and black, were used as the materials of expression. They are used as the instruments as a musical composition might be, where the tone-color variety results from the simultaneous juxtaposition of different instrument groups. It is the "7th Ave. Style" because I have had it in my studio on 7th Ave. for 15 years. (quoted in Hills 1996, 19).

Look at *Hot Still-Scape for Six Colors—7th Avenue Style*, 1940, Stuart Davis, http://upload.wikimedia.org/wikipedia/en/5/54/Hot_Still-Scape_for_Six_Colors_-_7th_Avenue_Style.jpg.
Listen to "Swingin' the Blues," 1941, Count Basie and His Orchestra, http://www.youtube.com/watch?v=TYLbrZAko7E.

Another jazz-inspired work by Stuart Davis is *The Mellow Pad*, which is in the collection of the Brooklyn Museum of Art (see figure 1.1). By comparing this painting to his earlier work *House and Street* from 1931, one notes the division of the canvas and the establishment of key shapes and colors.

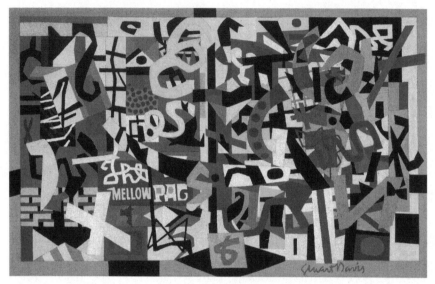

Figure 1.1. Stuart Davis, *The Mellow Pad*, 1945–1951, oil on canvas. © Estate of Stuart Davis/Licensed by VAGA, New York, NY.

Davis made a journal entry in 1947, saying, "*The Mellow Pad* was started on the premise that *House and Street* was a good painting and that its simplicity could be used as a base on which to develop new material" (quoted in Hills 1996, 124). This is similar to the way a jazz musician treats musical material. As a jazz musician reuses material as a "riff," Davis drew upon material from *House and Street* but moved beyond it in establishing independent new material. The idea of a "mellow pad" comes from the world of jazz, meaning a "cool" place to be. Like jazz artists, Davis started with a theme and worked it out through improvisation characterized by complex rhythms and dynamic colors.

Listen to "After Hour Stuff," 1945, Tommy Dorsey, http://www.youtube.com/watch?v=sy535pfZD4E.

Listen to "Symphony in Riffs," 1938, Tommy Dorsey, https://www.youtube.com/watch?v=gxlOiORnLkk.

In *The Mellow Pad*, one can find similarities between the ways Davis used paint and the ways jazz musicians used sound. Davis used recurring patterns like a jazz musician would use a recurring harmonic progression. Just as jazz

artists use a riff—a repeated pattern of notes, chords, or phrases as a basis for improvisation—Davis created new versions of established shapes and patterns—recurrent yet not exactly the same.

Davis did not just talk about jazz as an influence. He personally knew some of the great jazz artists of his day, and he knew their music. In 1943 Davis had an exhibition at the Downtown Gallery on East Fifty-first Street in New York City. The opening of the show also included a live jam session with many of the great jazz artists of the day playing. This included major jazz artists, such as W. C. Handy, George Wettling, Duke Ellington, and boogie-woogie pianist Pete Johnson. The artist Piet Mondrian, known for his love of boogie-woogie music, attended this opening. Critics noted the connection with observations like "If you feel the nervous spirit, the hectic movement which jazz and swing celebrate in modern music, you doubtless have sensed what Davis intends his pictures to convey" (Carlyle Burrows of the *Herald Tribune*, quoted in Hills 1996, 135). Emily Genauer, a writer for the *World-Telegram*, noted, "Davis hoped that guests would see how the irregular geometrical shapes and piebald colors of his compositions . . . echo the rhythms and tempo of swing music. And they do, too" (quoted in Hills 1996, 134).

Musical and Visual Counterparts

Davis considered jazz to be a musical counterpart to abstract art. How can syncopation, an accent in an unexpected place, be seen in painting? Perhaps through the artist's use of squiggly, asymmetrical, and unexpected lines; repetitive moving shapes; colors in a painting. The sounds of the cornets, trombones, and clarinets turn to hot reds, intense yellows, and cool blues. Consider what jazz riffs might *look* like. Perhaps, to some viewers, those cycles of chord progressions suggest lines that direct the eye and create a sense of visual rhythm.

The artist's connection to jazz is apparent when looking at these works. Davis said, "I think all my paintings, at least in part, come from this influence. . . . My objective was to make paintings that could be looked at while listening to [a jazz] record at the same time" (quoted in Kuh 2000, 53). Davis was particularly struck by the music of jazz great, Earl "Fatha" Hines and Duke Ellington, who said, "You've got to find some way of saying it without saying it."

~

Arthur Dove and George Gershwin

A *Brush with* Rhapsody in Blue

The United States entered the twentieth century with a strong sense of youthful optimism and confidence. This period of time witnessed the growth of such big cities as New York City and a general shift in population from rural areas to quickly developing urban centers. It also introduced the voice of a new distinctively "American" music—jazz! From its roots in African music, spirituals, ragtime, and blues, jazz took hold as a new style, one that quickly gained popular appeal. This new music impacted people differently. For the general population, it was a form of dance music and entertainment in clubs and social halls. For musicians, it offered endless possibilities for composition, performance, and improvisation, and for some visual artists it was an exciting source of inspiration for new ideas in painting.

Such was the case with American composer George Gershwin (1898–1937) and American painter Arthur Dove (1880–1946). Gershwin, who was also an amateur artist, believed that music could influence the visual sense. He collected art, and he even took up painting later in his life, making portraits of important people in the world of music and art. Dove was an amateur musician who played the piano, drums, and mandolin and who wrote essays in which he addressed analogies between music and art. He believed that abstract painting could express musical sounds, emotions, and ideas. Both Gershwin and Dove created in their respective forms of art from the modern life around them. An intersection of their common ideas and environment took shape in Gershwin's *Rhapsody in Blue* (1924) and Dove's "music paintings," specifically those created in response to Gershwin's music.

Gershwin and *Rhapsody in Blue*

George Gershwin was born in Brooklyn, New York, to Russian/Ukrainian immigrant parents. As a New Yorker of European-Jewish heritage, he was an urban kid who grew up hearing music on the streets of the city. He did not study music formally; rather, he became familiar with a great range of music and musical traditions simply by engaging in his surroundings. In 1927, he reflected on these days of his youth and noted their importance in his development as a composer. He wrote, "I was becoming acquainted with that which later I was to interpret—the soul of the American people. Having been born in New York, and grown up among New Yorkers, I have heard the voice of that soul. It spoke to me on the streets, in school, at the theater. In the chorus of the city sounds I heard it" (quoted in Tick 2008, 436).

Gershwin dropped out of high school to take a job as a song plugger at Jerome H. Remick, a music publisher in New York City's Tin Pan Alley. This period of time saw swift developments in the music publishing industry, particularly in New York City. Tin Pan Alley refers to a specific city block—Twenty-eighth Street between Broadway and Sixth Avenue—which was packed with music publishers. The job of the song plugger was to sell new songs by singing and/or playing these songs to eager performers, theater managers, and bandleaders. Song pluggers on this busy city street worked long days, from early morning to late evening, in order to be successful in this highly competitive new market. The ever-present tinny and percussive sounds of the piano music could be heard in the streets outside, giving this bustling corner of the city the nickname "Tin Pan Alley." Gershwin, along with other well-known composers of the time, such as Irving Berlin, Cole Porter, and Jerome Kern, had stints as a song plugger. It was through this experience that Gershwin entered the world of American song, a world in which he would become iconic.

Gershwin started composing at a young age, and before too long, he was writing for Broadway shows and revues. Such songs as "I'll Build a Stairway to Paradise" appeared as soon as 1922 in *George White's Scandals of 1922* revue, which was first performed at the Globe Theater in New York. This was also the year that Gershwin composed a one-act opera called *Blue Monday*. Although the work was not received well and was withdrawn after opening night, it planted seeds of what would come later. It was about life in America, and it featured songs that reflected popular music of the time, including the blues, ragtime, and sentimental songs. Musician Paul Whiteman, who had recently moved to New York from the west coast, had become a fan of Gershwin's one-act opera *Blue Monday*; in fact he presented it later as *135th*

Street in a 1925 performance at Carnegie Hall after having it reorchestrated by Ferde Grofé (1892–1972).

Gershwin's gift of melody combined with his frequent collaborations with his brother and lyricist Ira Gershwin resulted in an enormous body of song repertoire. As a team, they created some of the most popular musical scores of their time, including *Lady, Be Good* (1924), *Oh, Kay!* (1926), and *Funny Face* (1927). Among Gershwin's best-known songs are "Fascinating Rhythm" (1924), "'S Wonderful" (1927), and "The Man I Love" (1927). His gift of song would echo in all of his compositions throughout his life.

Gershwin reflected on the songs of his youth in the city, saying,

> Old music and new music, forgotten melodies and the craze of the movement, bits of opera, Russian folksongs, Spanish ballads, chansons, ragtime ditties, combined in a mighty chorus in my inner ear. And through and over it all I heard, faint at first, loud at last, the soul of this great America of ours. And what is the voice of the American soul? It is jazz developed out of ragtime, jazz that is the plantation song improved and transformed into finer, bigger harmonies. . . . It is all colors and all souls unified in the great melting-pot of the world. Its dominant note is vibrant syncopation. (quoted in Tick 2008, 436–37)

As Gershwin was writing songs in New York City, musician Paul Whiteman (1890–1967) was building his musical career in the west, and before too long their paths would cross. Whiteman began his musical life as a classical musician playing viola in the Denver Symphony Orchestra and San Francisco Symphony Orchestra. Although he was working in the world of classical music, he witnessed important developments in ragtime, the blues, and early jazz, and he started his own band in 1918. His orchestral background influenced his approach to jazz. His finely tuned ear and his skill as an arranger resulted in the great versatility and polished sound of his orchestra. He became hugely successful in the United States and abroad. During his life he made more than 3,000 arrangements and over 600 records, and he became one of the most influential figures in American popular music of the time.

Whiteman commissioned Gershwin to write a composition in 1924 for a concert that was referred to as an "experiment in modern music" and was to be performed at Aeolian Concert Hall in New York City. Why was this referred to as an experiment? This concert was considered experimental because it showcased jazz for the first time in a traditional concert setting. Up until this time, the concert hall had been a sacred space of sorts, reserved for "art" or serious classical music. Jazz was still something of the clubs and

dance halls, and it had not been accepted by critics or audiences as "serious" music at this point. The fact that this concert was performed in a concert hall points to the growing value of jazz and popular music on the fine arts and concert music in the 1920s. A small headline in the *New York Tribune* on January 4, 1924, read, "Whiteman Judges Named: Committee Will Decide 'What Is American Music?'" (quoted in Jablonsky and Stewart 1996, 89). The brief article went on to name major names in the field of music, including great Russian composer and piano virtuoso Sergei Rachmaninoff and esteemed classical violinist Jascha Heifetz, as among those who would attend the concert.

The piece that Gershwin would write was the concerto-like *Rhapsody in Blue*, a work that was to become one of the most beloved among his compositions. The term *concerto* (believed to be from the Latin root *concertare* meaning "contest") has been used in classical music for centuries. The term suggests a work in a clear form for a soloist and an ensemble; piano and orchestra, for example. *Rhapsody in Blue* was originally composed for piano and jazz band and was premiered by Paul Whiteman's Jazz Band with Gershwin himself at the piano. Gershwin's title suggested the approach to the structure of the work with a bold nod to the jazz blues.

Gershwin originally composed the piece for two pianos. Writing music at the piano was a process with which he was familiar from his days in Tin Pan Alley and his experience in the theater. After completing the piece, he gave it to arranger and orchestrator Ferde Grofé, who created the versions familiar to today's audiences. The term *rhapsody* was not new; in fact, the term had been widely used in classical music by such composers as Franz Liszt to describe a work typically in a single extended movement and composed in a free, improvisatory style. Although Gershwin's piece was composed and clearly notated, the style suggests that of improvisation, which is at the heart of jazz. The title itself—*Rhapsody in Blue*—is thought to have been suggested by Gershwin's brother and lyricist Ira Gershwin after he visited a museum and saw paintings by American artist James McNeill Whistler, who used such titles as *Symphony in White*, *Symphony in Grey and Green*, *Harmony in Grey and Green*, and so on.

The term *blue* suggests the blues, an early form of vocal jazz. The early blues were sung by African Americans and told stories of hardship and hope. The vocal style of the early blues songs embodied a wide variety of tone qualities, ranging from guttural sounds to wide vibrato, as well as great rhythmic freedom. Pitch was deliberately stretched with techniques, such as vocal slides, suggesting crying or yearning, in order to create greater room

for emotional expression. When this style of vocal music carried over into instrumental music, it allowed jazz musicians a new sense of flexibility and creative space to experiment with new sounds on traditional instruments, such as the clarinet, trumpet, and trombone.

Gershwin experimented with these new freedoms as well by notating similar effects in *Rhapsody in Blue*. The piece opens with a now-famous clarinet glissando that slowly and dramatically leads up to the opening pitch. This "effect" was composed with Ross Gorman, the clarinetist in Whiteman's band, in mind. He was known for his technical wizardry in playing glissandi. This piece marked a new approach to music—one that combined elements of jazz, including rhythmic syncopations, jazz harmonies, and a feeling of improvisation with elements of classical music. In it Gershwin used elements of the jazz style within a primarily classical structure. It is interesting to note that this work reflects Whiteman's shift from classical music to jazz and Gershwin's entrée into the world of concert music from song writing.

In fact, Gershwin gained great popularity with the success of this performance. *Rhapsody in Blue* was the first of several major works he would compose, including *Concerto in F* (1925) for piano and orchestra; *An American in Paris* (1928), which is considered a "tone poem" for orchestra; and *Porgy and Bess* (1935), which was a full-scale opera. These are among his major works within a huge body of compositions from song to Broadway to Hollywood.

Gershwin composed *Rhapsody in Blue* in just weeks. As a composer who was always influenced by the sounds of the world around him, he recounted the inspiration he found for this piece while riding a train to Boston. Gershwin recalled,

> It was on the train with its steely rhythms, its rattle-ty bang that is often so stimulating to a composer. . . . And there I suddenly heard—and even saw on paper—the complete construction of the rhapsody from beginning to end. . . . I heard it as a sort of musical kaleidoscope of America—of our vast melting pot, of our unduplicated national pep, of our blues, our metropolitan madness. (quoted in Cassidy 1997, 13)

Listen to *Rhapsody in Blue*, 1924, George Gershwin and Paul Whiteman, http://www.youtube.com/watch?v=XIWrfW2M91U.

Arthur Dove and His "Music Paintings"

Like many American artists and musicians of the early twentieth century, Arthur Dove spent time in Europe. He traveled to France in 1907, where he became acquainted with the work of such artists as Henri Matisse and Paul Cézanne, whose bold approach to color would inspire his own work. Upon his return to the United States in 1909, he became associated with gallery owner and photographer Alfred Stieglitz in New York City. Dove, along with other American artists in Stieglitz's circle, such as Georgia O'Keeffe and John Marin, tried to capture the spirit of America in their work. Like these contemporaries, Dove connected to the United States not just through physical land but also through the developing city life, with its high buildings and emerging technology. To him, jazz embodied this new and vibrant modern life in America. In the same spirit, Dove tried to create a uniquely American art influenced by yet separate from European traditions.

He, along with such artists as Georgia O'Keeffe and Stuart Davis, were interested in the idea of "synaesthesia," which refers to perception through multiple senses. He was fascinated by music and the emotional power it carried. He believed that various combinations of visual elements, including color, line, and form, could create the same sense of emotion as that which could be created through musical sound. He even attempted to develop a system to translate musical sound to visual color. He wrote, "Art is nearer to music, not the music of the ears, but the music of the eyes" (quoted in Messinger 2011, 109).

Arthur Dove often listened to music while he painted. With the popularity of the radio as well as the Victor-Victrola, music was accessible to a wide audience across the country. Among Dove's favorite artists were George Gershwin and Louis Armstrong. Not only did the artist listen to and enjoy this music, but he also painted while listening, and he even attempted to create pure musical sounds into visual art. In the spirit of Kandinsky, whose treatises *Concerning the Spiritual in Art* and *Point and Line to Plane* Dove had read, the artist expressed his approach in the 1927–1928 catalog for his exhibit at Stieglitz's Intimate Gallery in New York, saying, "The line was a moving point reducing the moving volume to one dimension. From there on it is expressed in terms of color as music is in terms of sound" (quoted in Cassidy 1988, 20).

Dove made at least twelve music-related artworks, beginning with *Music* (1913) and ending with *Primitive Music* (1943). Six of these are specifically connected to George Gershwin and Irving Berlin. Most of his "music paintings" were made between 1913 and 1928. The oil painting *Sentimental Music*

(1917) was one of his early works on this theme. In this painting, Dove used soft pastel colors of rose and gray in short brushstrokes and juxtaposed this against strong, rhythmically pronounced bold black lines. The use of soft colors and short brushstrokes may suggest the emotion he felt in response to the music he heard.

The six abstract artworks with a specific musical connection named by the artist himself are those he did in the 1920s—the Jazz Age. They were exhibited at Stieglitz's Intimate Gallery in New York City in 1927 and 1928. The first three of these are dedicated specifically to the music of George Gershwin and are *Rhapsody in Blue, Part I*, *Rhapsody in Blue, Part II*, and *I'll Build a Stairway to Paradise*, all of which had been recorded by Paul Whiteman and his band. Dove created *Orange Grove in California* in response to music by Irving Berlin, who, like Gershwin, was a prolific songwriter, composing more than 1,000 songs during his life. Berlin's first hit was "Alexander's Ragtime Band" (1911). His style continued to develop in the 1920s with such songs as "Say It with Music" (1921), "Always" (1925), and "Blue Skies" (1927), which had sentimental and nostalgic overtones. His song "Orange Grove in California" was originally sung as a duet by Grace Moore and John Steel in Berlin's 1923 *Music Box Revue*.

The other two paintings from this group were *Rhythm Rag* and *Improvision*. The title *Rhythm Rag* is an obvious reference to ragtime music and the new approaches to rhythm; it, too, was inspired by a recording by Paul Whiteman. The title *Improvision* reflects both the improvisatory nature of jazz and the word *vision*—perhaps suggesting the new paths forged by this new style of music. It may have also been inspired by Kandinsky's "Improvisations No. 27," which Stieglitz bought in 1913.

Listen to *Orange Grove in California*, Paul Whiteman and His Orchestra, composed by Irving Berlin, https://www.youtube.com/watch?v=dMCk4bPtyTg.

The works dedicated to Gershwin—*Rhapsody in Blue, Parts I and II* and *I'll Build a Stairway to Paradise*—were both performed in Whiteman's concert *An Experiment in Modern Music*. The fact that Dove painted these works just a few years later points to the significance this music had for the artist. By using the title *Rhapsody in Blue* for his abstract paintings, he essentially opened a door to abstract painting for a broader audience. Gershwin's piece

had already garnered a great appeal to a broad audience. By using a title that was already known and appreciated by audiences, Dove invited a new and larger audience into the world of abstract painting.

The fact that Dove made two paintings on this theme and called them *Part I* and *Part II* likely suggests the way in which they were first recorded and ultimately heard by the listener. The first recording was on Victor-Victrola 78 rpm, and it featured Gershwin himself at the piano. The listener would have had to turn the album over to hear the entire piece. Therefore, Dove's title *Part I* probably suggests the opening "Allegro," and *Part II* likely reflects the slow middle section and upbeat finale recorded on side two.

Dove attempted to create the sound of this music visually through use of line, color, and medium. *Rhapsody in Blue, Part I* (see figure 2.1) is a collage of oil and metallic paint on aluminum with a clock spring. The materials, tempi, and rhythms of the modern age are reflected in his use of metallic paint, aluminum, and even the clock spring. The dramatic use of the color blue recalls the style of the blues. The strong vertical lines may even be a literal suggestion of the bold clarinet glissando that opens the musical composition. The varied and busy texture of short lines and angles juxtaposed with longer lyrical lines perhaps suggests the complex texture of Gershwin's music with its interchange among piano, clarinet, and brass instruments.

The vibrant new spirit of jazz invigorated both music and art. Gershwin understood the voice of jazz and its impact not just on his era but also on music in years to come when he said, "Jazz is the result of the energy stored up in America. It is a very energetic kind of music, noisy, boisterous and even vulgar. One thing is certain. Jazz has contributed an enduring value to America in the sense that it has expressed ourselves. It is an original American achievement which will endure" (quoted in Fisk 1997, 336–37).

Listen to "I'll Build a Stairway to Paradise," 1922, Paul Whiteman and His Orchestra, http://www.youtube.com/watch?v=UYu43Ba8dXE.

Like *Rhapsody in Blue*, Paul Whiteman's orchestra also recorded Gershwin's "I'll Build a Stairway to Paradise" in 1922. The painting of the same name was done in oil and metallic paint, again pointing to the modern age (see figure 2.2). Dove suggested the idea of a staircase through the use of vertical lines leading upward; the short, horizontal brushstrokes perhaps suggest stairs or even keys on a piano that one takes on the way to Paradise. He stressed

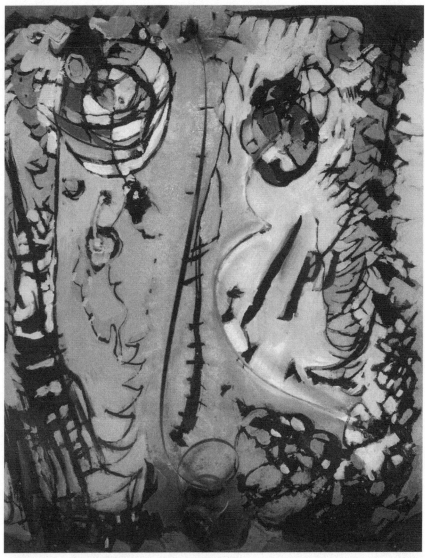

Figure 2.1. Arthur Dove, *George Gershwin—Rhapsody in Blue, Part I*, 1927, oil and metallic paint with clock spring on aluminum support, 11¾ × 9¾ in. © Estate of Arthur G. Dove, Courtesy Terry Dintenfass, Inc.

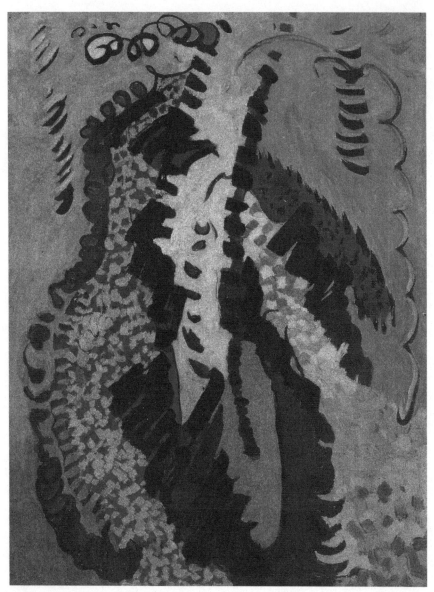

Figure 2.2. Arthur Garfield Dove, *George Gershwin—I'll Build a Stairway to Paradise,* 1927. Ink, metallic paint, and oil on paperboard, 50.8 x 38.1 cm (20 x 15 in.) Museum of Fine Arts, Boston. Gift of the William H. Lane Foundation, 1990.407. Photograph copyright 2014, Museum of Fine Arts, Boston

the color blue, perhaps reflecting the lyrics of the song that say "I've got the blues." He created a broad palette of lines and shapes similar to the complex syncopated rhythms of jazz. The opening of Gershwin's song is an upward leap similar to the opening clarinet solo in *Rhapsody in Blue*, maybe suggesting a stairway. The refrain of this song (lyrics by Ira Gershwin and Bud DeSylva) reflects the spirit of the times.

> I'll build a stairway to Paradise
> With a new step every day!
> I'm going to get there at any price:
> Stand aside, I'm on my way!
> I've got the blues And up above it's so fair!
> Shoes! Go on and carry me there!
> I'll build a stairway to Paradise,
> With a new step every day.

Although most of Dove's "music paintings" were created in the 1920s, he alluded to jazz again in his *Swing Music (Louis Armstrong)* from 1938. Dove was not alone in his fascination with jazz as a subject. Other jazz-influenced visual works from the 1920s include *Interpretations of Harlem Jazz* (1925) by Winold Reiss and *Blues* (1929) by Archibald J. Motley Jr.

Gershwin and the Visual Arts

Gershwin's legacy is most certainly as a composer. However, it is important to note how important visual art was to him. He collected art, and he made art. He started painting in 1931, and he went to Mexico in 1935 and sought out such artists as Diego Rivera and Frida Kahlo. He struck up a friendship with artist David Alfaro Siqueiros and even commissioned him to paint his portrait. Gershwin also became friends with composer Arnold Schoenberg, himself an amateur painter. Gershwin painted several portraits of important people in his life, including Irving Berlin, Arnold Schoenberg, and Diego Rivera, as well as members of his family. He also completed a self-portrait. There was even an exhibit of Gershwin's art at the Marie Harriman Gallery in New York City from December 18, 1937, to January 4, 1938. The exhibition brochure listed thirty-nine paintings, drawings, and watercolors by him.

Gershwin lived to be just thirty-nine years old. In those brief years, he created a distinctive sound in American music, one that bridged the popular with the classical. He said,

Rhapsody in Blue represents what I had been striving for since my earliest composition. I wanted to show that jazz is an idiom not to be limited to a mere song

and chorus that consumed three minutes in presentation. The *Rhapsody in Blue* was a longer work. It required fifteen minutes for the playing. It included more than a dance medium. I succeeded in showing that jazz is not merely a dance, it comprises bigger themes and purposes. It may have the quality of an epic. I wrote it in ten days. It has lived for three years and is healthfully growing. (quoted in Tick 2008, 437)

It continues to thrive as a voice of its time and place.

CHAPTER THREE

~

Romare Bearden and Visual Jazz

Romare Bearden (1911–1988) said, "I paint out of the tradition of the blues" (quoted in Berman 1980, 60). A prolific African American artist and writer, his art, like the blues, speaks of the African American experience and memories. From these he defined stories that hold universal themes. In reflecting on the music of the blues, he said, "Even though you go through these terrible experiences, you come out feeling good. That's what the blues say and that's what I believe—life will prevail" (quoted in Berman 1980, 62).

Bearden addressed broad issues of life through many artistic mediums, from watercolor and drawing to oil and gouache to book illustrations, monotypes, record album cover designs, public murals, and even one sculpture. He also designed sets and costumes for artists, including the Alvin Ailey American Dance Theater, the premier professional dance group that interpreted the African American experience through now-classic dance pieces, such as *Revelations* (1960), which is set to the music of spirituals. Bearden was particularly inventive in his approach to collage, in which he used materials from magazines, photographs, posters, foil, and so on to create works that speak of the past and the present and express experiences both personal and shared. The more than 2,000 works he created during his lifetime are imbued with a strong sense of social conscience.

Growing Up and the Harlem Renaissance

Bearden was born in North Carolina and was an only child whose family moved to Harlem, New York City, in 1914 while he was still a toddler. His

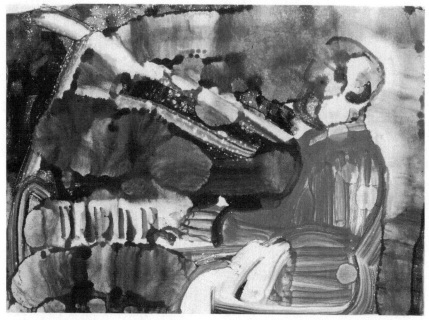

Figure 3.1. Romare Bearden, *Vampin'* (*Piney Brown Blues*), ca. 1970s, monotype on paper, 29½ × 41¼ in. Smithsonian American Art Museum, Washington, DC/Art Resource, New York, NY. © VAGA, New York.

family's move north was part of a larger demographic shift known as the Great Migration, during which time African Americans of the southern states moved both north and west. While growing up, Bearden visited North Carolina as well as Pittsburgh, where his grandmother lived. She lived near the gritty steel mills of this city. He later reflected, "I found it fascinating looking at those mills" (quoted in Tompkins 1977, 54).

The young Bearden came of age during the period known as the Harlem Renaissance, an intellectual and cultural movement of the 1920s and '30s, during which time African Americans across artistic disciplines created works that reflected identity and a new sense of political and racial pride. The movement was largely associated with literature and poetry, but music, theater, and visual arts played an important part as well.

In the world of jazz music, there was also geographical movement—from New Orleans, St. Louis, and Chicago to Harlem in New York City. Important developments took place not just in jazz but also in theater and beyond. The year 1921 marked the opening of the first all-black revue on Broadway

with the show *Shuffle Along*. With lyrics by Noble Sissle and music by jazz great Eubie Blake, this was the first African American musical, and it ushered in the Harlem Renaissance. In the 1920s and 1930s, shows began to feature black performers and addressed themes from the African American experience. This was reflected in such shows as *Showboat* (1927), with music by Jerome Kern and lyrics by Oscar Hammerstein II. This show included now-classic songs, such as "Old Man River," which many remember from versions in which it was sung by such artists as Paul Robeson and William Warfield.

The revue *As Thousands Cheer* (1933), with music and lyrics by Irving Berlin, featured blues singer Ethel Waters in the show. This marked the first time an African American artist was given equal billing with white performers. The 1930s was also the decade of the premier of the major American opera *Porgy and Bess* (1935) by George and Ira Gershwin. The opera, which was set in Charleston, South Carolina, depicts the lives of African Americans and was performed by an all-black cast.

While growing up, Bearden's Harlem home was a gathering place for many major figures of the Harlem Renaissance, including painter Aaron Douglas; poet Langston Hughes; and jazz greats Duke Ellington, Ella Fitzgerald, and Fats Waller, to name a few. He grew up surrounded by music, art, and ideas. Later in his life he reflected on these years, saying, "Harlem was very much like Paris in the '20s and '30s. The confines of where you lived were so narrow that you met everybody. W. E. B. DuBois and James Weldon Johnson lived on 135th Street. Just a little farther up were Claude McKay, Langston Hughes and Countee Cullen" (quoted in Berman 1980, 63).

As a youth, Bearden had broad interests in the arts as well as in mathematics, science, and baseball. He went to college, studying at Boston University and ultimately graduating from New York University. As a college student, he started creating political cartoons that appeared in publications, including *The Medley* of New York University and *The Crisis*, an activist journal that was sponsored by the National Association for the Advancement of Colored People. Through these early works, he came to understand the power of the arts as a voice for important political and social issues.

Bearden enrolled in art classes at the Art Students League in New York City, where he studied with German painter George Grosz, who reinforced his approach to art as one that conveyed social and political ideas. Bearden wrote, "It was during my period with Grosz under whom I began studying several months after graduating from New York University, that I began to regard myself as a painter rather than a cartoonist. The drawings of Grosz on the theme of the human situation in post–First World War Germany made

me realize the artistic possibilities of the American Negro subject matter" (quoted in Melberg and Block 1980, 20–21). In his interview for an article that appeared in the *New Yorker*, Bearden remembered Grosz as the person who "led me to study composition, through the analysis of Brueghel and the great Dutch masters, and in the process of refining my draftsmanship initiated me into the magic world of Ingres, Durer, Holbein, and Poussin" (quoted in Tompkins 1977, 56).

Bearden's commitment to social and political ideals shaped not just his art but also the way he spent his life. He was a social worker in New York City, where he was employed by the Department of Social Services. In addition to political and social issues, Bearden was interested in all of the arts—music, literature, visual arts. He was incredibly well read and dedicated to art history, poetry, religion, philosophy, and politics, as well as the work of contemporary writers. In addition to the work of the great Dutch masters, such as Vermeer and De Hooch, he studied cubism and African art. Bearden said that his objective was "to paint the life of my people as I know it—as passionately and dispassionately as Bruegel painted the life of the Flemish people of his day" (quoted in Berman 1980, 60). He was particularly drawn to themes of African American history and memory as well as issues of race, especially after the civil rights movement of the 1960s.

In addition to making art, Bearden was also a writer himself. He wrote reviews for exhibitions and articles, as well as three books dedicated to honoring the work of African American artists. These books are *The Painter's Mind* (1953), *Six Black Masters of American Art* (1972), and *A History of African-American Artists: From 1972 to the Present*, which was published posthumously in 1993.

Music

Music, specifically jazz, and the sense of memory it holds were major influences on Bearden in many of his works. He had young memories of the blues in the South followed by the sounds of the urban experience in the North. He said that he never actually left Charlotte, North Carolina, except physically. The experiences of his young life—of the people, the family garden— never left him. As in the music of the blues, he continued to tell his story through his art.

He was interested in jazz on many levels—as an art form born out of the African American experience, as a subject, and as a technique. He loved jazz, he listened to jazz for hours on end, and he personally knew such jazz artists as Duke Ellington. From the stories told through the rural blues to

New Orleans jazz to the vibrant urban sounds of New York City, jazz became a metaphor of sorts for what Bearden used as a subject and how he created his art. He lived in a neighborhood where he was surrounded by music; for many years his studio in New York City was above the still-famous Apollo Theater in Harlem.

Ideas derived from call and response in jazz to varied repetition to improvisation all influenced Bearden's work. He spoke of "call and recall. You start a theme and you call and recall" (quoted in Berman 1980, 60). Expressive and passionate jazz musicians appeared as subjects in Bearden's work in the 1940s. By the 1950s the artist explored the visual possibilities of thinking of musical jazz as visual jazz. This would impact his approach to the elements of line, rhythm, and texture. From jazz Bearden also drew upon musicians' use of color and improvisation.

Train as a Symbol and Sonic Landscape of Jazz

In 1964 Bearden created a work called *Watching the Good Trains Go By*. The symbol of the train was important in the African American experience. Joel Dinerstein noted "that the train had long been an important symbol of freedom and power in African American oral tradition and history dovetailed with its role in national unification. Swing musicians and fans alike caught the sonic association" (Dinerstein 2003, 94). The author highlights many examples of the train as part of both landscape and soundscape, as well as a symbol of freedom, hope, journey, memory, and history. In Bearden's *The Train* (1974), the artist created bold faces of those on the journey through collage on paper. He created a strong sense of visual rhythm through the use of bits of white and brief flashes of color in contrast to the grayscale used in the faces.

The subject of the train and the journeys associated with it were also addressed in jazz. In 1950 Fletcher Henderson's *Jazz Train* was played at the New York City nightclubs Bop City and Paradise. He, along with composer-pianist J. C. Johnson, composed the stage score, which was organized in six sections, each of which suggested a train car. The first train, "Congo," included dance; the second, "Plantation," included plantation dances; and the third, "Laughter," suggested short minstrel shows. Section 4, "New Orleans," included characters—"Lady Blues" and "Man with a Horn." Section 5, "Passengers," featured actors in the roles of major black jazz artists, including Bessie Smith, Ethel Waters, and Louis Armstrong. It also made references to major eras, such as "The Roarin' Twenties," and important new works, such as the opera *Porgy and Bess*. The sixth and final section—"train car"—was

called "Journey's End." Like Bearden's *The Train*, this work held history, memory, pride, and accomplishment through big band music.

In 1964, Bearden also created *Train Whistle Blues I* and *Train Whistle Blues II*, which suggest the train as both symbol and maker of music. Musical examples, such as Clara Smith's "Freight Train Blues," evoke an emotional journey, and Trixie Smith's "Choo Choo Blues" speaks in locomotive ono-matopoeia. Jimmy Rodgers's "Train Whistle Blues" offers a musical interpretation of the cry of the train's whistle. Like the classic twelve-bar blues AAB form, in which the second line is repeated with slight variation, Bearden used the technique visually. In the blues, this formal organizational structure allows the singer room for emotional expression in both the words and the sheer sound of the voice.

Listen to "Freight Train Blues," Clara Smith, http://www.youtube.com/ watch?v=TfN-t1JIMBg.

Listen to "Train Whistle Blues," 1929, Jimmy Rodgers, http://www. youtube.com/watch?v=J6KjvAC8l38.

From the Underground Railroad to the Glory Train and Soul Train, there is both story and music. In his introduction to Langston Hughes's *Book of Rhythms*, jazz great Wynton Marsalis shared his story about how the sounds of and stories of trains found their way into his music. He wrote that growing up

in those days, no rhythm was more a part of the landscape of sound than the music of the trains that passed near our house. I'd hear the Southern Crescent and all the trains coming and going. I always remember that ka-nunk, ka-nunk, ka-nunk ka-nunk, train-on-track sound of the woo-woo, woo-woo of its get-off-the-track whistle. When I play or compose now, I think about those rattling trains and try to get their sounds into my music. The trains have a romantic ring to them, too. At night I used to hear them in the darkness, coming from someplace mysterious, getting nearer, then going someplace far away. The train sounded like a machine, but it also sounded like something human: a voice, a wail. It sounded like a lot of things and that's what made it fun to hear. Jazz rhythm has that train sound. . . . The train is my symbol for rhythm in jazz music. (quoted in Hughes 1995, vii–viii)

Marsalis even used "locomotive onomatopoeia" in his composition *Big Train* (1998), with tracks including the titles "Smokestack Shuffle," "North-

bound-Southbound," "Night Train," and "The Caboose." In an interview prior to the premier of this hour-long piece, Wynton Marsalis shared ideas on the train as a symbol and as music. He said, "Jazz music actually is a train. . . . The shuffle [rhythm] is a train . . . then you got the train whistle . . . then you got the engine. . . . The heart of the train is the drum. . . . Then there's the train call and response [of the whistles] . . . wah WAH . . . wah WAH" (quoted in Dinerstein 2003, 94–95). According to Marsalis, the artists take the listeners "on a journey that crisscrosses the landscape of America transported by its greatest art form, jazz" (Wynton Marsalis and the Lincoln Center Jazz Orchestra 1999).

Listen to "Big Train," Wynton Marsalis, http://www.youtube.com/watch?v=rN3WpQT3qPY.

Collage as a Metaphor for Jazz

Bearden had a deep understanding of the work of the Dutch masters and of cubism. He went to Paris in 1950 to study philosophy at the Sorbonne. During this time he met major artists of the time, including Matisse, Braque, and Miró. He was fascinated not only with the artists and their work but also with the ways in which art and artists were so highly regarded in the greater society. He was influenced to a degree by cubist art and also by the bold cutouts of Matisse. Bearden's collage *Three Folk Musicians* (1967), which incorporated memories of the rural South, was inspired by cubism. It suggests Picasso's famous *Three Musicians* (1921), a painting that is an example of synthetic cubism in the way the oil paint gives the appearance of cut paper.

Look at *Three Folk Musicians*, 1967, Romare Bearden, http://graphics8.nytimes.com/images/2004/10/15/arts/15kimm2.l.jpg.
Look at *Three Musicians*, 1921, Picasso, http://sisnet.ssku.k12.ca.us/users/ehshist/public_html/Three%20Musicians.jpg.

In his collage works, Bearden drew upon many materials from daily life just as early jazz musicians did. Like early jazz artists who made music from the cry of the human voice and the instruments left over from the Civil War era and the late nineteenth century, Bearden used materials that were readily available, such as clippings from magazines, photographs, posters, foil, and so on in his collages. He cut up old magazines in his New York apartment, and he often used symbols of the African American experience, such as musical instruments and trains. From these fragments, Bearden found beauty, and he improvised upon them to create works of art that reflected his own voice.

Bearden was inspired by artist Stuart Davis, who encouraged him to explore the relationship between music and painting. Davis recommended that Bearden listen to the music of Earl Hines, in particular. Bearden took this advice and said, "I listened for hours to recordings of Earl Hines at the piano. Finally, I was able to block out the melody and concentrate on the silences between the notes. I found this was very helpful to me in the placement of objects in my paintings and collages. Jazz has shown me ways of achieving artistic structures that are personal to me" (quoted in Bearden and Gault 1987). Bearden also noted that Davis had told him to "always remember that in a painting color has a position and a place, and it makes space" (quoted in Berman 1980, 67).

In an article by Calvin Tompkins in the *New Yorker* magazine, Bearden talked about this, saying, "I take a sheet of paper and just make lines while I listen to records. A kind of shorthand to pick up the rhythm and intervals" (quoted in Tompkins 1977, 53). He said that American cubist painter Stuart Davis listened to jazz musician Earl Hines for the intervals: "Hines made the pauses between the notes into something important. The silences were as expressive as the sounds" (quoted in Tompkins 1977, 53). In the way that space or interval exists in the music of Earl Hines as time or silence, Bearden used this idea to influence his approach to structure, giving space between color and line.

Diedra Harris-Kelley, an artist and niece of Bearden, reflected on the artist, saying, "Bearden himself insisted that he structured his paintings and collages as if they were jazz compositions. . . . Given his broad knowledge of American culture, it seems logical to me that he was thinking of the fundamentals of this very radical, very modern American music and how it could be applied to his work" (Harris-Kelley 2004, 250). She described him as a man who was constantly absorbing the environment and life around him. She recalled the special way that Bearden articulated this using an analogy of a whale. She said that he believed that an artist must be like a whale, mouth

wide open, absorbing everything around it, and keeping only what he needs for his creative nourishment (Harris-Kelley 2004, 250).

Jazz as Subject and Technique

The theme of music, especially jazz, appears as a theme in many of Bearden's works. He created series around this subject—*Of the Blues* and *Of Jazz*—which focus on themes of singing spirituals, the bend of the blue note, urban jazz scenes, musicians in action, musical instruments, famous jazz venues, and so on. Similarly, Langston Hughes, the great poet of the Harlem Renaissance, addressed similar themes in his poems "Homesick Blues," "The Weary Blues," "Lenox Avenue," "Midnight," and "Dream Boogie." Bearden's jazz paintings were expressive, conveying not only the body language of performing jazz artists but also the sounds they created and the atmosphere of the venue.

One example from the series *Of the Blues* is Bearden's *Carolina Shout* (1974), which suggests a gathering during a baptism in a river. The painting evokes the vibrant spirit and movement of a Pentecostal church through the use of bright and bold colors. Similarly, James P. Johnson's "Carolina Shout" expresses similar ideas through music. Also from this series is *Of the Blues: At the Savoy* (1974), which alludes to an important New York City jazz venue. Chick Webb and His Orchestra recorded "Stompin' at the Savoy," which hit number 10 on the charts in 1934.

Listen to "Carolina Shout," James P. Johnson, http://www.youtube. com/watch?v=nSFGyipsNsg.

Listen to "Stompin' at the Savoy," Chick Webb and His Orchestra, http://www.youtube.com/watch?v=z0XKumOFmoE.

From the same series, *Of the Blues: Kansas City 4/4* (1974) is a collage painting that plays with the intersection of music and visual art. The musical meter—4/4—is part of the title. The sense of order and underlying anchor is alluded to in both the title and in the prominence of the bass drum, suggesting a basis upon which improvisation happens. Subjects of the musicians and the musical instruments as well as the collage technique itself reflect music.

This work is full of visual color, suggesting tonal color; bold visual rhythms created by sharp lines contrasting with blurred lines; and layers of sound, like the layers of visual images.

In talking about his process of making art, Bearden said,

> You have to begin somewhere, so you put something down. Then you put something else with it, and then you see how that works, and maybe you try something else and so on, and the picture grows in that way. One thing leads to another, and you take the options as they come, or as you are able to perceive them as you proceed. The fact that each medium has its own special technical requirements doesn't really make any fundamental difference. My overall approach to composition is essentially the same, whether I'm working with the special problems and possibilities of the collage, or with oils, water colors or tempera. As a matter of fact, I often use more than one medium in the picture. . . . Once you get going, all sorts of things begin to open up. Sometimes something just falls into place, like piano keys that every now and then just seem to be right where your fingers happen to come down. (quoted in Melberg and Block 1980)

Trying His Hand at Music—"Seabreeze"

Music was an important part of Bearden's life on many levels. With a passion for the story in the music of jazz, he connected strongly with musicians. This is reflected not only in his art and in his hours upon hours of listening to recordings and live music but also in his brush with song writing. Bearden himself tried his hand at writing song lyrics, hoping for a hit song and enough money to go back to Paris. In 1951 he and musician Dave Ellis founded the Bluebird Music Company. Bearden also collaborated with composer and newspaper columnist Larry Douglas, who had his own sheet-music publishing firm. Among the twenty or so songs Bearden wrote was "Seabreeze," which was recorded by Billy Eckstine and Dizzy Gillespie in 1954. This song was used by the Seagram's liquor company to promote the popular "seabreeze" cocktail. Other successful songs included "My Candy Apple," "Missus Santa Claus," and "My Stocking Is Empty," which were sung by then child star Leslie Uggams.

Reflections on Bearden by Other Artists

Bearden has been widely recognized not just with museum retrospectives of his work, such as those at the Mint Museum in his home state of North Carolina and the National Gallery of Art in Washington, DC, but also through

the voice of artists in other disciplines. The St. Lucia–born Nobel laureate poet Derek Wolcott published a collection of verse in *The Caribbean Poetry of Derek Walcott* in 1983. His verse was illustrated by Bearden's watercolors. Walcott wrote the poem "To Romare Bearden."

Jazz artist Branford Marsalis and his quartet recorded a CD to honor Romare Bearden—simply called *Romare Bearden Revealed.* The liner notes of this CD, which are written by Robert O'Meally (2003), begin with the statement, "This recording can be considered part of a jam session in which Romare Bearden's paintings play a vibrant part: the musicians playing the painting of a visual artist who had a mighty brush with the blues." The musicians on this CD did this through the inclusion of some old songs and fresh approaches to original songs, as well as contemporary songs by such artists as Wynton Marsalis. Tracks include Branford Marsalis's take on Bearden's song "Seabreeze." Duke Ellington's "I'm Slappin' Seventh Avenue" (1938) was revived in response to Bearden's "Slapping Seventh Avenue with the Sole of My Shoes" (1981). Blues numbers include "Steppin' on the Blues" and "Jungle Blues' (Jelly Roll Morton). The new composition by Branford Marsalis, "B's Paris Blues," was a musical response to Bearden's *Paris Blues* (1961), which reflected the influence of African art on modern art. Both the music and the painting embrace bold use of rhythm and color. Other tracks, such as "Laughin' and Talkin' (with Higg)," share a similar spirit as Bearden's *The Block* (1971), which "tells the story" of life on 133rd Street and Lenox Avenue. In this work Bearden shares a narrative of individual lives in buildings existing side by side in this busy neighborhood. On the street, through the windows and doors, the viewer witnesses life—in its repetition and variation. The variations of lives lived on the same block are reinforced through the materials used, including cut and pasted printed, colored, and metallic papers; photostats; pencil; ink marker; gouache; watercolor; and pen and ink on Masonite. Scenes from everyday life and its details of eating, grooming, talking, walking, and going about daily business are expressed through bold rhythms, a sense of repetition with variation, and "call and recall," as Bearden put it—call and response like the music.

The CD also features Wynton Marsalis's "J Mood," whose 1986 album of the same name features a work by Bearden on the cover. Wynton Marsalis remembered his meetings with the artist. Marsalis said, "I would run into him and he would rap to me. He said he'd work on my cover if I would come to his studio. So I did, about twenty times at least. He was a brilliant man, and soulful, *soulful*" (quoted in O'Meally 2003, liner notes).

CHAPTER FOUR

~

European Artists and American Jazz

The influence of jazz on visual artists was not limited to Americans. As Americans became acquainted with the work of European artists through the 1913 Amory Show in New York City, some European artists experienced the sights, sounds, and culture of modern America either by spending time in the United States or by hearing jazz as it made its way to Europe. Such artists as Francis Picabia (1879–1953) and Piet Mondrian (1872–1944) spent time in the United States. They became fascinated by the live sounds of jazz played in clubs and halls of New York City, and they used it as both a subject in their work as well as a source of inspiration.

Other artists, such as Henri Matisse, worked in Europe and became familiar with jazz as it migrated across the Atlantic Ocean. Although the experience of jazz for Europeans was limited and superficial in many respects in the 1910s and 1920s, the essence of this new music sparked interest in this new audience. Jazz is by its very nature multifaceted, derived from various cultural traditions, and created within a specific context of the black experience in the United States. For these European visual artists, it was the sound and spirit of jazz rather than the literal subject or cultural expression of jazz that inspired their work. The rhythms and new sounds of jazz can be "seen" in these artists' use of color, visual rhythm, and line.

Francis Picabia

The French artist Francis Picabia was fine-tuned to parallels between art and music. He first visited the United States in 1913 for his first solo exhibi-

tion at Gallery 291 in New York, which was run by photographer and art promoter Alfred Stieglitz. Through this gallery Stieglitz introduced works by many European avant-garde artists to a New York audience. Picabia stayed in New York from January to April 1913, which was long enough for him to experience the esprit of the great metropolis. Among the works he exhibited were *Chanson negre I* and *II* (*Negro Song I* and *II*), which were thought to have been influenced by music he heard performed by an African American vocalist. Jessica Murphy noted that a reviewer for the *New York Herald* suggested that the paintings were inspired by ragtime music (Messinger 2011, 45). *Chanson negre II* (1913) alludes to the atmosphere of New York City and the halls and clubs in which this music was performed through the use of abstract form and bold browns and purples contrasting against white.

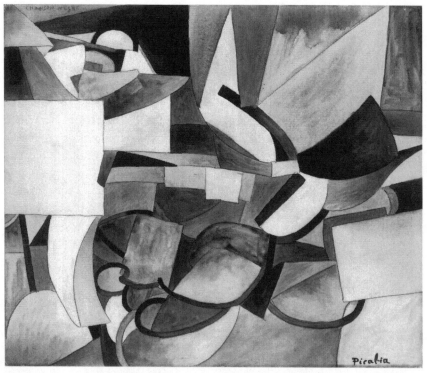

Figure 4.1. Francis Picabia, *Negro Song II*, 1913, watercolor and graphite on illustration board, 21⁷/₈ × 26 in. (55.6 × 66 cm). Gift of William Benenson, 1991 (1991.402.14). The Metropolitan Museum of Art, New York, NY. © The Metropolitan Museum of Art. Source: Art Resource © Artists Rights Society, New York, NY.

Picabia addressed his understanding of connections between music and art in a statement from 1913 in which he said, "Art resembles music in some important respects. To a musician the words are obstacles to music expression. . . . The attempt of art is to make us dream, as music does" (quoted in Hoffman 1997, 38).

He also talked about the concept of improvisation, which is at the core of jazz. In an interview for the *New York Tribune*, he compared art and music, saying, "I improvise my pictures as a musician improvises music. . . . We moderns . . . express the spirit of the modern time, the twentieth century, and we express it on canvas the way great composers express it in their music" (quoted in Hoffman 1997, 38). The artist here alluded to a shared process— that of improvisation.

Piet Mondrian and Boogie-Woogie

Dutch painter Piet Mondrian came to the United States in 1940 to escape the outbreak of World War II. When he arrived in New York City, he quickly became familiar with the jazz scene as a regular at jazz clubs. He was particularly drawn to a style of jazz known as boogie-woogie, which was very popular from about 1920 to the end of World War II in 1945. Mondrian owned many records of this style of music, including recordings by some of the leading boogie-woogie artists of that time, such as Pete Johnson and Albert Ammons, whose album *Boogie-Woogie Stomp* from 1936 was a pivotal recording in the genre. These artists, along with Meade Lux Lewis, had performed at Carnegie Hall in the late 1930s on a series of concerts called "From Spirituals to Swing." The presence of jazz in the concert hall reflected the growing interest in and acceptance of jazz across strata of society. It had moved from a place of dance music and entertainment to the prestigious concert hall, which had historically been the sacred performance venue for classical, "serious" music.

The three musicians, Pete Johnson, Albert Ammons, and Meade Lux Lewis, played at the Café Society, often in combinations of two and even three pianos. Music for two pianos was not uncommon, but a trio of pianists playing three pianos simultaneously created an exciting and bold new sound. The use of three pianos playing in a boogie-woogie style resulted in a distinctive timbre, or tonal color—one of a rich, dense, and highly complex musical texture.

This style of jazz, which was piano music derived from the blues tradition, was closely related to dance and was characterized by relentless, driving rhythms and a repeated bass line. It was highly percussive, somewhat unpre-

dictable, and seemingly uneven. Boogie-woogie music emphasized rhythm over melody, and it always featured the left hand playing a repeated bass line. It also relied on the form of the twelve-bar blues from which it was derived— AAB. This meant that it was based on three chords—tonic, subdominant, and dominant—which were used as the basis around which other musical material was created.

Mondrian painted two works in which he alluded to this style of jazz in their titles: *Broadway Boogie-Woogie* (1942–1943) and *Victory Boogie-Woogie*. The latter was left unfinished at the time of the artist's death in 1944. *Broadway Boogie-Woogie* is dominated by right angles and by the repetitive use of the primary colors of yellow, red, and blue in sharp contrast to white, black, and shades of gray. The geometric nature of this work, along with the use of bold colors, has counterparts in boogie-woogie music.

Look at *Broadway Boogie-Woogie*, 1942–1943, Piet Mondrian, http:// uploads2.wikipaintings.org/images/piet-mondrian/broadway-boogie-woogie-1943.jpg.

Listen to "Boogie-Woogie Stomp," 1939, Albert Ammons, http://www. youtube.com/watch?v=tBmVtW5qxGs.

As noted earlier, boogie-woogie music relies on the use of three chords primarily—tonic, subdominant, and dominant—which create a harmonic grid of sorts. Each chord has a specific sound function that guides the ear. Within this, the left hand reinforces the harmonic structure through a repeated figure in the bass line.

In the painting, the primary colors of yellow, blue, and red (along with white, black, and gray) are used in repeated shapes, angles, and lines that appear throughout. The irregular placement of color creates a sense of visual syncopation and a feeling of rhythmic complexity, one that jumps out as if in real time, like music. If syncopation in music refers to accents in unexpected places, the idea of syncopation is conveyed visually through the uneven placement of color in the painting. In a 1943 interview, Mondrian addressed his ideas about visual rhythm, saying, "I view boogie-woogie as homogenous with my intention in painting—a destruction of melody equivalent to the destruction of natural appearances, and construction by means of a continual confrontation of pure means—dynamic rhythms" (quoted in Maur 1999, 100). This statement also reflects one of the key characteristics of boogie-

woogie music—the emphasis of rhythm over melody. Stuart Davis said that Mondrian felt the impact of jazz on art. Davis noted, "I talked to him about this several times. He responded to the basic rhythms of jazz in a direct physical way; they even made him want to dance" (quoted in Kuh 2000, 53).

His painting *Broadway Boogie-Woogie* suggests not only the music of the same name but also the city in which the artist experienced it—New York City. In addition to being seen as a sort of visual boogie-woogie, this painting can also be interpreted as an abstract image of the great city, with its bright yellow taxicabs; their boisterous, erratic, rhythmic horns; and the bright lights of Broadway within the urban cityscape with its numbered grid of city streets.

American painter Stuart Davis made reference to Piet Mondrian and his love of boogie-woogie music in his work *For Internal Use Only* (1944–45). In the 1970s, John Lane, who organized a retrospective of the work of Stuart Davis, spoke with its original owner, Mrs. Burton Tremaine, who said that she had discussed the painting with Davis. According to her, Davis said that the "title had to do with his recollections of Mondrian and how he missed their experiences listening to jazz together. Davis pointed out that the picture contained the abstracted piano keys, bow tie, and black face of one of Mondrian's favorite boogie-woogie pianists, and the abstracted marquee of a New York jazz scene" (quoted in Hills 1996, 124).

Henri Matisse and Maurice Ravel

Jazz arrived in France in the early twentieth century. In fact, the first public use of the word *jazz*, which had been derogatory at first, was in conjunction with a performance that was advertised as the "great American jazz band," which featured an ensemble of black musicians. Jazz quickly took hold and became popular, though it was not until the 1930s that the depth and complexity of true jazz came to be understood in Europe. In 1929, the French journal *Revue du jazz* was first published, and in 1932 the Hot Club de France was founded. After World War II, bebop and avant-garde jazz made its way to France, along with some of the greatest jazz artists of the day, Charlie Parker, Lester Young, and Miles Davis among them. As jazz became more popular in Europe, some Europeans became more familiar with it by spending time in the United States.

Among them was the composer Maurice Ravel (1875–1937), who along with other French composers of his day, such as Erik Satie and Darius Milhaud, became inspired by this new American music—at least the spirit and flavor of this music. Milhaud, for example, used elements of the blues and

ragtime music along with traditional jazz instruments, such as the saxophone, in his ballet *Le Creation du monde* (*The Creation of the World*) in 1924. Among Ravel's jazz-influenced works are the *Violin Sonata*, the two-piano concerti, and his music for the ballet *Daphnis and Chloe*, which he composed for the great impresario Sergei Diaghilev and the *Ballets Russes*.

Artist Henri Matisse (1869–1954) was a prolific artist and an important member of the Fauve group, which was known for its pure and brilliant use of color. Not only was Matisse interested in music as an art form, but he also made portraits of important musicians of his day, including composer Sergei Prokofiev and pianist Alfred Cortot. Matisse himself played the violin, and he depicted his daily practice in his painting *Violin Player at the Window* (1917). Music was a theme that the artist visited at many points in his career in such works as *Interior with Harmonium* (1900). His *Music* (1910) was a companion to *Dance* (1909–1910). Like a triadic chord in music that is build out of three pitches, these paintings are built on three colors—blue, green, and red. Matisse noted, "Colors are forces—as in music" (quoted in Maur 1999, 22).

In 1941 Matisse started to create collages, referring to this process as "drawing with scissors." This process was formally called *pochoir*, which literally means "stenciling" in French. The technique dates back a thousand years to China and was introduced to French publishing in the late nineteenth century. This approach involved the artist hand-cutting stencils, which were printed with the same colors used in the collages; therefore, the precise placement of the stencils was crucial. As a result, *pochoir* is characterized by crisp lines and vivid colors.

In 1992 to 1993, the Museum of Modern Art in New York held a retrospective of the works of Matisse, which was divided into seven sections. The last section, called "1943–1954: The Final Years," included his work *Jazz*, a book that was first published on September 30, 1947, by Teriade. This book was comprised of twenty color cutouts along with text by the artist himself.

In this work, Matisse did not create cutouts about jazz, but rather he conveyed the spirit of jazz in his use of color and visual rhythm as well as in the precise placement of cutouts. In this work, Matisse made a series of paper cutouts and then combined them into larger compositions. The subjects of most of the cutouts allude to the artistic life of a circus. The subjects of the plates are of a variety of images, including clown, circus, Icarus, cowboy, sword swallower, swimmer in the tank, lagoon, and toboggan. For Matisse, the use of cutouts was an attempt to combine drawing and painting. By doing so, the elements of color and image had great significance.

Along with the cutouts, Matisse wrote an accompanying text noting that the text should "only serve as an accompaniment to my colors, just as asters help in the composition of a bouquet of more important flowers. THEIR ROLE, THEREFORE, IS PURELY VISUAL" (Matisse 2001, 61). He went on to write about such topics as the bouquet, the airplane, drawing with scissors, happiness, lagoons, artists, and love.

As the artist sought to name this work, he considered two possible titles—*Jazz* and *Circus*. His final words in the book are titled *Jazz*, and here he shared his thoughts on the choice of this title. Matisse wrote:

Jazz
These images, with their lively and violent tones,
Derive from crystallizations of memories of circuses,
folktales, and voyages.
I've written these pages to mollify the simultaneous
reactions of my chromatic and rhythmic improvisations;
pages forming a kind of "sonorous ground"
that supports them, enfolds them, and protects them,
in their particularities. (Matisse 2001, 75)

The work is not "about" jazz but rather was inspired by it and shares with it the use of vivid bold colors, strong syncopated rhythms, and a feeling of improvisation. Katrin Wiethege noted, "Jazz stands for improvisation within a given form—an unrestrained interplay of freely defined rhythms on the basis of one movement. It is quite possible that Matisse regarded his compositions as free improvisations of a theme within one defined form" (quoted in Matisse 2001, 12).

Look at *Jazz*, 1947, Henry Matisse, http://www.artsobserver.com/wp-content/uploads/2012/04/IMG_4799.jpg.
Listen to Maurice Ravel *Piano Concerto in G*, Leonard Bernstein, piano, http://www.youtube.com/watch?v=4jYVnNHo3S8.

As Matisse was creating jazz for the eyes, French composer Maurice Ravel was creating bold, new colors for the ear. He was a prolific composer who wrote music for a wide variety of instruments and in both large and small forms. As a person who was naturally curious and interested in things that

were somewhat exotic at the time, he drew upon many influences throughout his career. He composed much of his piano music during the same era of composer Claude Debussy. Ravel admired Debussy's music and was known for his own use of tonal color and for drawing upon many sources of inspiration, including impressionism. Like Debussy, he often gave his pieces descriptive names, such as *Miroirs*, *Oiseaux Tristes*, and *Gaspard de la Nuit*. Among his important compositions for piano is his *Valses Nobles et Sentimentales* from 1911 (later published for orchestra in 1912.) It is a suite of eight waltzes that combine modern sounds with the traditional waltz form and hints of impressionistic style. In this piece, Ravel used harmonies and chord progressions later heard in jazz.

He was also interested in classical forms and in the music of other composers, such as Chopin, Mozart, and Saint-Saens; Ravel himself referred to the influence of the latter two composers on his *Piano Concerto in G Major*. His very famous piece *Bolero*, which was composed in 1928, is one of several compositions that reflect a Spanish influence; others include *Iberia* and *Rhapsodie espagnole*. In *Bolero*, Ravel focused on a repetitive and pounding rhythmic figure over melody.

Ravel was also fascinated by jazz and the blues, and he found many ways to create jazz effects in his music. In his 1992 article, David Schiff noted that some of the chords commonly used by jazz pianists and composers were first heard in Ravel's *Valses Nobles et Sentimentales*. As Ravel was influenced by new and modern sounds, he also created them and influenced other composers. Schiff mentioned Gershwin's classic song "Summertime" and Duke Ellington's "Daydream" as examples of music that reflect Ravel's pioneering harmonies (Schiff). Jazz was not a dominant element in Ravel's music, but the fact that he experimented with it within his unique approach to composition is undeniable.

Ravel toured the United States in 1928, traveling across the country and visiting cities from New York City to Houston, New Orleans to Kansas City. He conducted major concerts featuring his own music, performed piano music, and gave lectures at several universities around the country. While on this extended tour, he met many important American musicians, such as bandleader Paul Whiteman and composer/pianist George Gershwin. Ravel spent hours listening to jazz in Harlem, and he could not understand why more composers did not use this music as a source of inspiration in their own. One composer who did was Gershwin. Not only did Ravel meet Gershwin, but he also heard him play the piano in Harlem, and he even attended a performance of the composer's *Funny Face*. Ravel reflected on jazz, saying, "The most captivating part of jazz is its rich and diverting rhythm. . . . Jazz

is a very rich and vital source of inspiration for modern composers" (quoted in Rogers 1935).

This inspiration was apparent in many of Ravel's works, including his *Violin Sonata*, which he composed between 1923 and 1927, as well as the two piano concerti—the *Concerto for Left Hand in D Major* (1929–1930) and the *Piano Concerto in G Major* (1929–1931). The middle movement of his *Violin Sonata* is titled "Blues." In this movement, Ravel used glissandi, which are fast slides up and down the finger board of the violin and are reminiscent of vocal glides in vocal blues. He also used complex ornamentation, which suggests the improvisatory nature of jazz. Another hint of jazz is the high position the performer must use—a technical challenge but one that ultimately suggests the sounds of a blues singer. During his American tour, Ravel gave a lecture in Houston and said:

> In my opinion the "blues" is one of your greatest musical treasures, authentically American. . . . Some musicians have asked me how it was that I came to write a blues as the second movement of my sonata for violin and piano. Here again, we have the same process to which I have alluded, for I make bold to say that in adopting the popular form of your music it is nevertheless French music—music of Ravel—that I have written. Yes! These popular forms are but the material of the construction and the work of art appears only in the ripened conception where no detail has been left to chance. Moreover, scrupulous stylization in the manipulation of those materials is absolutely essential. . . . To understand more fully the meaning of the process to which I refer it would be sufficient here to see these same blues treated by some of your own musicians and by the musicians of European countries other than France. You would then surely find these compositions very dissimilar, more of them bearing the nationality of the original material, the American blues (quoted in James 1983, 103)

Both of his piano concerti were composed after his visit to the United States. Ravel composed the famous *Concerto for Left Hand* for Paul Wittgenstein, an Austrian concert pianist who had lost his right arm due to an amputation stemming from a severe war injury. Ravel noted that only one movement from this work contains jazz effects. He said, "After an introductory section . . . there comes an episode like an improvisation which is followed by a jazz section. Only afterward is one aware that the jazz episode is actually built up from themes of the first section" (quoted in Seroff 1953, 258).

The *Piano Concerto in G Major* was composed over a two-year span from 1929 to 1931. In it Ravel combined the classicism of Mozart with jazz idioms,

such as rich harmonies, rhythmic syncopations, and improvisation-like passages. However, these passages were carefully composed and notated to sound like improvisation, leaving the soloist in the place of interpreter rather than creator as in pure jazz. About this composition, Ravel noted, "In some ways my *Concerto* is not unlike my *Violin Sonata*; it uses certain effects borrowed from jazz, but only in moderation" (quoted in Seroff 1953, 258).

Viewers of Matisse's work and listeners of Ravel's music are fortunate to have words by the artist and composer, respectively, reflecting on their work. Matisse's book is not about jazz, and Ravel's composition is not pure jazz. However, both were influenced by the spirit of this new American style. Matisse used musical terms like *chromatic*, which suggests levels of color in art and levels of pitch or chords in music. He also used the phrase *rhythmic improvisations*, which points to two key elements of pure jazz. His book *Jazz* was well received in its day, and similarly, Ravel was famous and highly regarded as both a performer and a composer during his lifetime. He received great success and, along with it, high fees and fame. As the spirit and process of improvisation influenced Matisse, it also influenced Ravel but in a different way. He imbued some of his compositions with elements of jazz and conveyed the essence of improvisation; however, his improvisatory-sounding passages were very carefully crafted and notated for the classically trained performer. Perhaps these works of both artists reflect the words of Keith Jarrett, who said, "Jazz is an inner process that is manifested as a continual discovery" (quoted in Matisse 2001, 8).

CHAPTER FIVE

~

Kandinsky and Schoenberg

On the Verge

The early twentieth century was a time of great synergy among the arts in general and between painting and music in particular. From the United States to Europe to Russia and beyond, this was a period of major change and the beginning of a new era. Artists were experimenting with new ideas in their work and exchanging these ideas with kindred spirits across artistic disciplines. It was not only the artist's relationship with ideas but also often his or her relationship with other artists that supported and stimulated innovation.

One such relationship that began in the early twentieth century was between Austrian composer and painter Arnold Schoenberg (1874–1951) and the Russian-born painter Wassily Kandinsky (1866–1944). Although Schoenberg is primarily remembered as a composer, it is important to note that he also painted. Kandinsky was an important artist, and he also produced several written works about art; among the best known is his *Concerning the Spiritual in Art* (1911), in which he wrote about aesthetics and about the emotional and psychological power of color, as well as form and theory. After seeing a painting by Kandinsky with a bold red stroke on a canvas of blue, the great American dancer, choreographer, and founder of modern dance Martha Graham said, "I will dance like that" (quoted in Gardner 1993, 271).

Arnold Schoenberg, the Composer

Arnold Schoenberg was a major musical figure of the twentieth century. Born in Vienna, Austria, he began studying violin at the age of eight and

also began composing while still in his youth. He left school as a teenager, already having decided to spend his life in music. The only musical instruction he ever had was from Alexander von Zemlinksy, a young composer who was just two years older than Schoenberg and with whom he studied counterpoint for just a couple of months. The elite musical circles of Vienna in the late nineteenth century were engrossed in the music of Richard Wagner (1813–1883). Major works, such as his opera *Tristan and Isolde*, forecasted a break from the Romantic Era in music and, along with it, a breakdown of traditional western harmony as it was known.

The early 1900s was a decade of bold change in all the arts. Painters were experimenting with new ideas. For example, the group of artists known as Fauvists focused on pure color; German expressionism in painting was born. As a composer, Schoenberg, along with artists across disciplines, revolted against ideals of the nineteenth century and in doing so made bold artistic leaps that would take hold in the first decade of the twentieth century. Like all artists, his work changed throughout his lifetime. His early compositions are considered somewhat "Wagnerian" in their use of chromaticism, yet they continued to push the boundaries of established harmony. He broke away from established traditions of an old aesthetic and charted new territories in harmony. Among these early works are *Verklaerte Nacht* (*Transfigured Night*; 1899) for string sextet; *Pelleas und Melisande* (1902–1903), a tone poem; and *Gurrelieder*, which was composed in 1900 and orchestrated in 1911 for an enormous corps of musicians, including an orchestra of 150, four choirs, and six soloists.

Traditional tonal harmony was the basis for musical composition in the Western world through the nineteenth century. It has a strong center or home key, such as C major or G minor. Once a key area is established, the listener's ear is directed to that home key. Harmonies can create tension through dissonance and can create a sense of release through consonance and resolution. The relationship of chords within the harmonic structure supports musical expression in the way harmonies are created, changed, and resolved.

In the hands of Schoenberg, that sense of center was broken down. The body of Schoenberg's tonal compositions culminated with his *String Quartet No. 2 in F-Sharp Minor, op. 10* (1907–1908), which was the last composition in which he used a key signature. Schoenberg added a vocal part in this quartet using the words of German poet Stefan George. It is fitting that the text of the last movement begins with the words "*Ich fuhle Luft von anderen Planeten*" ("I feel the air of other spheres"). These words as well as the last chord of the piece suggest the change that was to come.

Schoenberg's composition *Three Piano Pieces*, op. 11 (1909) marked the beginning of a period of atonal expressionist writing. Because atonal music has no tonal center, the function of dissonance changed. Prior to this, dissonance needed to be prepared and resolved—tension moved to release and resolution. Schoenberg freed dissonance from this role in his early works in particular. For example, in his *Verklarte Nacht,* a clear tonal center is not clearly recognizable to the listener. Change took hold in 1909 with such works as *Three Piano Pieces,* op. 11 and *Das Buch der hangenden Garten,* op. 15 (1908), which is based on fifteen expressionist poems by Stefan George. Schoenberg's *Pierrot Lunaire* (*Pierrot of the Moon;* 1912) was composed for flute, clarinet, violin, cello, and piano (and piccolo, bass clarinet, and viola) and a woman's voice singing in a new and strange technique known as *sprechstimme,* which lies somewhere between speech and song. This dissonant and jolting sound is an example of the ideals of German expressionism manifested in music and a movement toward music that is considered to be "atonal"—music marked by the absence of a tonal center or home key.

Expressionism in Art and Music

As the term *impressionism* was taken from the world of art, so, too, was the word *expressionism.* The German school of expressionist painters included Ernst Ludwig Kirchner and Oskar Kokoschka, whose art focused on the subjective, inner world of the human psyche. Their musical counterpart was the concept of expressionism in music, which found its voice in early works of Schoenberg, as well as in music by Alban Berg, whose operas *Wozzeck* and *Lulu* have come to define expressionism in music through the use of dissonance and highly charged emotional subject matter. Kokoschka painted a portrait of Arnold Schoenberg—an expressionist painter making a portrait of a composer/painter who was exploring the concept of expressionism in music. As these ideas were playing out across artistic disciplines, the early twentieth century experienced a simultaneous musical and visual revolution. Schoenberg, along with composers Alban Berg and Anton Webern, came to be known as the Second Viennese School of composers.

Look at *Portrait of Arnold Schoenberg,* 1924, Oscar Kokoschka, http://calcdn.artcat.com/images/exhibits/3159_1252009454.original.jpeg.

Wassily Kandinsky

Kandinsky was born in Moscow and raised in the Crimean city of Odessa. He played the piano and cello in his youth and had always been intrigued by both music and painting. He studied law and economics in Moscow, and soon after he completed his studies, he was offered an academic appointment at the University of Dorpat in Estonia. However, he declined the position, turned his back on this career, and moved to Munich to study painting. Kandinsky spent much of his life in Germany and later in France, but he always held his Russian homeland close to his heart. Some artists, such as the analytic cubist painter Georges Braque, referenced such classical masters as Bach; however, Kandinsky was closely aligned with contemporary composers in charting new frontiers and in creating an aesthetic in painting that echoed new approaches to dissonance and atonal composition in music.

Gesamtkunstwerk

An early experience in Russia had a profound impact on Kandinsky's decision to devote his life to art. The arts had always been a part of his life, but he wrote about a specific performance of Wagner's opera *Lohingrin* at the Bolshoi Theater in Moscow that directed him toward life as an artist. Kandinsky wrote, "I saw all my colours in spirit, before my eyes. Wild, almost crazy lines were sketched in front of me" (quoted in Ward 2006). He also wrote, "It became absolutely clear to me that art in general was much more powerful than I had thought, and that, on the other hand, painting was capable of developing powers akin to those of music" (quoted in Maur 1999, 30).

This experience strongly influenced Kandinsky's ideas about *Gesamtkunstwerk*—the idea of a total or complete work of art that combined art forms in drama, music, text, color, and so on. The concept was based on the idea of a union of art forms and on the underlying belief in the inherent power of the arts. If a single art form, such as poetry or music, could have a powerful emotional impact, then what might be created by combining multiple art forms into a single piece? Such works as Wagner's monumental *The Ring of the Nibelung*, a cycle of four operas, which stood as the embodiment of music, word, and visual art, greatly influenced Kandinsky's ideas.

Kandinsky's own ideas about a "total work of art" were manifested in *Klange* (*Sounds*, 1913), a collection of poems and prints. He referred to this book as a "musical album"; it contained thirty-eight prose poems that he had written between 1909 and 1911, as well as fifty-six woodcuts he started in 1907. The theme of the horse and rider appeared like a leitmotif in this al-

bum and was to Kandinsky a symbol of moving beyond representational art. He developed this idea in other works, such as *On Stage Composition*, a text, and *Yellow Sound*, a play.

Synaesthesia

This concept of multiple senses reflects a condition known as synaesthesia, which comes from the Greek; *syn* means "together," and *aesthesis* means "sensation." The term suggests the ability to experience multiple senses together. For example, someone who "hears" colors or someone who "sees" sound. Kandinsky wrote in his *Concerning the Spiritual in Art*, "Colour is the keyboard, the eyes are the hammers, the soul is the piano with many strings. The artist is the hand which plays, touching one key of another to cause vibrations in the soul" (Kandinsky 1977, 25). In this treatise, Kandinsky spelled out his color theories on the way he believed color influenced our emotions. The artist believed that one could "hear" colors and that color, like music, has the power to move the soul. He made specific connections between visual color and tone color. For example, he connected yellow to a bright, shrill-sounding trumpet; orange to the warm tones of a viola; red to a tuba or timpani; violet to a bassoon; blue to the cello; and green to the violin.

1911 in Painting and Music

The year 1911 was important in the lives of both Schoenberg and Kandinsky. Not only was it the year that both published significant works (Kandinsky's treatise *Concerning the Spiritual in Art* and Schoenberg's treatise *Theory of Harmony*, which is a treatise about both harmony and aesthetics), but it was also the year that their friendship and exchange of ideas began. In January 1911, Kandinsky, along with fellow painters Franz Marc, Gabriele Munter, Marianne von Werefkin, and Alexei von Jawlensky, attended a concert of Schoenberg's music in Munich. The concert featured Schoenberg's *Second String Quartet in F-Sharp Minor*, op. 10 (1908); *Three Piano Pieces*, op. 11 (1909); his *Funf Lieder* (*Five Songs*), from op. 2 (1899); no. 1 *Erwartung* (*Expectation*); *Lieder*, op. 6 (1903–1905); no. 4 *Verlassen* (*Forsaken*); no. 6 *Am Wegrand* (*By the Roadside*); no. 3 *Madchenlied* (*Maiden's Song*); and no. 8 *Der Wanderer* (*The Wanderer*), as well as the *First String Quartet in D Minor, op. 7* (1904–1905), in the order they were performed in the concert. These pieces represent a period of composition in which Schoenberg was moving toward radical new ideas in music. These compositions reflected ideals of German expressionism and a break toward atonal music composition. In this concert,

Kandinsky and his friends heard in the music the revolutionary ideas they were committed to in their art—dissonance, a bold break from tradition, and an exploration of the emotional power of art.

Kandinsky heard this shift away from an old aesthetic, and he was so moved by the music he heard that the same day as the concert he began work on a new painting. He did two sketches, the first of which was a quick sketch of the performance space with a piano and figures who suggest musicians. The second sketch was more abstract. In it the piano appeared much larger, and it included the suggestion of the audience. These were sketches for the final work, *Impression III (Concert)*, a painting alive with bright colors (see figures 5.1 and 5.2). The painting is vaguely representational in that the outline of a piano seems clear. Yet that image dissolves into a more abstract approach that conveys the essence of the musical experience and the sound of the music itself rather than a literal image of the performance space and musicians.

Figure 5.1. Wassily Kandinsky, *Impression III (Concert)*, charcoal on sketchbook paper, 10 × 14.9 cm. Musée National d'Art Moderne, Centre Georges Pompidou, Paris, France. © CNAC/MNAM/Dist. RMN-Grand Palais/Art Resource, New York, NY. © Artists Rights Society, New York, NY.

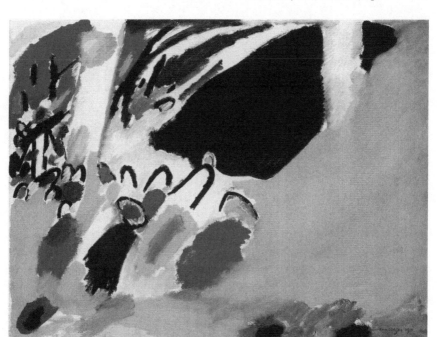

Figure 5.2. Wassily Kandinsky, *Impression III (Concert)*, 1911, oil on canvas, 77.5 × 100 cm. Städtische Galerie im Lenbachhaus, Munich, Germany. © 2014 Artists Rights Society, New York, NY/ADAGP, Paris.

Listen to Schoenberg *Three Piano Pieces*, op. 11, Movement 3, Claudio Arrau, http://www.youtube.com/watch?v=A5D1Qd7i-UU&feature =relmfu.

Kandinsky's abstract painting features bold lines and shapes as well as bright colors. One can make out a concert stage with a piano, but the painting goes deeper than the mere suggestion of the image of a concert hall. Kandinsky tried to put onto canvas what he *heard*—the sound of yellow! About Schoenberg's "emancipation from dissonance," Kandinsky wrote, "Schoenberg is endeavoring to make complete use of his freedom and has already discovered gold mines of a new beauty in his search for spiritual harmony. His music leads us into a realm where musical experience is a matter

not of the ear but of the soul alone—and from this point begins the music of the future" (Kandinsky 1977, 17).

This painting suggests Kandinsky's interest in synaesthesia. The color yellow is most dominant, and it contrasts boldly with black lines and shapes. In his treatise *Concerning the Spiritual in Art*, Kandinsky wrote about the color yellow, saying, "Yellow, if steadily gazed at in any geometrical form, has a disturbing influence, and reveals in the colour an insistent, aggressive character. The intensification of the yellow increases in the painful shrillness of its note" (Kandinsky 1977, 37–38). He included footnotes that further explain this statement, writing, "It is worth noting that the sour-tasting lemon and shrill-singing canary are both yellow" (Kandinsky 1977, 37). He added, "Any parallel between colour and music can only be relative. Just as a violin can give various shades of tone, so yellow has shades, which can be expressed by various instruments. But in making such parallels, I am assuming in each case a pure tone of colour or sound, unvaried by vibration or dampers, etc." (Kandinsky 1977, 38). Kandinsky spoke of black, saying, "A totally dead silence, on the other hand, a silence with no possibilities, has the inner harmony of *black*. In music it is represented by one of those profound and final pauses, after which any continuation of the melody seems the dawn of another world" (Kandinsky 1977, 39).

Kandinsky wrote to Schoenberg after the 1911 performance, and they became friends as well as critics of each other's work. In his letter to the composer, Kandinsky wrote,

> I have just heard your concert here and it has given me real pleasure. . . . In your works, you have realized what I, albeit in uncertain form, have so greatly longed for in music. The independent life of the individual voices in your compositions, is exactly what I am trying to find in my paintings. At the moment there is a great tendency in painting to discover the "new" harmony by constructive means, whereby the rhythmic is built on an almost geometric form. My own instinct and striving can support these tendencies only half-way. *Construction* is what has been so woefully lacking in the painting of recent times, and it is good that it is now being sought. But I think differently about the *type* of construction. I am certain that our own modern harmony is not to be found in the "geometric" way, but rather in the anti-geometric, antilogical way. And this way is that of "dissonances in art,' in painting, therefore, just as much as in music. And "today's" dissonance in painting and music is merely the consonance of "tomorrow." (quoted in Hahl-Koch 1984, 21)

Along with the letter, Kandinsky enclosed his *Xylographies* (1909, a collection of woodcut photo engravings), as well as photos of two of his paintings from 1910—*Improvisation 7* and *Improvisation 16*.

That same year, 1911, Schoenberg published his treatise *Theory of Harmony*, an excerpt from which appeared on the poster for the January 1 concert. It read, "Dissonances are only different from consonances in degree; they are nothing more than remoter consonances. Today we have already reached the point where we no longer make the distinction between consonances and dissonances. Or at most, we make the distinction that we are less willing to use consonance" (quoted in Hahl-Koch 1984, 24).

Clearly, the work of these artists—both visual and musical—during this time represented a bold and intentional break with convention. Kandinsky was moving toward abstraction, and he broke away from conventional representational art. Schoenberg was writing atonal music and moving away from the conventions that had guided Western classical music until now. Later their paths took new directions, with Schoenberg writing in the twelve-tone system and Kandinsky teaching at the Bauhaus in the 1920s. Kandinsky did not abandon ideas about music or concepts across art forms. In fact, while teaching at the Bauhaus, he shared a house with artist and colleague Paul Klee, who also was intensely interested in music throughout his life.

In 1926, Kandinsky wrote another important treatise, *Point and Line to Plane*. In this work he addressed these ideas as they manifest across disciplines. For example, in his chapter on point, he considered this concept in the disciplines of dance, painting, and music, even creating a visual representation of musical notation through a series of dots of various sizes placed on various planes. In his chapter on line, Kandinsky referred to sounds that are created by specific angles. For example, he wrote that acute angles form a triangle, which suggests the color yellow; right angles form a square, which suggests the color red; and obtuse angles form a circle, which suggests blue (Kandinsky 1979, 74). Kandinsky expounded upon these complex and abstract ideas in great detail and with examples from different artistic disciplines. In a discussion about time, he wrote about time in painting, for example.

Der Blaue Reiter (The Blue Rider)

The year 1911 was also important for a group of artists known as *Der Blaue Reiter* (The Blue Rider), which was named after a 1903 work by Kandinsky. This early painting by the artist suggests a rider cloaked in blue on horseback speeding through a green landscape with a sense of urgency. Kandinsky would write about the color blue in *Concerning the Spiritual in Art* as having spiritual yearnings. He wrote, "Blue is the typical heavenly colour. . . . In music a light blue is like a flute, a darker blue a cello; a still darker a thunderous

double bass; and the darkest blue of all—an organ" (Kandinsky 1977, 38). The Blue Rider was cofounded by Kandinsky and fellow artist Franz Marc in Munich around avant-garde modern ideas.

They were also associated with the development of German expressionism, which focused on the power of the arts to express an "inner" world of the unconscious. In an exchange from Schoenberg to Kandinsky in 1911, the composer wrote, "Every formal procedure which aspires to traditional effects is not completely free from conscious motivation. But art belongs to the unconscious!" (quoted in Schiff, 16). In his *Concerning the Spiritual in Art*, Kandinsky discussed the notion of inner and outer beauty. He wrote about Schoenberg, "To those who are not accustomed to it the inner beauty appears as ugliness because humanity in general inclines to the outer and knows nothing of the inner. Almost alone in severing himself from conventional beauty is the Austrian composer, Arnold Schoenberg" (Kandinsky 1977, 16).

The group had their first exhibit in 1911 followed by another in 1912. This period also marked the beginning of *Der Blaue Reiter Almanach* (*The Blue Rider Almanac*), which was a journal that gave members and kindred spirits a platform on which to explore avant-garde ideas in the arts. Contributors to the journal included painters, writers, and composers. Paintings by such artists as Kandinsky, Marc, and Jawlensky appeared in the journal. The journal included musical compositions, such as songs by Berg and Webern, as well as Schoenberg's *Herzgewachse* scored for voice, harp, harmonium, and celeste. Articles were published on such subjects as the music of Russian composer Alexander Scriabin; Schoenberg's essay "The Relationship to the Text" was also published here.

Kandinsky's "Music in Art"

The idea that painting could suggest music became a theme in Kandinsky's work. He frequently used general titles, such as *Composition, Improvisations,* and *Impressions,* to name his paintings. The words *composition* and *improvisation* are not limited to music but are at the core of the work of composers and musicians. His *Impression III* (*Concert*) from 1911, which he painted after hearing music by Schoenberg, is one of the best examples of this. Kandinsky used the title *compositions* from 1907 with his *Composition I* until 1939 with *Composition* X. He also used more specific musical terms as titles of his works in paintings, such as *Fugue, Opposing Chords,* and *Harmonie Tranquille.* He didn't simply borrow terminology, but rather he attempted to make visual the ideas and expressive powers of music. Other works by Kandinsky suggest music. His work *Poems without Words* (1903) is a collection of 122 woodcuts

published by Kandinsky in Moscow. The title nods to musical works by such composers as Felix Mendelssohn, who wrote music called *Songs without Words*.

Kandinsky was not alone in his desire to explore the relationship between color and sound. Alexander Scriabin was a Russian composer of Kandinsky's generation who related keys and harmony to color. He created a system called "music-color-emotion," and he sought to find a system that showed specific connections between tones in color and music. He associated the twelve pitches of a chromatic scale with twelve visual colors. In his work *Prometheus: Poem of Fire* (1909–1910), he included a "color keyboard" that lit up the concert hall, making a vivid connection between color in music and color in visual art in a visual and powerful way. An article about this work was published in the *Blue Rider Almanac*. The composition was an inspiration for Kandinsky's *The Yellow Sound* (1913).

Arnold Schoenberg, the Painter

As artists of this time were exploring new abstract ideas about the arts, it should not be surprising to see that these creative endeavors sometimes migrated across disciplines. Schoenberg's place in history is primarily as a composer; however, he also painted. He turned to the medium of painting when he was not able to express an idea through music. His paintings are often categorized into two categories—those that reflect nature and those that focus on an inner world. These "inner" works took form in his self-portraits or portraits that often took on the themes of "gaze" or "vision." Through painting, Schoenberg expressed ideas related to the inner world of psychology, emotion, and the unconscious in a visual outward way. One such work is his *Red Gaze* from 1910.

> Look at *Red Gaze*, 1910, Arnold Schoenberg, http://upload.wikimedia.org/wikipedia/en/b/bb/Arnold_Schoenberg_%27The_Red_Look%27_-_Kandinsky_1910.jpg.

Schoenberg exhibited some of his paintings in Vienna in the fall of 1910, just a few months before the 1911 concert. This exhibit included studies for his opera *Die Gluckliche Hand*, as well as portraits, including those of the composer Gustav Mahler, self-portraits, and works that he referred to as

"impressions" and "fantasies." This exhibit was not particularly successful, and it was the music critics who seemed to offer a context and understanding of the essence of these visual works.

Music critic Elsa Bienenfeld of the *Neues Wiener Journal* wrote,

> Schoenberg paints these portraits and fantasies with brutal simplicity, in a style of Kokoschka. One large blot of color stands wild and mutinous next to another. . . . And yet one cannot deny, that as dreadful, as audacious, as child-ish as his manner of painting appears to be, there is always a flash of something elemental and peculiar to the person or mood portrayed. (quoted in Da Costa Meyer and Wasserman 2003, 39)

Paul Stefan, a writer for the journal *Der Merker*, connected Schoenberg's art with his music, saying, "Only musicians, only those who know Schoenberg's music and its secrets, should look at these pictures, for only they will experience them elementally as sounds transposed across all the accidental boundaries of form. It was therefore virtually essential to have the music of Schoenberg ringing in one's ears as one viewed this exhibition" (quoted in Da Costa Meyer and Wasserman 2003, 39). Some of Schoenberg's paintings were exhibited in the first "Blue Rider Exhibition" of December 2011, including his *Self-Portrait, Walking* (1911) and his *Night Landscape* (1910). Two of his paintings appeared in the *Blue Rider Almanac*.

Look at *Self-Portrait, Walking*, 1911, Arnold Schoenberg, http://tod-dtarantino.com/hum/schoenbergbehind.jpg.

Exhibitions on Their Relationship

Given the depth of the artistic dialogue among artists during these years, both verbal and in the language of the arts, it should be expected that these relationships would become the focus of exhibitions both in the United States and abroad. In 2000, the Schoenberg Center in Vienna organized an exhibit called "Schoenberg, Kandinsky, Blauer Reiter and the Russian Avant-Garde—Art Belongs to the Unconscious," which was comprised of paintings, manuscripts, and drawings. The show was the result of collaborative efforts between the Schoenberg Center and the Russian Museum in St. Petersburg.

Four years later, the Jewish Museum in New York created an exhibit similar to the one at the Schoenberg Center, becoming the first American museum to organize an exhibit focusing on the relationship between Kandinsky and Schoenberg through art and music. This exhibit included sixty paintings representing works of Kandinsky and Schoenberg, as well as those by members of the Blue Rider, such as Franz Marc, August Macke, and Gabriele Munter. The exhibit also included musical manuscripts, letters, photos, and so on. In 2005, the Schoenberg Center followed with an exhibit called "Arnold Schoenberg, the Painter," and in 2006, the Tate Modern in London held a show called "Kandinsky: The Path to Abstraction."

While Schoenberg's body of visual art does not compare to his work in music, it sheds light on the dialogue that took place among artists not simply through words but *through* art. It also suggests that artists sometimes reach beyond their own domain through idea or creation to say what they want and need to say. Exhibits such as these and others help the listener and observer gain a glimpse into the process of making the art and composing music rather than just experiencing the final product.

Christian Meyer, who was curator of the exhibit "Schoenberg, Kandinsky, Blauer Reiter and the Russian Avant-Garde" at the Schoenberg Center in Vienna in 2000, wrote,

> While Schoenberg's music was an inspiration to Kandinsky as he explored abstraction, today Kandinsky's paintings function as ambassadors for Schoenberg's musical works. The strong colorful essence of Kandinsky's pre-war works has the same richness of sound colors in Schoenberg's compositions. And even his own paintings reveal much to those searching for a musical understanding of the works by the composers of the Second Viennese School. It seems that in today's visual world the fine arts are still required to understand music, the most abstract of all the arts. (quoted in Da Costa Meyer and Wasserman 2003, 11)

PART II

~

INTERLUDE 1

Composers Respond to Artists

The following five chapters highlight the work of composers who wrote music that was based upon or influenced by a specific work of visual art. Some of the composers discussed in these chapters reflected upon their visual counterpart. For example, jazz great Dave Brubeck composed music based on a specific painting by the Catalan artist Joan Miró—a musician and an artist seemingly worlds away. Brubeck wrote about why he was inspired by the artwork and how this painting guided his musical ideas. In the music of composer Gunther Schuller, we "hear" paintings by Paul Klee, an artist for whom music was an important part of his life. From Klee's painting *Little Blue Devil*, Schuller composed a movement for orchestra in a "bluesy" style. This pairing came about as a result of a commission by a symphony orchestra.

In the music of composers Earle Brown, Morton Feldman, and John Cage, we explore the important relationships between composer and artist that paved the way for musical counterparts to works of visual art. These composers, along with artists Alexander Calder, Mark Rothko, and Robert Rauschenberg, embraced some of the same philosophical issues and questions that related not only to art but also to life in general. Such questions as, Who's in control? and Is a white canvas really empty? and Is a musical piece with nothing notated really silent? provided a rhetorical backdrop to much of their creative work.

Whether because of a natural inspiration, shared philosophies about art and life, or a specific commission, one work was born out of another. These composers used the colors, shapes, forms, textures, stories, concepts, ideas, and "emptiness" from visual art as an important source from which they created another work of art—art in sound.

~

Dave Brubeck and His Reflections on Miró

Music and Art across Time

Jazz great Wynton Marsalis wrote in an introduction to Langston Hughes's *The Book of Rhythms*, "Jazz musicians always say, 'Rhythm is our business.' Without rhythm, there is no music. I don't mean only jazz music, I mean any music. Rhythm is motion—no motion, no rhythm. No rhythm, no music.... The rhythm is the vitality of the music" (from Hughes 1995, vi). From the words of painter Stuart Davis, who said, "I've always liked hot music.... But I never realized it was influencing my work until one day I put on a favorite record and listened to it while I was looking at a painting I had just finished. ... It seemed to amount to the same thing—like twins, a kinship" (quoted in Cassidy), to his paintings, such as *Swing Landscape* (1938) and *Hot Still-Scape for Six Colors—7th Avenue Style* (1940), it is clear that the artist was greatly inspired by jazz.

However, in the case of jazz great Dave Brubeck, the conversation went the other way. This musician was influenced by modern art in his innovative album *Time Further Out*, which Brubeck himself referred to as a "jazz interpretation" of a painting by the Spanish artist Joan Miró. From the titles of some of his best-known and innovative albums—*Time Out, Time Further Out, Time in Outer Space*, and *Time Changes*—there can be no doubt that the concepts of time and rhythm are at the core of this music. In addition to the album *Time Further Out*, Brubeck released other "time" albums that feature images of modern paintings on the covers. Other artists whose work appears on these album covers are American painters Neil Fujita, Franz Kline, and Sam Francis.

Brubeck's now-classic recording *Time Out* (1959) is all about innovations in the elements of time and rhythm. The music on this progressive album draws upon the roots of jazz in African culture, elements of classical music, and Turkish folk music, which the composer had heard during recent travels in Eurasia. As noted in chapter 1 on Stuart Davis and the roots of jazz, the march with its regular and strident 4/4 meter was an important precursor to early jazz. Occasionally a 3/4 meter found its way into jazz through its origins as dance music. However, with Dave Brubeck, these common time signatures that listeners of jazz had come to expect were tossed aside in favor of "experiments" with irregular and unexpected meters; from 5/4 to 9/8 to patterns of 6, the use of these time signatures in new and surprising ways took hold in this next chapter of jazz.

Look at the cover image of *Time Out* by the Dave Brubeck Quartet, http://upload.wikimedia.org/wikipedia/en/e/e5/Time_out_album_ cover.jpg.
Listen to "Blue Rondo a la Turk," Dave Brubeck, http://youtu.be/KAl-VasHbipo.

It was not simply the use of meters such as these that was groundbreaking but the complex rhythmic possibilities they held. For example, the "Blue Rondo a la Turk" embodies the influences of African roots, classical structures, and rhythmic patterns of some Turkish folk music. The use of the word *blue* alludes to the jazz blues, the term *rondo* refers to a traditional structure based on a principle of repetition used in classical music, and *a la Turk* invites the use of rhythmic patterns used in Turkish folk traditions. The piece alternates sections in 9/8 time with passages in a more traditional 4/4. The alternation in and of itself was innovative, but the way the 9/8 rhythms were divided created a surprising new sound in jazz. Nine can be divided in many ways—3 + 3 + 3, for example, comes to nine and gives a piece a strong feeling of three. However, if the division is 2 + 2 + 2 + 3, the division is irregular, best imagined by saying "apple, apple, apple, pineapple" very quickly. For jazz audiences accustomed to clapping hands, snapping fingers, or tapping feet, rhythmic innovations such as these offered a great challenge!

"An experiment with time" was how Steve Race, author of the liner notes on the original album, described this music (The Dave Brubeck Quartet 1997). This experimental approach is heard in every track on the album.

"Strange Meadow Lark" frequently relies on ten-bar phrases, again irregular and new to the contemporary ear. More traditional phrasing would be organized into four or eight bars. "Take Five," which follows, is in 5/4 as the name suggests, and it became a hit in mainstream popular music with its catchy saxophone melody played by Paul Desmond.

The next two tracks, "Three to Get Ready" and "Kathy's Waltz," are based in 3/4 and 4/4 meters, but both pieces alternate the two time signatures. "Three to Get Ready" begins as a waltz in three but soon starts to alternate with common time (4/4). Quickly a pattern is established that relies on this alternation—two bars of three alternating with two bars of four. The approach to alternation is the opposite in "Kathy's Waltz" and begins in four before moving to three, which is the meter one would expect in a piece titled "waltz."

The final track of the album, "Pick Up Sticks," is based on a pattern of six notes, which serves as the foundation of this complex piece. The innovative and very progressive approach to "time" is created not simply by using irregular time signatures or even by alternating various meters. The use of compound rhythm creates rhythmic counterpoint by layering complex rhythmic patterns.

This album, *Time Out*, was the first of many by Brubeck to focus on the element of time in music, and it was also the first of many to use an image of a modern painting on the cover. The painting used as the cover for this album was done by the Hawaiian-born American painter and graphic designer Neil Fujita (1921–2010). He became the director of the art department at Columbia Records in New York City, where he was responsible for designing album covers. His work was not just featured on *Time Out* but also on other jazz albums, such as Charles Mingus's *Mingus Ah Um* (1959), as well as on classical records, including a recording by Glenn Gould. In an interview for the American Institute of Graphic Arts, Fujita said, "Jazz called for abstraction, a certain kind of stylization, using modern painters" (quoted in Heller 2007). In this interview, Fujita, who was influenced by such artists as Braque, Picasso, and Klee, elaborated, "It wasn't modern painting but it was a modern approach." The vibrant visual rhythms and bold colors reflect the great success of "time experiments"—clearly modern in approach—in the music.

From Art to Music

The success of this album was followed by *Time Further Out* (1961), which has an even stronger and clearly articulated link to its cover—*Painting: 1925* by the Spanish Catalan artist Joan Miró (1893–1983; see figure 6.1), who

Figure 6.1. Joan Miró, *Painting*, 1925, oil on canvas, 195 × 129.2 cm. Inv. AM1983-92. Musée National d'Art Moderne, Centre Georges Pompidou, Paris, France. © Successió Miró/Artists Rights Society, New York, NY/ADAGP, Paris, 2014. © CNAC/MNAM/Dist. RMN-Grand Palais/Art Resource, New York, NY.

was born in Barcelona. Subtitled *Miró Reflections*, this album was referred to as a "jazz interpretation" of Miró's painting by Brubeck himself. This work is a "blues suite," which, like its predecessor *Time Out*, combines elements of the blues, namely the use of the twelve-bar blues form or a variation upon it, within the overall organization of the "suite," a term used for centuries in classical music to refer to a collection of dance movements. While these two overarching ideas helped to create the architecture for this record, Brubeck's innovations in time and rhythm continued to develop a new sound.

Listen to "It's a Raggy Watltz," Dave Brubeck, http://www.youtube.com/watch?v=JsGSxbAB3qk.

Viewers of art note different things in the same painting. Miró's work of the middle 1920s reflected a "system" he created in which symbolic meanings were connected to numbers and figures within a specific context. Miró referred to abstract figures in his works as "personages," and many works from this time period contain "personages" and a flame. While some viewers might look at a painting and try to understand the intention of the artist, others will make other connections whether they were intended by the creator (artist) or not. One viewer might look at Miró's painting and see no connection with music or jazz at all, but that was not the case with Brubeck.

There are four distinctive circular shapes in white, green, red, and black—perhaps reminding Brubeck of his quartet. Then there are the numbers in the painting:

3
4
5
6
7 3
8 4
9
0

appearing vertically with the number 3 near 7 and the number 4 next to 8. The most obvious connection between the painting and the music is Brubeck's "interpretation" of the numbers. Beginning with track 1, "It's a

Raggy Waltz (3/4)," Brubeck explored the numbers 3 and 4 as time signatures within the same track. He worked through the sequence of numbers, using them as meters with "Bluette" (3/4), "Charles Matthew Hallelujah" (4/4), "Far More Blues" and "Far More Drums" (5/4), "Maori Blues" (6/4), "Unsquared Dance" (7/4), "Bru's Boogie Woogie" (8/8), and "Blue Shadows in the Street" (9/8).

Brubeck articulated many of his ideas in the original liner notes from the album. The first track, "It's a Raggy Waltz," was described by Brubeck as a "rhythmic variation" on both a rag and a waltz. Like ragtime music, accents shift often and unexpectedly, creating a feeling of triple meter within a quadruple meter. While this technique was not new to music, it was new to jazz. Composers of the 1920s sometimes used this technique, as did Tin Pan Alley songwriters, such as George Gershwin. He used this idea in his great song "Fascinating Rhythm," as well as in his larger orchestral work *Rhapsody in Blue* (1924).

In the next track, "Bluette," the listener hears a jazzy Chopinesque waltz in three with an underlying twelve-bar blues structure. This is followed by the joyful and solo-dominated track called "Charles Matthew Hallelujah," which is in 4/4 and celebrated the birth of one of Brubeck's children. The next two tracks are composed in 5/4. "Far More Blues" retains the essence of the blues but features complex harmonies. "Far More Drums," also in 5/4, reflects percussive influences of Africa. Brubeck even noted the use of the seemingly strange 5/4 meter in authentic field hollers of the South. Continuing with the next track, "Maori Blues," which is in 6/4, Brubeck explained his use of this meter, saying, "The number 6 on the Miró painting reminded me of an effective 6/4 rhythm I had heard sung at a welcoming ceremony given us by the Maoris in Wellington, New Zealand when the Quartet played there in 1959" (The Dave Brubeck Quartet 1996).

The next track pokes fun of the square dance with the whimsical title "Unsquared Dance," which is in the anything but square meter of 7/4. "Bru's Boogie Woogie" in 8/8 nods to both the number 8 in the painting and to the jazz style of the boogie-woogie, which is characterized by a prominent bass line. The final track on the album is "Blue Shadows in the Street," and it is in 9/8. Brubeck summed up the entire record, "Mindful of the capricious spirit of the Miró painting, there is a suggestion of whimsy in these reflections and a conscious attempt to distill rather than magnify rhythmic complexity. . . . My gratitude to Joan Miró for his inspiration" (The Dave Brubeck Quartet 1996). Brubeck noted later on that he had actually wanted to use this image on the cover of his earlier *Time Out* but was not able to secure the rights at that time. Miró's painting was used as the cover image of *Time Further Out*

with the artist's blessing. The painter added, "It would be an honor" (quoted in The Dave Brubeck Quartet 1996).

Time Further Out drew inspiration from Miró's painting as stated by Brubeck, and because of that, this album is probably his most famous in terms of a concrete link to a painter. However, his album *Time in Outer Space* (1962) featured an image of a painting by Franz Kline (1910–1962) on the cover, and his record *Time Changes* (1963) used an abstract painting by Sam Francis (1923–1994) as the cover art.

Franz Kline

Franz Kline was an American painter who was associated with the abstract expressionist movement in New York City in the 1940s and '50s. He did a series of works for the Cedar Tavern in New York City in 1940. This bar was a popular gathering place for abstract expressionist painters, such as Jackson Pollock and Robert Motherwell, as well as beat poets and progressive composers. Kline painted a mural series called "Hot Jazz" for the bar; this work reflected the restless and dynamic rhythms of New York in the rapid, dynamic brushstrokes and bold lines.

Like Jackson Pollack, Kline was referred to as an "action painter," which implies the physical act of painting through gesture and motion. The physicality of this approach results in paint drips, strokes, and splashes that are in contrast to carefully applied paint. This seemingly spontaneous approach to painting is not unlike jazz improvisation. Like jazz improvisation, Kline's "spontaneous" style was carefully planned. He described his works as "painting experiences" and said, "I don't decide in advance that I'm going to paint a definite experience, but in the act of painting, it becomes a genuine experience for me" (quoted in Kuh 2006, 231). In his best-known abstract expressionist paintings, he typically relied on a black-and-white palette. In the painting used on the cover of Brubeck's *Time in Outer Space*, the black lines are in bold contrast to white and an unexpected splash of red.

Look at the cover of Brubeck's *Time in Outer Space*, featuring a painting by Franz Kline on the cover, http://www.musiconvinyl.com/fotos/484_foto1_product_groot.jpg.

Sam Francis

Brubeck's album *Time Changes* features a painting by the American painter and printmaker Sam Francis (1923–1994). The California-born artist was interested in color and light. Like the call and response heard in jazz, he often used vivid colors in conversation with white, which helped direct the color into shapes and patterns. Considered an abstract expressionist artist, he frequently used "drips" of color in contrast to white. He was also interested in and influenced by Japanese art and calligraphy.

Look at the cover of Brubeck's *Time Changes*, featuring a painting by Sam Francis, http://upload.wikimedia.org/wikipedia/en/2/2d/Time_Changes_album-cover.jpg.

Brubeck's album *Time Further Out* and the painting by Miró on the cover is a widely known pairing of modern art and music. What was it about Miró's painting that inspired Brubeck? Clearly the use of numbers in the painting was significant to Brubeck. But, what did Miró have in mind? Why did he include numbers? What do the organic, curvy shapes in white, green, red, and black represent? Why are these spots of color placed together against a neutral but textured and nuanced background? Why are the shapes connected to lines? Was Miró thinking about music?

Joan Miró

One thing that is certain is that Miró was greatly influenced throughout his career by his native Catalan, as well as by poetry, music, and dance. He was born in Montroig, Spain, a village near Barcelona. His early paintings frequently suggested the rhythms of nature. In such works as *Vines and Olive Trees, Montroig* (1919) and *The Farm* (1921–1922), which is considered to mark the culmination of these early works, one notes his use of rhythm—repetition of lines, forms, and colors in such a way as to give a sense of rhythmic texture and unity. The eye is drawn to a strong sense of rhythmic distribution, whereby specific lines or shapes, as well as color, are placed in specific areas. These works also create a feeling of spontaneity within a carefully planned composition, not unlike jazz improvisation.

Miró was also greatly influenced by such French poets as Apollinaire and Rimbaud. The artist said, "I make no distinction between painting and poetry. It therefore happens that I illustrate my canvases with poetic phrases and vice versa" (quoted in Soby 1959, 96, 98). Miró used a combination of poetry and calligraphy in many of his works, such as his painting from 1925 *Le corps de ma brune*, in which the words of the poem are literally part of the painting.

From the middle-1920s, Miró was guided by the great force of the imagination, which led to works that were much more abstract. The painting used on the cover of Brubeck's album *Painting, 1925* was done during years in which the artist created what are sometimes referred to as "dream paintings." It was a period of time when he experimented with surrealist ideas that included a desire to draw upon the subconscious, hallucinations, and chance. The painting *Ceci est la couleur de mes reves*, also from 1925, translates to "This is the colour of my dreams"; these words were painted in calligraphy as part of the artwork.

Sometimes artists in one discipline create something specifically in response to a work in another artistic discipline and name it as such. This was the case with Brubeck reflecting on Miró's painting, Stuart Davis commenting on the jazz he listened to while he painted, and Arthur Dove creating and naming his "music paintings." However, sometimes the connections simply come about without deliberate intention on the part of one or both of the artists.

Brubeck himself addressed this in the liner notes from the original 1961 album *Time Further Out: Miró Reflections*, saying,

> To explain the relationship of the Miró painting to the music is not a simple task. I can point to the numbers in the upper right hand corner of the painting and the time signatures of each of the pieces in the album. There is a more tenuous link in the Miró abstract forms, suggesting human figures moving in a visual rhythm which *could* be interpreted as a jazz quartet. However, beyond these objective relationships of symbols and figures, I feel that in Miró's painting he has expressed in visual terms my own approach to music—that is, a search for something new within old forms, an unexpected perspective, a surprising order and inner balance that belies the spontaneity of composition. (The Dave Brubeck Quartet 1996)

CHAPTER SEVEN

~

Paul Klee

The Music in the Art

Painters Who Play—Paul Klee (Bach, Mozart, Schuller)

While there are connections that can be made between works of art and musical compositions through analysis and interpretation, there are examples of connections made and named by the artist. Such was the case with Paul Klee (1879–1940), who was born in Bern, Switzerland, into a musical family. His father was a music teacher with broad intellectual interests, and his mother was a singer. As a youth he studied violin, played in orchestras, and participated on musical tours. Klee remembered his violin teacher and the broad influence that relationship had on him as a youth. Klee wrote,

> I had an excellent violin teacher, a highly cultivated concertmaster who had switched from theology to music, moved in Burckhardt's circle and was also a lover of graphic art. He had Knackfuss monographs about the house—especially on Raphael and Leonardo, of course. The new method of reproduction was what made the greatest impression upon me. (quoted in F. Klee 1962, 4)

Klee's son noted that there are more than 500 titles in his father's work that are associated with music, mask, and theater. Clearly the combination of sight and sound was of great interest to the artist throughout his life.

As a young man, Klee pondered a future as a musician or a painter. He wrote in his diary in 1889, "Music, for me, is a love bewitched. Fame as a painter? Writer, modern poet? Bad joke. So I have no calling, and loaf" (P. Klee 1964, 26). However, his passion for music remained with him. A few

years later in 1897, at the age of eighteen, Klee wrote in his diary, "As time passes I become more and more afraid of my growing love of music. I don't understand myself. I play solo sonatas by Bach. . . . It makes me smile. La Landi made a deep, unforgettable impression on me with old Italian songs. I sigh, Music! Music!" (P. Klee 1964, 14).

Paul Klee even married a musician, Lily Stumpf, who was a pianist. Music was an integral part of his life, not just in his youth, but also throughout his life. Paul Klee's son Felix noted,

> In 1956, I edited his *Diaries*. . . . Those diaries give a comprehensive picture of my father's many-sided interests, artistic and human: they express his views on painting, sculpture, drawing, poetry, architecture, theater, his dealings with other persons, and above all music. This last remained a key aspect of his life. My father was an excellent violinist, a student of Meister Jahn in Bern, and he used to take refuge in music until very late in life. (F. Klee 1962, ix)

Paul Klee continued to play the violin throughout his life, regularly attended concerts, and wrote critiques of musical performances featuring the repertoire of master composers, including Beethoven, Mozart, Brahms, Schubert, Tchaikovsky, Offenbach, and Verdi. In his diaries, Klee even noted specific details about performances of choral, instrumental, and operatic music. He regularly made thoughtful and honest notes about performers, conductors, and the music itself.

Klee traveled extensively during his life. In 1905, he went to Paris, where he became familiar with works of Goya, Tintoretto, Monet, Manet, and Renoir. In 1905, the artist noted, "More and more parallels between music and graphic art force themselves upon my consciousness. Yet no analysis is successful. Certainly both arts are temporal; this could be proved easily" (P. Klee 1964, 177). His exposure to contemporary artists and their work continued in 1911, when he became acquainted with artists at the "Blue Rider Exhibit" in Germany. The Blue Rider refers to a group of artists including Russian immigrants Wassily Kandinsky and Alexej von Jawlensky, as well as native German artists Gabriele Munter and Auguste Macke. The group of artists changed in the 1910s and 1920s, but the dominant ideal of this group was the belief that the inner human spirit could best be communicated and shared through the integration of multiple art forms. This group came to involve composers, musicians, and writers, as well as visual artists.

The year 1914 was pivotal for Paul Klee. He visited Tunisia for the first time, where he was struck by the intense light of North Africa. Here he gained new ideas about the use of color and its potential for expression. He

experimented with using color as separate from nature. In paintings from later years, such as *Tunisian Gardens* (1919), he used squares of color almost like mosaics. His experience in Tunisia led him to experiment with abstract forms. His exposure to the art, light, and color of such cities as Paris, Munich, and now Tunisia combined with his broad interests and lifelong dedication to music would impact his work throughout his career.

In the early 1920s, Klee was appointed to the faculty of the Bauhaus, where Kandinsky was also teaching. The Bauhaus was an art school established in Weimar, Germany, in 1919 that focused on art, design, and architecture. The school moved to the industrial city of Dessau in 1925, where Walter Gropius (1883–1969), an architect and founder of the school, designed the Bauhaus studio building, which was made of glass and cement. He also created the avant-garde four "master houses," which were designed as interlocking cubes. This is where the professors lived. One of these houses was shared by Klee and Kandinsky while they were teaching there. Both Klee and Kandinsky were greatly influenced by music, and they also shared the ideals of the Blue Rider. In 1924, Klee had his first American exhibition at the Société Anonyme in New York. This was also the year when art dealer Emmy "Galka" Scheyer organized the Blue Four, a group of artists comprised of Klee, Kandinsky, Feininger, and Jawlensky, for whom she organized exhibits across the United States.

In his book about his father, Felix Klee reflected on his own childhood and the years at the Bauhaus. One theme that echoes throughout the book is the role of music in the life of the entire family. Felix Klee remembered,

> Our lovely family habit of music-making was continued in our so splendidly situated Weimar apartment. The ensemble was enlarged with the addition of Karl and Leo Grebe from Jena. On musical days the group "worked" like mad, playing string and piano quartets and quintets by Mozart, Beethoven and Haydn. Paul Klee, who ordinarily seemed so calm and deliberate, would suddenly be blazing with a southern ardor and temperament; he played first violin with passion, and if a movement turned out particularly well, it was usually repeated. (F. Klee 1962, 54)

Klee's passion for music, both as a concertgoer and as a violinist playing chamber music, was a driving force in his creative world.

Music was central to Klee's work as an artist throughout his life. The influence of music was ever present as he considered metaphorical questions, such as, What might music look like? He often used musical terms as title of his paintings. Such words as *harmony, rhythm, nocturne, fugue,* and *polyphony* appear frequently as titles of major works. Such paintings as *Fugue*

in Red (1921), *Harmony in Blue-Orange* (1923), *Polyphony* (1932), and *New Harmony* (1936) are but a few of the many works with specific references to music.

In his writings, Klee often compared music and painting. He was moved by the music of Bach and Mozart, particularly by Bach's polyphonic writing, which had a sense of great clarity and order, and by Mozart's operas, which Klee considered to be a high form of art. Klee showed little interest in modern music, which he considered dry and academic. One exception was the composer, Paul Hindemith, in whose music he showed some interest. Not surprisingly, Hindemith drew on many principles of formality found in the music of Bach and Mozart. One of Klee's most famous late works, *Ad Parnassum*, a complex "polyphonic painting," takes its name from the famous treatise on polyphonic harmony *Gradus ad Parnassum* (1725) by Johann Fux, an eighteenth-century composer and music theorist whose work continues to teach and influence composers today.

Klee named specific elements of music that particularly interested him in painting. He was fascinated by the notion of *time* in both art and music. Because music exists in time, time is core to all music. How is art impacted by time? Klee wrote, "I am continually being made aware of parallels between music and the fine arts. As yet they defy analysis. It is certain that both art forms are defined by time. This can easily be proved" (quoted in Duchting 1997, 9). Klee pointed to the creative process of making a working of art—the creative process takes time. Out of time comes the element of *rhythm*, which he believed marked time in both music and art.

Klee was also fascinated with the concept of *color* across disciplines. Color is easy to see in painting, but it also exists in music, albeit metaphorically. Tone color or timbre in music refers to the essence of the sound created. For a composer of orchestral music, for example, the orchestral instruments become the palette of colors—tone colors or sounds. The colors of the music are created by specific combinations of instruments, their relative high to low pitches and loud to soft dynamic levels. The color or timbre of a flute is distinctive and different from the color or timbre of a trumpet or a human voice. Is the sound created by a vibrating string or by air moving through a brass instrument? It is through the rich range of sounds made by the human voice and musical instruments, as well as the infinite possible combinations, that color in music is created. For Klee, the idea of visual color in painting and aural color in music was fascinating. As a young painter in 1910, he wrote, "One day I must be able to improvise freely on the keyboard of colours: the row of watercolours in my paintbox" (quoted in Duchting 1997, 17).

In order to understand Klee's musical and visual explorations, it is important to consider the music of the composers whom Klee admired—J. S. Bach (1685–1750) from the baroque period and W. A. Mozart (1756–1791) from the classical period in music. Why would a modern painter find inspiration by looking back in musical history? Klee experienced great power in the works of both composers. About Bach, the painter once said, "I felt the benefits of the holidays in that I am filled with art. This realization has been further confirmed by playing Bach over and over again. I have never experienced Bach with such intensity, never felt so much at one with him. What concentration, what a unique and final gift" (quoted in Duchting 1997, 7). In the music of Mozart, Klee found art of the highest level—that which ranges from the profound to the witty to the childlike. For Klee, Mozart's music was the "ultimate pinnacle of art" (quoted in Duchting 1997, 8).

Musical Terminology

In addition to words like *time*, *rhythm*, and *color*, Klee frequently used the term *polyphony*. Literally this means many (*poly*) sounds (*phony*) and refers to music that incorporates multiple lines that operate independently. A canon, or a round, such as the children's song "Row, Row, Row Your Boat," is polyphonic. Each line has a melodic function but functions independently. This is in contrast to a monophonic texture, which involves just a single line without harmony, or a homophonic texture, which involves a melody with a chordal accompaniment. A polyphonic texture is one that sounds busy, has a strong sense of forward motion, and in which each line is essentially competing for the listener's attention.

The term *fugue* is often used in Klee's titles. A fugue is a musical form that is always polyphonic—it always involves multiple lines based on an opening *subject* (brief melodic phrase) and developed according to a strict sense of order. The appearance of the subject restated at a higher or lower interval is referred to as the *answer*. Fugues also include passages referred to as *episodes*, which are sections in which the subject (short theme) or fragments of it may or may not be present. The interplay among the voices, the use of imitation in the various voices, and the independence of each line make a fugue *polyphonic*.

It is clear that music was a major source of influence in Klee's work. In looking at this more closely, one sees that the artist used aspects of music and musical ideas in his work in clearly identifiable ways. These include: music as subject matter, musical terms or forms as titles, use of musical notation

symbols within a painting, and visual interpretation of a musical form or piece of music.

Music as Subject

Klee's interest in music often became the subject of his work. In addition to the use of musical terms to name his work, many of his works suggest characters from operas he saw, images of musical instruments, or graphic notation

Figure 7.1. Paul Klee, *The Bavarian Don Giovanni*, 1919, watercolor and ink on paper. 8⁷/₈ × 8³/₈ in. (22.5 × 21.3 cm). Estate of Karl Nierendorf, by purchase. The Solomon R. Guggenheim Museum, New York, NY. © 2014 Artists Rights Society, New York, NY. Photo Credit: The Solomon R. Guggenheim Foundation/Art Resource, New York, NY.

suggesting a musical score. One of the artist's favorite works by Mozart was the famous opera *Don Giovanni*, which was first performed in Prague in 1787. In 1919, the artist completed a painting inspired by this work—*The Bavarian Don Giovanni* (see figure 7.1).

Listen to *Don Giovanni* ("Leporello's Aria—Catalogue of Lovers"), Mozart, http://youtu.be/6gYKI3dVOTM.

This painting is at once abstract but also personal. In *Don Giovanni*, there is a famous scene in which the character Leporello names the more than 2,000 love affairs he has had. Klee's painting is personal in that the names in the painting refer to specific women—both singers (Emma Carelli and Therese Rothauser) and models (Kathi, Mari, and Cenzl) with whom the artist had brief romances. In Klee's hands, these names become part of the painting itself.

Also reflecting his affection for opera, Klee's *Hoffmanesque Fairytale Scene* from 1921 was inspired by Offenbach's opera *Tales of Hoffman*. The seemingly simple and playful lines in this work evoke the innocence of childhood and the freedom of a child's creative spirit. Similarly, Mozart's *Piano Concerto No. 27, K. 59,* Movement III, reflects the lightheartedness and humor associated with childhood in its playful thematic material. Like Mozart, Klee's work has been described as visionary, witty, and childlike.

Look at *Tale à la Hoffmann*, 1921, Paul Klee, http://metmuseum.org/Collections/search-the-collections/483143.
Listen to Mozart *Piano Concerto No. 27, K. 595,* Movement III, Murray Perahia, http://youtu.be/7vqBBRVRwSg.

Musical Terms and Forms as Titles

Klee sometimes used musical terms as titles of his visual works. Words like *harmony, rhythm, polyphony, fugue,* and *nocturne* are among the musical terms used by the artist. He used one such term—*nocturne*, which means "music for evening"—in his *Nocturne for Horn* (1921). This watercolor and pen work depicts the bell of a horn as fragments that have been cut up and rearranged.

In this work, Klee used layers of graduated color patterns suggestive of night, which are marked by bold, rhythmic lines.

Look at *Nocturne for Horn*, 1921, Paul Klee, http://reproduction-gallery.com/oil_painting_reproduction_gallery/Paul-Klee-Nocturne-for-Horn-1921-large-1341388809.jpg.

Use of Musical Notation Symbols

Klee was interested in symbols and signs—in his art, shapes often suggested a sound or a meaning. In addition to the use of musical terms, Klee sometimes used actual musical notation in his art. His picture *Drawing (Instrument for the New Music)* (1914) was created using literal musical nomenclature—lines and shapes suggesting clefs, rests, and note values. One symbol that occurs many times in his work is the fermata—the musical symbol to hold. It appears in numerous works, including *In the Style of Bach* (1919), *Stage Landscape* (1937), and *Kettledrummer* (1940). Klee's use of the fermata sometimes suggests an eye, at times seemingly watchful, as in *Stage Landscape*, and other times bold and perhaps very personal, as in *Kettledrummer*.

Look at *In the Style of Bach*, 1919, Paul Klee, http://www.kunstkopie.de/kunst/paul_klee_11025/Im-Bachschen-Stil.jpg.
Look at *Stage Landscape*, 1937, Paul Klee, http://uploads3.wikipaintings.org/images/paul-klee/stage-landscape-1922%281%29.jpg.
Look at *Kettledrummer*, 1940, Paul Klee, http://www.paulklee.net/images/paintings/kettledrummer.jpg.

Visual Interpretation of Music and Polyphonic Painting

Klee used the phrase *polyphonic painting*, applying a common musical term to describe a busy musical texture to painting. As polyphonic music involves the overlapping of multiple musical lines, polyphonic painting involves the overlapping of visual structures and color. Klee sometimes borrowed the musical term *fugue* in these works. For example, *Fugue in Red* (1921) con-

tains identifiable shapes, such as triangles, rectangles, squares, leaves, and pots, which are fragmented, repeated, and constantly changing in size and color gradation. The shapes are clearly layered and suggest forward movement through repetition, creating an almost visual sense of time passing. Is this what a fugue might look like? Might the shapes suggest a fugal subject, answer, or episode, moving through time together yet independently? In Klee's book *Exact Experiments in the Realm of Art* (1927), he discussed what he considered to be the "temporal" element of line. The longer the line, the longer the element of time associated with it. His polyphonic paintings from 1929 explored ideas of polyphonic music in the approach to multiple lines of color like multiple lines of sound.

Look at *Fugue in Red*, 1921, Paul Klee, https://c2.staticflickr.com/6/530 2/5638015325_1948217a3f.jpg.
Listen to *Fugue in C Minor* (BWV 546), J. S. Bach, http://www.youtube.com/watch?v=T89LCNoAI4M.

Klee's Influence on Modern Music

Klee's love of the music of Bach and Mozart in particular was expressed by the artist himself. However, Klee's work has influenced modern composers. The prolific composer Gunther Schuller composed a seven-movement orchestral work called *Seven Studies on Themes of Paul Klee*, which was premiered in 1959 by the Minneapolis Symphony under the baton of Antal Dorati. In this piece, the composer connected each movement to a specific work of Klee. These movements are: "Antique Harmonies," "Abstract Trio," "Little Blue Devil," "Twittering Machine," "Arab Village," "An Eerie Moment," and "Pastorale." Schuller is known for a type of musical composition known as *third stream*—music that reflects both jazz and classical styles. Elements of both are evident in these short movements, which are essentially a musical response to Klee's work. Schuller wrote, "Each of the seven pieces bears a slightly different relationship to the original Klee picture from which it stems. . . . Some relate to the actual design, shape, or color scheme of the painting, while others take the general mode of the picture or its title as a point of departure" (quoted in Schuller 2007).

For example, the first movement, "Antique Harmonies," utilizes blocks of sound and dense orchestration suggestive of the visual weight of the picture.

The opening of the movement is still at first, with staggered entrances by various instruments—these sound blocks suggest the color blocks in Klee's painting. In his painting *Abstract Trio*, Klee suggested music in the title. This work features a sparse texture with line figures that could be seen as musical instruments or musicians. By contrast, the third movement, "Little Blue Devil," is composed in a jazz style that utilizes a blues progression.

Look at *Antique Harmonies*, 1925, Paul Klee, http://uploads7.wikipaintings.org/images/paul-klee/abstract-colour-harmony-in-squares-with-vermillion-accents-1924.jpg.
Look at *Abstract Trio*, 1923, Paul Klee, http://www.metmuseum.org/toah/images/h2/h2_1984.315.36.jpg.
Look at *Little Blue Devil*, 1933, Paul Klee, http://www.indiana.edu/~dws/art_music/images/03KleeBLUDEV.jpg.

Klee's *Twittering Machine* (1922; see figure 7.2) is a pen drawing and watercolor done with a great sense of economy. The painting is of playful yet enigmatic birdlike creatures with curious expressions that are created by a notation of sorts comprised of lines and shapes appearing over the strange machine. The creatures could be interpreted as musical notes; in the faces there is a hint of the musical fermata. There is also a suggestion of sound, perhaps a cacophony of bird sounds or simply noise that is created through the somewhat distorted images of these creatures. However, the approach is not one of nostalgia but rather a reflection of the Machine Age. The painting itself connects with more than just the eye; it suggests sound, and it requires the ear to imagine. Schuller's piece gives "sound" to the painting with the opening flurry and flutter of high-pitched woodwinds and the busy rhythms of percussion instruments.

The movement "Arab Village" is exotic and recalls travel to foreign lands. This is followed by the dissonant "An Eerie Moment." In the final movement, "Pastorale (Rhythms)," the composer used melodic rhythmic figures that function like visual shapes and are heard at various pitches and tempi. This suggests Klee's picture in which parallel lines and shapes are fragmented, rearranged, and repeated through variation, almost suggesting a grid.

Consider the instrumentation of Schuller's *Seven Studies on Themes of Paul Klee*, which is for a very large orchestra with big woodwind, brass, and string

Figure 7.2. Paul Klee, *Twittering Machine* (*Die Zwitscher-Maschine*), 1922, oil transfer drawing, watercolor and ink on paper with gouache and ink borders on board, 25¼ × 19 in. (64.1 × 48.3 cm). Purchase. The Museum of Modern Art, New York, NY. © 2014 Artists Rights Society, New York, NY. Digital Image © The Museum of Modern Art/ Licensed by SCALA/Art Resource.

sections, as well as a full array of percussion instruments, including piano and harp. These were the instruments of the composer's palette. Like Klee, he combined them through orchestration in ways that suggest the paintings that inspired them. As an artist whose life was filled with music, it seems natural that Klee's contributions to the world of art might migrate across disciplines and inspire the creative work of a composer in whose musical compositions his paintings were given sound.

~

Mark Rothko and Morton Feldman

Somewhere between Presence and Absence, Sound and Silence

The Rothko Chapel in Houston, Texas, is the realization of a vision that was shared by those who founded it, those who designed and built it, and those who created art for its space. The mission statement of the chapel reads: "The mission of the Rothko Chapel is to inspire people to action through art and contemplation, to nurture reverence for the highest aspirations of humanity, and to provide a forum for global concerns" (www.rothkochapel. org). The chapel was founded by art collectors Dominique and John de Menil, who emigrated from France to Houston in 1941. They collected art and artifacts from around the world; this vast collection represented many cultures. In 1964 they commissioned artist Mark Rothko (1903–1970) to create fourteen paintings for the space. They gave him the creative control to the shape the meditative space according to his artistic vision. Rothko worked closely with the original architect, Philip Johnson, as well as architects Howard Barnstone and Eugene Aubrey, who guided the structure to completion.

This interfaith chapel was formally dedicated in 1971, along with Barnett Newmann's sculpture *Broken Obelisk*, which stands on the plaza. Both the chapel and the sculpture are dedicated to Dr. Martin Luther King Jr. The chapel is a meditative space and a museum; it is a place that is known for religion, art, and architecture. As a chapel, it is always accessible—free to anyone and open every day of the year. It offers programs that engage intellectual, artistic, architectural, spiritual, and humanitarian interests, and it has become a forum for leaders in human rights, such as Nelson Mandela and the Dalai Lama.

Mark Rothko and the Chapel Paintings

Mark Rothko's commission to create the chapel paintings came late in his career. He was born in Dvinsk, Russia (now Daugavpils, Latvia), and he came to the United States in his youth. He was a person with broad interests ranging from music and literature to math and science to politics. During his life he developed a deep admiration for the music of Mozart and Beethoven and for the words of Shakespeare. Rothko later said, "I became a painter because I wanted to raise painting to the level of poignancy of music and poetry" (quoted in Wheeler 1991, 48). He won a scholarship to Yale University, where he studied for two years. He came to art later while in New York City, where he happened upon a life-drawing class. From there he studied art briefly at the Art Students League in New York under Max Weber. However, he was mostly self-taught. He regularly attended exhibitions and visited the studios of such artists as Milton Avery.

In his thirties and early forties, Rothko experimented with styles, such as expressionism and surrealism. He was also a painter who was associated with color-field painting. In this type of painting, the focus is on color and "chromatic values" and the effect of color rather than on line. In this style of painting, the canvas is covered in fine, translucent washes of color. Painters were able to convey meaning and emotion through unified fields of color on large canvases. Artists associated with color-field painting were also interested in the myth. In a 1943 radio broadcast, Rothko said, "If our titles recall the known myths of antiquity, we have used them again because they are eternal symbols upon which we must fall back to express basic psychological ideas" (quoted in Moszynska 1990, 163).

It was after 1947, however, that he began to develop a distinctive approach to abstraction. He started painting large rectangular forms in various "color fields." In these works the edges are often blurred as if the fields of color are literally moving over the canvas. This causes the observer to look at the paint itself, the pigment, and the texture in a way that requires time and stillness. The effect creates a sense of calm, transcendence, and meditation. For Rothko, color was a means rather than an end.

Rothko articulated the need for careful placement of his paintings when they were presented publically. In 1954, prior to a Chicago exhibit, he wrote to curator Katharine Kuh with instructions on showing his work, saying, "Since my pictures are large, colorful and unframed, and since museum halls are usually immense and formidable, there is the danger that the pictures relate themselves as decorative areas to the walls. This would be a distortion of their meaning, since the pictures are the opposite of what is decorative" (Kuh 2006, 146–47).

Rothko suggested that his paintings expressed human emotion—not personal emotion but universal emotion related to the human condition. In a 1957 interview, the artist said,

> I am not interested in relationships of color or form or anything else. . . . I am interested only in expressing the basic human emotions—tragedy, ecstasy, doom, and so on—and the fact that lots of people break down and cry when confronted with my pictures shows that I communicate with those basic human emotions. The people who weep before my pictures are having the same religious experience I had when I painted them. And if you, as you say, are moved only by their color relationships, then you miss the point! (quoted in Wheeler 1991, 50)

The careful presentation of his paintings implied a relationship between the work and the viewer. This spatial relationship helps create the emotion.

Mark Rothko worked on the fourteen almost monochrome chapel paintings from 1964 to 1967 (see figure 8.1). There is a triptych in the apse of the chapel and four panels on the diagonal-facing walls. These are painted black with washes of maroon. There are two additional triptychs on the side walls and another panel on the entrance wall opposite the apse that are black,

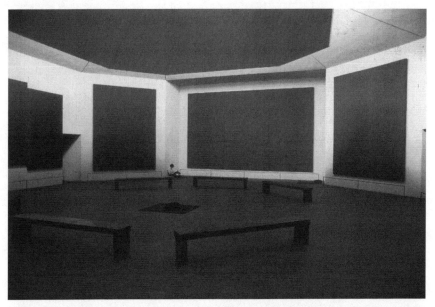

Figure 8.1. Mark Rothko, Interior. Rothko Chapel, Houston, TX. © 1998 Kate Rothko Prizel and Christopher Rothko/Artists Rights Society, New York, NY. Photo Credit: Nicolas Sapieha/Art Resource, New York, NY.

hard-edged rectangles on a maroon field. The panels are dark in color, but the actual color is impacted by light and shadow. They create a sense of both presence and void. At the opening of the chapel in 1971, Dominique de Menil described the panels as "intimate and timeless. They embrace us without enclosing us. Their dark surfaces do not stop the gaze. . . . But we can gaze right through these purplish browns, gaze into the infinite" (quoted in Weiss 1998, 284).

Mark Rothko did not live to see the opening of the chapel. He died by his own hand in 1970. Katharine Kuh, the art writer and curator, was a personal friend of Rothko. She wrote about these fourteen paintings in the chapel,

> which, though dark, are based on a hidden radiance more related to religious passion than to personal mood. I believe that with those murals he was also trying to prove he no longer needed luminosity to accomplish his ends. And whether subconsciously or not Rothko was competing with his colleagues Franz Kline, Clyfford Still, and Reinhardt, who found the dark of the moon as persuasive as the light of the sun. (Kuh 2006, 144–45)

Kuh also reflected on his process in creating the chapel paintings, writing,

> He worked on the chapel paintings with such oneness of purpose that he was virtually burned out when they were completed late in 1967. He sank all his energies into them, and now, quite suddenly, he seemed to have lost his *raison d'etre*. At that point Rothko had said in paint what he had to say, and anything further was either superfluous or repetitive, yet he persisted. . . . Mark himself readily agreed that most of his paintings, if not strictly religious, were related to realms of the spirit and conceived as a contemplative experience. (Kuh 2006, 163–64)

Morton Feldman and *Rothko Chapel*

American composer Morton Feldman (1926–1987) attended the opening of the Rothko Chapel in 1971. Like some other composers of his time, such as John Cage, Earle Brown, David Tudor, and Christian Wolff, he was drawn to the art of abstract expressionist painters, such as Robert Rauschenberg, Jackson Pollock, Philip Guston, Willem De Koonig, Franz Kline, Robert Motherwell, and Mark Rothko. They, along with poets, dancers, and sculptors who shared similar ideas and approaches, were labeled the New York School from around 1943 to 1967. Cage and Motherwell served as coeditors of the journal *Possibilities*, which explored abstract expressionism across the

arts. Members of this group frequently met at the Cedar Tavern or at The Club on East Eighth Street in New York City. Of the art he experienced, Feldman wrote, "The new painting made me desirous of a sound world more direct, more immediate, more physical than anything that had existed heretofore" (Feldman 1985).

Feldman composed music for the 1951 Hans Namuth documentary about the process of drip-painting at the request of Jackson Pollock. He also composed a soundtrack for Namuth's documentary De Kooning (1963). Feldman wrote several compositions that referred to artists in their titles; these include Piano Piece (to Philip Guston) (1963), For Franz Kline (1962), and For Frank O'Hara (1973).

Feldman and Rothko were friends. Feldman noted,

> On numerous occasions we went together to the Metropolitan, where his favorite haunts were, surprisingly, not the painting galleries, but the Near Eastern collection and especially a small room of Greco-Roman sculpture. Rothko always followed through his reaction to something that would catch his attention with a brief, reflective commentary. I remember his absorption one afternoon with the Greco-Roman sculpture: "How simple it would be if we all used the same—dimension—the way these sculptures here resemble each other in height, stand, and the distance between one foot and the other." . . . It is not form that floats the painting, but Rothko's finding that particular scale which suspends all proportions in equilibrium. (Feldman 1985, 137)

At the opening of the chapel, Feldman was asked to compose a work as a musical tribute to Rothko. That work would be premiered a year later.

Morton Feldman was the son of Ukrainian American parents and grew up in Queens, New York. He worked for the family's garment business for much of life and later became a music professor at SUNY Buffalo. He studied composition with Stephan Wolpe; he knew and worked for a while with the experimental ideas of John Cage. Feldman rejected much about musical composition, including the work of "tonal" composers whom he thought wrote music to please audiences, university composers whom he thought geared their music toward their colleagues, and composers who "invented" new music for esoteric and elite audiences at festivals. Feldman was one of several composers who in some works broke away from traditional musical notation on a staff and instead created graphic notation. He was appointed professor of music at SUNY Buffalo in 1972 but always maintained his belief that composition could not be taught.

Feldman's Sound Events

In general, his music is extremely slow and extremely soft. Feldman was interested in pure sound and the element of time in his music, particularly in his late works. The phrase *sound events* is sometimes used to describe Feldman's approach. A sound event refers to pure sound—tonal colors—set apart from one another by time and resonance so that they are not heard by the listener as being in association with one another. The sounds essentially stand alone and are separated by resonant space. John Cage reflected in his book *Silence*,

> And in connection with musical continuity, Cowell remarked at the New School before a concert of works by Christian Wolff, Earle Brown, Morton Feldman, and myself, that here were four composers who were getting rid of glue. That is: Where people had felt the necessity to stick sounds together to make a continuity, we four felt the opposite necessity to get rid of the glue so that sounds would be themselves. (Cage 1985, 71)

Feldman composed the work *Rothko Chapel* for percussion, celesta, viola, wordless chorus, and soprano. The piece is characterized by slow-moving pure sound—pure tonal color—sparse textures, and wordless singing. As visitors to the chapel look at the color, texture, pure paint, and pigment of Rothko's painting, listeners of this work hear pure sound created by long chords, resonant space, and the repetition of patterns.

This piece calls for a very unusual combination of instruments. Although the instrumentation is limited, Feldman often grouped certain instruments together to create specific timbres, or tone colors. These groups include combinations, such as the choir with chimes and the timpani with the bass drum. The viola solos frame the piece. The choir sings block chords on a hum—like the dark colors of Rothko's paintings. The vocal soloists also sing without words. The piece is sectional, slowly guiding the listener from section to section as if looking at Rothko's paintings one at a time. The violist moves within the piece from one physical location to another, heightening the sense of physical space. The sense of time and resonant space is in and of itself expressive.

Feldman reflected on this piece,

> To a large degree, my choice of instruments (in terms of forces used, balance and timbre) was affected by the space of the chapel as well as the paintings. Rothko's imagery goes right to the edge of his canvas, and I wanted the same effect with the music—that it should permeate the whole octagonal-shaped

room and not be heard from a certain distance. The result is very much what you have in a recording—the sound is closer, more physically with you than in a concert hall. The total rhythm of the paintings as Rothko arranged them created an unbroken continuity. While it was possible with the paintings to reiterate color and scale and still retain dynamic interest, I felt that the music called for a series of highly contrasted merging sections. I envisioned an immobile procession, not unlike the friezes on Greek temples. (Feldman 1985, 141)

The pure sound reflects the huge dark canvases of Rothko's canvases. The music is meditative, and like the physical room for which it was composed, it requires time and space. Listeners have to spend time with the music.

The viola plays an important role in the composition. The warmth and natural range of the instrument reflects the space, but the way Feldman used the instrument was specific. Although the viola frames the piece with solos at the beginning and end, it is the instrument that plays the only distinctive melodic material of the whole piece. The melody played at the end is a quasi-Hebraic one that Feldman had composed as a high school student during World War II. Feldman noted, "Certain intervals throughout the work have the ring of the synagogue" (Feldman 1985, 141). The music is transcendent and echoes the sense of mystery and contemplation created by the chapel itself.

As Rothko set up spatial relationships between the painting and the viewer, Feldman set up relationships between pure sound and the listener. Feldman believed that sounds should breathe. He wrote, "I feel that music should have no vested interests, that you shouldn't know how it's made, that you shouldn't know if there's a system, that you shouldn't know anything about it . . . except that it's some kind of life force that to some degree *really changes your life* . . . if you're into it" (Feldman 1985, 238).

Listen to *Rothko Chapel*, Morton Feldman, http://www.youtube.com/watch?v=D0B74tkxI2I.

Rothko's chapel paintings have inspired many responses expressed through music. The musician Peter Gabriel visited the chapel and wrote a song about his experience called "Fourteen Black Paintings." This coming together of architecture, art, and music is a powerful intersection of various art forms and artists. People from around the world continue to visit the chapel, and the range of responses is as diverse as the visitors themselves.

~

Earle Brown and Alexander Calder

Who's in Control?

By the middle of the twentieth century, composers and artists were experimenting with many elements in art and music. They had broken away from traditional approaches to melody, harmony, rhythm, texture, and color. This breakdown of convention led to the creation of new ideas and approaches to making art and music. Composers and artists were also approaching the element of form in new ways. Within the topic of form emerged the question of control—control versus freedom.

For centuries Western music had relied on a system of musical notation that allowed the composer to tell the performer what and how to play through a series of marks on the page—marks that indicated tempo, instrumentation, clefs, pitch, rhythm, meter, dynamics, and so on. No musical notation is perfect in conveying the wishes of the composer; it is the performer, or "interpreter," who determines how the music will actually be played and ultimately heard by the audience. Composers in the mid-twentieth century explored this issue, and some composed music that forced the dichotomy of control versus freedom. Who decides? American composer Earle Brown (1926–2002) and American artist Alexander Calder (1898–1976) were two such figures in whose work we see and hear this broad question.

Influence of John Cage and the New York School

John Cage was an incredibly prolific composer who experimented with and pushed conventional limits not only through his music but also through his

writings. He was closely associated with other art forms including dance, writing, and painting. Cage worked closely with such composers as Morton Feldman, Christian Wolff, David Tudor, and Earle Brown, and he encouraged them to explore and experiment. These composers were most closely connected between 1950 and 1954.

Over the span of his lifetime, Cage experimented with many concepts and questions, including those related to sound and silence, control and freedom. In 1951, composer Christian Wolff gave Cage an English-language version of the classic Chinese text *I Ching—Book of Changes*. This book contains a system of symbols that serves to determine order within chance events. For Cage, this influenced his compositions beginning in the 1950s in such works as *Imaginary Landscape No. 4* (1951) for twelve radios, each of which was set to a different number, and *Music of Changes* (1951–1952). The title of the latter alludes to the *I Ching* and reflects the fact that Cage's compositional process was derived from this *Book of Changes*; it was premiered by pianist David Tudor in 1951.

Cage made clear the difference between the concepts of "chance" and "indeterminacy" in the compositional process. Chance involves something random in the composition of a piece—rolling dice, for example. Indeterminacy, on the other hand, refers to a style of composition in which the composer creates and notates concrete material that can be played in a multitude of ways based on the choices made by other people. The decisions regarding how this music is played is shared with the performers, who help determine exactly what the final musical product will be. The final composition is determined by the choices they make.

Earle Brown—Chance or Choice?

Earle Brown started out in jazz and later studied trumpet and musical composition. He remained interested in jazz throughout his life. There is a sense of freedom in jazz improvisation—freedom within a structure or on specific material, such as a chord progression. Brown explored the notion of freedom in music as well as the question of how music is created and who creates it. He considered the idea of freedom in music but within a predetermined and precise structure.

He was one of four composers who were grouped together (along with John Cage, Christian Wolff, and Morton Feldman) and later labeled the New York School. Feldman said, "Each of us in his own way contributed to a concept of music in which various elements (rhythm, pitch, dynamics, etc.) were de-controlled. Because this music was not 'fixed,' it could not

be notated in the old way. Each new thought, each new idea within this thought, suggested its own notation" (Feldman 1985, 48). These composers experimented with many new ideas. For example, *time notation* was developed by Brown specifically, and introducing *open form* was also one of his great achievements. Along with these new ideas came a rethinking of form in music and who defines it—the composer or the conductor/performer who is the "interpreter." Brown, who also painted and experimented with various compositional techniques, was greatly influenced by the art of Jackson Pollock and Alexander Calder.

Brown's approach to form was one in which he gave musicians choices to make in performing the music. Some associated this with the idea of "chance," however it is really "choice" that determines the final performance. By giving performers choices in the music making, their role goes beyond that of "interpreter" and brings them into the creative process by giving them a voice in the process of composing. The concrete material was created by Brown, but some decisions on how it was to be performed was left to the performers.

One of the composer's boldest pieces involving "indeterminacy" is his work "December 1952" (from *Folio*), which was noted in graphic notation— traditional notation is completely absent and instead the composer's score is comprised of short lines of varying lengths and thicknesses in either horizontal or vertical alignment. To the eye, the score looks more like a visual artwork than a musical score. The composer gave little concrete information about how this piece was to be performed. He included notes that explained that the piece was composed for "one or more instruments and/or sound producing media," which left even the instrumentation open. He continued saying that the score could be "performed in any direction from any point in the defined space for any length of time and may be performed from any of the four rotational positions in any sequence" (quoted in Morgan 1991, 367–68). In one sense, this leaves much to chance; however, the final performance is a result of the *choices* made by the performers. Brown still "composed" the music, however the final composition is determined through the decisions the performers make. As a result, the performers become part of not just the final "product" but also the compositional process.

Brown's composition *Music for Cello and Piano* (1954–1955) is an example of time notation in which he gave specific pitches and instructions for dynamics (relative loud and soft) but gave vague suggestions regarding time. He did this by suggesting note lengths visually rather than through specific instructions regarding tempo and meter. The determination of time is left open to interpretation. In doing this, each performance is different

depending upon the performers and the decisions they make. Brown wrote about the notation used in this score,

> The kind of rhythm which I was, and am, trying to achieve is one which is independent of the rhythmic patterns and relationships upon which standard notation is based. This intention then is technically achieved most effectively by creating widely varied time-duration relationships rather than by highly complicated and necessarily limited sub-divisions of note values. (Brown 1954)

Listen to *Music for Cello and Piano*, 1954–1955, Earle Brown, http://www.youtube.com/watch?v=gZwjB86YA3M.

Open Forms and Kinetic Art

Earle Brown was influenced by the art of Alexander Calder. He was a composer who approached the element of form as something that was variable or open—like the mobiles and stabiles of Calder. One of the best examples of this is the composer's *Available Forms I* (1961), a score for eighteen performers in which he notated specific musical material that he referred to as "events" in six unbound pages. According to Brown, the conductor determines not just the tempo and dynamics but also the order of "events," giving him or her specific choices to make. These choices go beyond the interpretation of notation, and they include choices regarding tempo, dynamics, *and* form. In this work, the creative process and certain decisions are shared by both the composer and the conductor.

Similar concepts are explored in Brown's *Available Forms II* (1962), which requires a large orchestra that is divided into two ensembles, each with its own conductor. Each player is given a copy of the score, which consists of several unbound pages and, like *Available Forms I*, has several musical "events" notated. The order of the "events" is determined by the conductor, but within these "events," durations are approximated. The pitches are specific in some places and are merely suggested in others by ambiguous lines, which suggest just the general contour.

Earle Brown gave performance instructions in his *Novara* (1962) "Directions for Performance—Preliminary Notes," in which he also reflected upon the influence of Calder. He wrote,

> Spontaneous decisions in the performance of a work and the possibility of the composed elements being "mobile" have been of primary interest to me for

some time. . . . For me, the concept of the elements being mobile was inspired by the mobiles of Alexander Calder, in which, similar to this work, there are basic units subject to innumerable different relationships or forms. The concept of the work being conducted and formed spontaneously in performance was originally inspired by the "action-painting" techniques and works of Jackson Pollock in the late 1940s, in which, the immediacy and directness of "contact" with the material is of great importance and produces such an intensity in the working and in the result. The performance conditions of these works are similar to a painter working spontaneously with a given palette. (Brown 1962)

Alexander Calder

American sculptor and painter Alexander Calder was born in Pennsylvania to a family of artists. He was a pioneer in kinetic arts and was considered to be the inventor of the mobile. Both his grandfather and father were sculptors, and his mother was a painter who specialized in portraiture. Both of his parents studied art in Paris and at the Pennsylvania Academy of Art. As a child Calder made small jewelry pieces and toys from metal. However, he studied mechanical engineering in college, and he did not develop a serious interest in art until he was in his early twenties. From 1923 to 1926, he studied painting at the Art Students League in New York City.

In 1924, he became a freelance artist for the *National Police Gazette*, in which he sketched circus performances and sports events. In Calder's autobiography he recalled this time, writing,

> An art dealer, Marie Sterner, had told me to paint athletic events; so with my *Police Gazette* pass in hand, I went to bicycle races and fights. The bike races, the sprints especially, were very funny, with great big fellows trying to stand up motionless on their pedals to later speed by the opponent who had been forced into the lead. I went to the circus, Ringling Brothers and Barnum & Bailey. I spent two full weeks there practically every day and night. I could tell by the music what act was getting on and used to rush to some vantage point. Some acts were better seen from above and others from below. (Calder 1966, 72–73)

Even as a spectator, Calder was interested in movement and in capturing its essence in art.

In 1926, he illustrated his first book, *Animal Sketching*, which is based on sketches he did in New York City at the Central Park Zoo and the Bronx Zoo. These depicted animals in motion with text by the artist. Even his early sketches had a strong sense of movement, which was created with one single unbroken line. He went on to make wire sculptures that appeared as line drawings in space.

From 1926 to 1927, Calder visited Paris, during which time he created a whimsical miniature circus and brought it to life in performances he gave to audiences of the Parisian avant-garde. He made each circus character with his hands, and he gave them both movement and voice. His circus performers included a huge array of figures in constant motion—from human characters to a menagerie of animals, including a man-eating lion and chariot races with running horses. There were the usual acrobats and the flying trapeze, as well as a belly dancer, a weight lifter, and a character that blew up a real balloon. During the performances, which were held in his studio, he would get down on the floor on his hands and knees and bring the spectacle to life by putting his characters in motion. He would blow a whistle to mark sections of the performance and narrate while his wife took charge of the circus music by winding up a gramophone offstage. Once Calder put the charming characters into action, their movement took off, and they came to life. Calder always carried the miniature circus with him when he traveled. He took it along in five suitcases, each marked "Calder" in large print on the side.

Look at and listen to "Calder Le Cirque," Alexander Calder, http://www.youtube.com/watch?v=MWS96nzFUks.

Calder divided his time between Paris and the United States. He became friends with Miró, and he admired the sense of fantasy in the works of Miró and Klee. In the 1930s, Calder was the key figure in the development of mobile sculptures, which are referred to as "mobiles." His earliest mobiles were moved by motor power or by hand. In 1943, he began to make mobiles that were not powered. These were made of pieces of painted tin, and they were hung from thin wires or cords. He was interested in the concepts of balance and response to the natural environment. These mobiles were designed to move with even the most subtle and unpredictable movement of air. This invited elements of process and chance into the work itself, as it was always changing and it was dependent upon elements in the environment. Calder described them as "four dimensional drawings."

He borrowed organic shapes from paintings by Miró and built mobiles from these shapes. Such works as *Red Petals* (1942) create a sense of open form through the repetition of leaf shapes balancing on wire tendrils moving in space. His work *Lobster Trap and Fish Tail*, which measures 8'6" by 9'6", suggests the sea creature's motion in the water. These works are constantly

changing, and they possess a sense of freedom inherent in the possibility of movement. This natural movement creates a sense of "time."

Look at *Lobster Trap and Fish Tail*, 1939, Alexander Calder, http://www. moma.org/collection_images/resized/687/w500h420/CRI_211687. jpg.

Calder achieved great success during his life, and he contributed to the arts in myriad ways. In 1952, he won the first prize for sculpture at the Venice Biennale. After this he worked on many public commissions in the United States and abroad. He is primarily remembered for his mobiles and stabiles— art that requires space and time. It was his work in this area that introduced the element of movement into the world of serious art.

Calder was incredibly versatile, and he worked in other areas of the arts, including jewelry design, textile design, and printmaking. Always interested in movement, he produced performance settings and collaborated in other disciplines with such people as dancer-choreographer Martha Graham. These performance settings were referred to as "plastic interludes" and consisted of spirals and circles "performing" onstage during intermissions of Graham's ballets. Later in his life, he created set designs and costumes for dance and theater productions. He enjoyed an international reputation, traveled extensively, and installed many public commissions.

Calder Piece and *Chef D'Orchestre*

The influence of Calder is manifested in Brown's composition *Calder Piece* (1963–1966) for four percussionists and mobile—not any mobile but a mobile "expressly made for this work" by Calder called *Chef D'Orchestre*. In the program notes to the score, Brown described how this composition came to be. He wrote,

> Those who are familiar with my work are aware that the original impulse and influence that led me to create "open form" works (which, in 1952, I called "mobile" compositions) came from observing and reflecting upon the mobiles of Alexander Calder. I later met Calder at his home in Connecticut (in 1953) and he therefore knew of my work and my indebtedness to his concept and work. In Paris I began the work for the quartet with the idea that it would be

"conducted" by a mobile in the center of the space with the four percussionists placed equidistantly around it, the varying configurations of the elements of the mobile being "read" by the performers and the evolving "open form" of each performance different and changing perspectives in relation to it. Calder was immediately intrigued and excited by the idea. (Brown 2007)

Chef d'Orchestre is literally a mobile—a playable mobile that essentially functions as the conductor (see figure 9.1). Like a conductor, its movements are what determine when and how the musicians "play" it. This work was commissioned by the Percussion Quartet of Paris, and it was premiered in Paris in 1967 at the *Theatre de L'Atelier*. According to Claude Rostand, a writer for *Le Figaro*,

> The dialogue between sound and color is established. Not an approximate and vague one between the sensibilities as it may already have existed in the past, but a dialogue which goes to the root of things, to the very functional. A symbolic illustration of this has been offered us with this work of Earle Brown, where the conductor is of a new sort, a mobile by Calder, the movements of which determine the actions of the musicians. (Rostand 1967)

Brown continued in the program notes, "In addition to the mobile functioning as a conductor, the musicians actually use it as an instrument. One is not conditioned to tolerate the striking of a work of art and the sounds of breath-holding could be heard in the audience when the musicians first approached and played the mobile" (Brown 2007). One of Calder's slightly disappointed comments after that first performance was, "I thought that you were going to hit it much harder—with hammers." Brown concluded his program notes with the statement "The piece is one of a kind, and the music must never be independent of that particular mobile. It is my very deeply felt homage to 'one of a kind' Sandy Calder and to his life and work" (Brown 2007).

Cage and Calder

John Cage wrote music for a film about Calder. *Works of Calder*, which premiered in 1951, was a short film of just twenty minutes by made by Herbert Matter. The film includes footage of the artist at work in his studio. It points out that movement is all around us, from the wind that makes everything move to the sun and the water. Viewers of the film learn that Calder made his mobiles out of many things, from tin and wood to steel and wire, and that they moved by themselves. For composer John Cage, those materials became musical instruments as well as art objects.

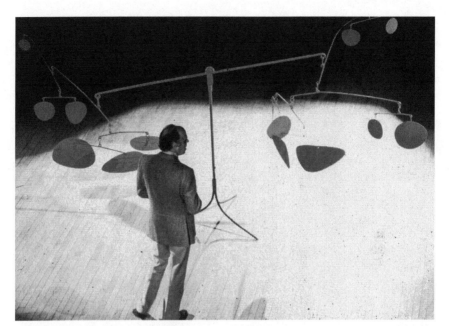

Figure 9.1. Earle Brown with Calder Mobile, *Chef d'Orchestre*, 4.5 × 3 in. Courtesy of the Earle Brown Music Foundation.

The music that Cage composed for the film was for prepared piano and magnetic tape. Prepared piano refers to a traditional piano that is "prepared" in such a way that its natural sound is altered through the use of strips of materials, such as rubber or paper, inserted across strings; the use of metal bolts attached to strings; and/or "retuning" the piano. Like Calder, who used such common materials as tin and steel, Cage used everyday objects to manipulate the sound of the piano. As a result, it is often difficult to identify the sound as that of a piano because it sounds much more like a percussion ensemble. The first and last sequence in the film feature music for prepared piano. The sonorities range from still single notes followed by resonant space to simple intervals to short motifs. Rhythm moves from stillness and quiet to spurts of rapid motion filled with repetition followed by contrasting moments of silence.

The middle sequence is for magnetic tape, which captures the music of the mobiles. Cage recorded this material while Calder worked in his studio; the tape features real sounds from the artist's studio. As the mobiles bumped against one another, they created their own music, which held percussive timbres not unlike the sections for prepared piano. Cage's idea was that

the music—the literal sounds in Calder's studio—is relevant to what one is seeing. In his "A Few Ideas about Music and Film," Cage wrote about this music, "Rhythmically composed sequences suggest a parallel between familiar forms and movements in nature and the movements of Calder's mobiles" (Cage 1951). Cage's score was awarded first prize at the Woodstock Art Film Festival in 1951.

Earle Brown, too, spoke about being influenced by the work of artists, including Alexander Calder. In Calder's floating and precise yet unpredictable mobiles and stabiles, he saw possibilities. How might such ideas be realized in sound? Through Brown's music using indeterminate compositional techniques and open forms, he offered open-ended possibilities in sound.

~

John Cage and Robert Rauschenberg

Life of Art—Art of Life

John Cage (1912–1992) said, "I had early seen that musicians were the people who didn't like me. But the painters did. The people who came to the concerts which I organized were very rarely musicians—either performing or composing. The audience was made up of people interested in painting and sculpture" (quoted in Pritchett 1993, 141). One of the artists with whom Cage became friends was Robert Rauschenberg (1925–2008). Rauschenberg reflected on their relationship, saying that he and Cage were soul mates both spiritually and philosophically. This strong connection informed their individual works as well as their many collaborative projects throughout their lives.

Cage was a major American avant-garde composer of the twentieth century, but he was more than that. He was also a writer, lecturer, philosopher, and prolific collaborator whose creative output embraced numerous artistic disciplines. Among his many collaborative projects were those he did with dancer-choreographer and personal partner Merce Cunningham, whom he had met while working as a composer and dance accompanist in the late 1930s in Seattle. Cage would later compose many pieces of music to accompany the pieces of Cunningham as well as other dancers. During his life he also created numerous visual works, including paintings, prints, etchings, photographs, and monotypes.

Black Mountain College in North Carolina was an important place in the lives of Cage, Rauschenberg, and Cunningham. It was an innovative college that reflected the ideas of philosopher and educational reformer John Dewey,

who is considered to be the founder of the progressive education movement and who wrote extensively about education, art, and inquiry; his book *Art as Experience* (1934), among many others, continues to resonate today. Central to the mission of the college was the belief that the arts should be at the core of a liberal arts education. Although the college was in existence for just twenty-four years (1933–1957), it brought together visionary artists from the worlds of music, choreography, visual art, poetry, and design. It was experimental and interdisciplinary by design. Both faculty and students contributed to innovative projects and events. Many collaborations created by Cage, Rauschenberg, and Cunningham were born out of their experience at Black Mountain College. One such collaboration was the first "happening"—an event that featured multiple art forms and involved the audience in new ways.

Robert Rauschenberg

Robert Rauschenberg was born in Texas of German and Cherokee descent. He studied under artist Joseph Albers at Black Mountain College in North Carolina, where he became both a friend of and collaborator with John Cage. Like Cage, he was a philosopher as well as an artist. In his art he explored the boundaries between art and life, and in doing so, he sought to combine art with elements of the everyday experience. Throughout his life he collaborated across artistic disciplines, working with composers, artists, choreographers, printmakers, papermakers, and so on. He even did theater designs for choreographers, including Merce Cunningham and Paul Taylor.

Like Cage, Rauschenberg was constantly experimenting with and exploring broad issues, such as the relationship between art and the everyday and the basic question of what art is. He challenged the viewer to look differently, to see differently, and to make meaning differently. In some of his work, he used sequences of layered images—layers that "moved" back and forth and required the viewer to look in a new way. This approach has been compared to a musical composition by Cage that was written for an "ensemble" of many television sets all tuned in to different channels working simultaneously. The challenge for the listener and viewer was enormous and required new and multidimensional ways of listening and looking. Both Cage and Rauschenberg would test and push the limits of art.

Rauschenberg moved to New York City and had his first show there in 1951. In the early 1950s, Rauschenberg created a series of monochrome paintings. His series of "White Paintings" (1951) were created with basic

white house paint applied with a roller to canvas. These paintings, which had a smooth surface, were done on rectangle and square panels and were grouped in various configurations.

These were followed by his "Black Paintings" (1951–1953). In these, Rauschenberg worked with newspaper as well as with black paint. The artist placed newspaper comics that he tore up and made into strips and lumps and put on the canvas. He then painted over the entire surface with black paint, allowing just a few glimmers of the newsprint to show through. In some places the paint and newspaper is two to three inches deep, creating a very dense texture. In his "Red Paintings" (1953–1954), he went further in his use of materials and added pieces of wood, nails, and fabric to the paint.

His work of the 1950s and '60s reflected the urban culture of the streets of New York City. He would walk the streets looking for objects to incorporate in his art. In these "found objects" he saw beauty and possibilities. The works that Rauschenberg created using found objects are referred to as *combines*—essentially paintings with objects meshed into the surface. Technically this term refers to his work between 1954 and 1962, when he started using collage techniques in which he utilized objects from everyday life. From these objects, or what some might call trash, he created art that he believed filled the gap between art and life. These followed his monochrome paintings and were created with not just paint but with the addition of an array of objects, such as nails, fabric, wood, and so on.

Representative works from these years include *Collection* (1954) and *Charlene* (1954). The latter is nine feet high. It was made with oil paint and collage with postcards, comics, cloth, wood, part of an undershirt, and mirrors—a great variety of materials resulting in highly contrasting textures. It was the first work in which he combined and balanced painting, collage, and found objects. In his combines, Rauschenberg collaborated with his environment, finding inspiration, beauty, and possibilities from everyday objects and even trash, including scarves, paint, newspaper headline clippings, comics, fabric, cartons, broken objects, once-loved stuffed animals, and even exposed canvas. The artist never attempted to repair or improve any of these objects; they were simply part of life and ultimately part of his art. Rauschenberg's work *Bed* (1954) is one of the boldest examples of his use of everyday objects and of connecting art with life. The work was made with oil paint, pencil, sheets, quilt, and pillow. Urban legend rumors that he used his own bedding because he did not have enough money to purchase art supplies. Rauschenberg said, "A picture is more like the real world when it is made from the real world" (quoted in Kotz 2004, 16).

Look at *Charlene*, 1954, Robert Rauschenberg, http://ericlittman.com/ populart/images/rauschenberg_charlene_1954.jpg.

In 1961, Cage wrote an article called "On Robert Rauschenberg, Artist and His Work," which was first published in *Metro* (Milan). He wrote about his friend and the way his use of found objects was part of the way he connected art with everyday life. Cage wrote,

> There is in Rauschenberg, between him and what he picks up to use, the quality of encounter. For the first time, if, as happens, there is a series of paintings containing such and such a material, it is as though the encounter was extended into a visit on the part of the stranger (who is divine). (In this way societies uninformed by artists coagulate their experiences into modes of communication in order to make mistakes.) Shortly the stranger leaves, leaving the door open. . . . Having made the empty canvases (*A canvas is never empty.*), Rauschenberg became the giver of gifts. (Cage 103)

Cage continued, "*Painting relates to both art and life. Neither can be made. (I try to act in that gap between the two.)* The nothingness in between is where for no reason at all every practical thing that one actually takes the time to do so stirs up the dregs that they're no longer sitting as we thought on the bottom. All you need do is stretch canvas, make markings, and join" (Cage 105).

John Cage

As Rauschenberg experimented with the inclusion of objects from the everyday, Cage explored the same idea in music. In music, the idea of found objects or materials from everyday life had a counterpart in sounds and noises from daily life—the sounds of automobiles, nature, appliances at work, laughing, coughing, and so on. As Rauschenberg created art from the everyday, Cage made music from the sounds of the everyday.

In his talk "The Future of Music: Credo," which he delivered in 1937, Cage said,

> Wherever we are, what we hear is mostly noise. When we ignore it, it disturbs us. When we listen to it, we find it fascinating. The sound of a truck at fifty miles per hour. Static between the stations. Rain. We want to capture and control these sounds, to use them not as sound effects but as musical instruments. Every film studio has a library of "sound effects" recorded on film. With

a film phonograph it is now possible to control the amplitude and frequency of any one of these sounds and to give it rhythms within or beyond the reach of the imagination. Given four film phonographs, we can compose and perform a quartet for explosive motor, wind, heartbeat, and landslide. (Cage 1937, 3)

Prepared Piano

In addition to composing music using the sounds of daily life, Cage wrote music that treated traditional musical instruments in new and unconventional ways. The piano is a traditional instrument in Western music; however when it was "prepared" according to a set of instructions, it was capable of new sounds. The idea of "prepared piano" was one that Cage explored along with composer Henry Cowell.

As a young composer and dance accompanist at the Cornish School in Seattle, Cage was introduced to the idea of writing for percussion ensemble through the world of dance, essentially using the dancers as musicians. In 1938, Cage was approached by a dancer to compose a piece for percussion ensemble, however the hall where the performance was to take place was too small for an ensemble. It was then that Cage drew upon the music of his former teacher Henry Cowell and started composing for prepared piano.

The result was an "instrument" that sounded nothing like the traditional piano. Cage, however, pushed the boundary of what a piano could do and what a piano could sound like. In his music for prepared piano, he prescribed a series of very specific preparations in which the sound of the piano would be dramatically changed. This could include many things, including changing the tuning as well as inserting into the instrument objects from daily life, such as bolts, screws, nuts, coins, rubber, weather stripping, and bamboo strips. He also required the performer to use techniques, such as plucking the strings or muting the strings by hand. In doing so, the sound of this traditional instrument became something completely new and often hard to identify. Frequently the prepared piano sounded like a percussion ensemble.

Cage started writing for prepared piano in the 1940s. He wrote many such works, including those for solo piano, ensembles, and even film. Many of these were composed to accompany dance with collaborators. His piece *Our Spring Will Come* (1943) was composed for a work by Pearl Primus, who was a dancer-choreographer and pioneer of African dance in the United States. In this piece Cage called for the use of screws, nuts, and bamboo strips. The performance of the work included a reading of the words of poet Langston Hughes, whose poem of the same name is about the African American experience. Works for Merce Cunningham include *The Unavailable Memory of*, *Spontaneous Earth*,

Root of an Unfocus, A Valentine Out of Season, and *Tossed as It Is Untroubled,* all of which were composed in 1944.

Listen to *Our Spring Will Come,* 1943, John Cage, http://youtu.be/ DoItL4K0Q7g.

Film collaborations included *Dreams That Money Can Buy,* a 1947 surrealist film by Hans Richter. Segments of the film were designed by different artists, and Cage composed music for the segment designed by artist Marcel Duchamp. This was an early project in which Cage started to explore the idea of silence. Another film work was *Works for Calder,* a short piece on the work of Alexander Calder. Cage's music for this film was composed in three sections, the first and third of which are for prepared piano. The second section is comprised of recorded sounds from Calder's studio. These sounds are quite literally the "music" of the mobiles themselves—the "noise" created by the artist's mobiles bumping into one another.

In the mid-1940s, Cage became interested in Eastern philosophy and aesthetics influenced by India and Japan, as well as Hinduism and the study of Zen Buddhism, at Columbia University. These influences had a strong impact on his approach to music and to life. This became significant in his work after he became familiar with *I Ching,* the Chinese *Book of Changes* in 1950. In 1949, Cage gave his famous "Lecture on Nothing" at the Artist's Club on Eighth Street in New York City, a club that was started by artist Robert Motherwell. In his foreword to his book *Silence,* which is a collection of lectures and writings by the composer, Cage wrote,

This "Lecture on Nothing" was written in the same rhythmic structure I employed at that time in my musical compositions (*Sonatas and Interludes, Three Dances,* etc.). One of the structural divisions was the repetition, some fourteen times, of a single page in which occurred the refrain "If anyone is sleepy let him go to sleep." . . . Later during the question period, I gave one of six previously prepared answers regardless of the question asked. This was a reflection of my engagement in Zen. (Cage 1985, ix)

Rauschenberg's "White Paintings"

In 1951, Rauschenberg created the famous "White Paintings." He simply applied regular white house paint to a canvas with a conventional paint roller,

creating an even and smooth surface. The artist reflected on these, saying that he found them to be very sensitive. He said, "One could look at them and almost see how many people were in the room by the shadows cast, or what the time of day was" (quoted in Kotz 2004, 76). They were first shown as part of a "happening" referred to as "The Event" at Black Mountain College in 1952. This "event" featured Cage's *Theater Piece No. 1*. In this performance, four panels of Rauschenberg's "White Paintings" appeared in the shape of a cross and were suspended from the ceiling.

The "White Paintings" were later exhibited in New York City in 1953 at the Stable Gallery. These were canvases that were simply painted white—seemingly nothing. However, when one really looks at them, there is interplay with what is around them—light, shadow, texture—ever changing depending upon who is in the room, the light, movement, and so on. The artist's goal in these works was to reduce a painting to its most basic essence. The "White Paintings" caused an uproar in the art world because they challenged the viewer's assumptions about what a painting can be. They challenged one's sense of expectation, and they required the viewer to push and perhaps question his or her own understanding of what constitutes a work of art. At what point is nothing something and something nothing?

In an interview, Rauschenberg referred to the "White Paintings" as "icons of eccentricity." He continued, "They didn't fit into the art world at that time. . . . I did them to see how far you could push an object and yet it still mean something. . . . There was a kind of courage that was built into them, in their uniqueness, in their individuality" (quoted in Interview at www. sfmoma.org). Cage referred to Rauschenberg's paintings as "poetry of *infinite possibilities*" (Cage 103).

Cage Responded

John Cage wrote a piece of music in direct response to the "White Paintings." The composer made this very clear when he wrote, "To Whom It May Concern: The white paintings came first; my silent piece came later.—J. C." (Cage 98). Rauschenberg's "White Paintings" begged the question, What is art? Cage challenged people to consider broad questions, such as, What is music? with his piece *4'33"* (1952). This composition was first performed by David Tudor. During the premier, the pianist went to the piano and prepared to play, however during the "performance" of this piece, not a single note was played. Rather the performer remained still for *4'33"*. Is there music? Is there silence? Is there anything? Is there nothing? Cage used this piece to suggest that there is no true "silence." During "performances" of *4'33"* the sounds

of everyday—the restless sounds and motions of a baffled and perhaps even irritated audience, a cough, the sound of a door, sounds from outside, and white noise are the "music."

This piece was a direct response to Rauschenberg's "White Paintings." In an interview, Cage said he always believed "there should be a piece that had no sound in it, but I hadn't yet written it, and the thing that gave me the courage to do it finally was seeing the quite empty paintings of Bob Rauschenberg to which I responded immediately." He went on to describe Rauschenberg's paintings as "mirrors of the air" and "airports for lights, shadows, and particles" (quoted in Interview at www.sfmoma). He wrote, "The white paintings caught whatever fell on them" (Cage 108). Ultimately it was the presence of the people, lights, and objects of the world beyond the paintings that created the paintings and the changing movement within them.

Similarly, in 4'33", Cage abandoned traditional elements of music, such as organized and scripted pitch, melody, harmony, rhythm, timbre, texture, and so on and left only silence. That "silence" is filled by the sounds of the people in the room, the sounds from outside, and others. He described the composition as "silences put together. . . . It seems idiotic . . . but that's what I did." He continued, saying that the piece "can be any length so that we can listen at any time to what there is to hear, and I do that with great pleasure and often" (quoted in Interview www.sfmoma.org). Rauschenberg's "White Paintings" and Cage's 4'33"—the empty and silent works—were imbued with "gifts" from their environment.

A Trophy for Cage

Rauschenberg noted that to Cage all sound was music. The artist made a series of "trophies," which were works dedicated to fellow artists as a way to both thank and acknowledge them. He made five trophies: *Trophy I* (1959) for dancer-choreographer Merce Cunningham; *Trophy II* (1960) for painter Marcel Duchamp and his wife, Teeny; *Trophy III* (1961) for sculptor Jean Tinguely; *Trophy IV* (1961) for John Cage; and *Trophy V* (1962) for painter Jasper Johns.

In these works Rauschenberg used a wide variety of materials, and he frequently included allusions to the lives and works of these people, as well as his relationship with these artists. For example, in his *Trophy I (for Merce Cunningham)* (1959), Rauschenberg combined oil paint and collage. To honor his friend and frequent collaborator, the artist included a photo of Cunningham and under it a metal sign that reads "Caution, Watch Your Step."

Rauschenberg created *Trophy IV* (1961) for his friend John Cage. This work is a sculpture featuring a moveable old boot that, when moved by hand, kicks a piece of bent metal and ultimately makes a noise. The actual sound depends upon who moves the boot, how hard they move it, how fast they move it, the acoustics of the room, and so on. The sound could be loud or soft or bright or mellow or rhythmic or fast or slow or silent. Cage would understand. It's all music.

Cage–Rauschenberg Collaborations

Collaborations were numerous. In 1952, Cage's collaborative *Theater Piece No. 1* was staged at Black Mountain College. This was the first of what were to be referred to as "happenings." It was a multimedia event that drew upon the participation of other artists-in-residence, including Merce Cunningham, David Tudor, and Rauschenberg. In this "happening," multiple and completely disconnected events took place at the same time. These "events" included Cage delivering a lecture from a ladder, Cunningham dancing, Tudor playing Cage's score, poetry readings, and Rauschenberg playing records on an old Victrola while images were projected onto four panels of his "White Paintings," which were suspended from the ceiling in the shape of a cross.

Rauschenberg, Cage, and Cunningham worked together for more than a decade. Rauschenberg said, "I felt more at home with the discipline and dedication of those dancers than I did in painting." He also said, "The idea of having your own body and its activity be the material—that was really tempting" (quoted in Kotz 2004, 115). For these three men, music, art, and dance were separate but took place at the same time as in "The Event" at Black Mountain College. They worked collaboratively, but each artist was free to create his own independent work within the collaboration.

Minutiea

Rauschenberg's *Minutiea* (1954) is a free-standing combine comprised of paint, collage, and objects. He created this for Merce Cunningham's dance of the same name with music by John Cage. This marked the beginning of a decade-long collaboration with the Merce Cunningham Dance Company, for which Rauschenberg would design sets, costumes, and even lighting. Similar to Cage's and Rauschenberg's interest in the everyday, Cunningham incorporated everyday movements into his dance. With the Cage–Cunningham–Rauschenberg collaboration, the Merce Cunningham Dance Company

would gain international success and become a leading company in the world of postmodern dance.

In 1966, Cage and Rauschenberg were among ten New York artists and thirty engineers and scientists of the Bell Telephone Laboratories who collaborated on a large-scale series of inventive performances of music, dance, and theater. Known as "9 Evenings: Theater and Engineering," these events took place at the Sixty-ninth Regiment Armory in New York City. This encouraged further collaborations between art and technology. In 1977, he collaborated with John Cage and Merce Cunningham once again in *Travelogue*, for which Rauschenberg created the set and costume designs.

Of Art and Life

As friends and collaborators, Rauschenberg and Cage shared many ideas about art and life. In 1957, Cage addressed the conference of the Music Teachers National Association in Chicago. His lecture was called "Experimental Music," and in it he said,

> And what is the purpose of writing music? One is, of course, not dealing with purposes but dealing with sounds. Or the answer must take the form of a paradox: a purposeful purposelessness or a purposeless play. This play, however, is an affirmation of life—not an attempt to bring order out of chaos nor to suggest improvements in creation, but simply a way of waking up to the very life we're living, which is so excellent once one gets one's mind and one's desires out of its way and lets it act of its own accord. (Cage 12)

For both Cage and Rauschenberg, creating art—both visual and musical—was about the journey of process and discovery and ultimately about living life.

PART III

~

INTERLUDE 2

Shared Inspiration
and Influence across Domains

The chapters comprising part III address overarching themes and styles that impacted both art and music. In the family of "-isms," we find labels that come from the world of art—impressionism, cubism, and minimalism. For the most part, these terms weaken when applied to music, although in certain musical works, we can identify influences from the visual arts. In the discussion of such composers as Claude Debussy and Igor Stravinsky, however, we also consider the broad range of music they composed and the limits of such labels. Minimalism started in the art world and migrated to music in the works of composers, such as Terry Riley, Steve Reich, Philip Glass, and Arvo Pärt. In these works, both visual and musical, we explore the breadth of possibilities out of limited means.

The chapters in this section also address the influence of broad social and political change on artists. Through the murals of Diego Rivera and the music of Carlos Chávez, we see and hear the story of Mexico and the impact of the revolution on its people. In the art of American painter Georgia O'Keeffe, we see the landscapes and cityscapes of a quickly developing young nation. As we are introduced to the beauty of the southwest and the excitement of New York City through the paintings of O'Keeffe, we are invited to these places in the music of Aaron Copland and Roy Harris. Through common subject matter and stylistic similarities, we find the voices of artists across disciplines that speak of their time and place in the voice of their art.

CHAPTER ELEVEN

~

Claude Debussy
and the Fin-de-Siècle

The fin-de-siècle in Paris was a period of great artistic change and achievement. It was a fertile time for artists who were gradually breaking away from established traditions and forging a path into a new century. Artists across disciplines knew one another. The French café became a popular meeting place for artists, composers, and writers to gather and share ideas. Through three major international expositions in the second half of the nineteenth century, artists across domains would see art and hear music from beyond Europe. This was the era of the famous cabarets of Montmartre depicted in the posters of such artists as Toulouse-Lautrec. Many artists of the time, including Manet and Degas, would depict music making as a subject. The piano often appeared in paintings, perhaps because of its interesting shape and its popularity in the home and the concert hall.

There are some eras in which music and art share a stylistic or descriptive term or label, such as *impressionism* and *expressionism*, for example. The word *impressionism* is used to describe the style of painting created by a group of French artists from the late nineteenth and early twentieth centuries. Some of the seeds of this new style were planted decades earlier. The1860s had been a decade of exchange, influence, debate, and inspiration among bohemians in Paris. The *Café Guerbois* on the Avenue de Clichy in Paris was a regular gathering place for writers and artists, including Claude Monet, Auguste Renoir, Alfred Sisley, Emile Zola, and Edouard Manet.

Manet (1832–1883) was trained in the tradition of classical painting, but he also experimented with new approaches to light and color; new and

sometimes controversial subjects; and new methods of working, such as painting from life rather than in the studio. He used a technique called *alla prima* or "at once," which refers to a painting done in one sitting. This was conducive to *plein air* painting, which requires the artist to capture nature's fleeting subjects, such as a sunrise or sunset, or to paint the impression of a particular atmosphere, such as rain or clouds. In 1863, Manet exhibited his painting *Luncheon on the Grass* (1862–1863) at the *Salon des Refusés* in Paris. This salon was ordered by Napoleon III to give painters whose work had been rejected by the official salon a place to show their work. Manet's painting was controversial and would be among many paintings to follow that would challenge traditional conventions. Over time, Monet and Renoir, along with such artists as Degas, Pissarro, and Cézanne, also rejected traditional approaches to painting, which dictated appropriate subject matter and technique. They broke free from the expectations of established aesthetic values and became key figures in a new style that was to be called impressionism.

In 1869, Monet (1840–1926) and Renoir (1841–1919) painted *La Grenouillere*, a resort on the banks of the Seine River in Paris, complete with a floating café. This would become the first of many outdoor paintings in which open-air scenes, such as landscapes, picnics, boulevards, and especially water, became common. After all, water provided artists a unique opportunity to experiment with light and its effects on water at various times of day. These artists were not interested in light and color in terms of creating a photographic image but rather in the way they interacted to create atmosphere.

Monet focused on color within an object rather than on the object itself. As he developed as an impressionist painter, he began to paint the same scene many times at different times of day or in different seasons in order to explore the impact of natural light. Among the most famous of these works are his paintings of haystacks, poplars, and the façade of Rouen Cathedral, which he painted more than thirty times.

The Birth of Impressionism in Painting

In nineteenth-century France, the government sponsored "official" salons, which were important exhibitions that typically featured the work of established artists as well as that of artists from the prestigious *École des Beaux-Arts* (School of Fine Arts) in Paris. The year 1874 marked the first of several independent exhibitions. This show was organized by the *Société anonyme des peintres, sculpteurs et graveurs* (Anonymous Society of Painters, Sculptors, and Engravers), an independent group of artists that broke away from established tradition. It was here that Monet showed his now-famous

painting *Impression, Sunrise* (see figure 11.1). This painting depicts the port town of Le Havre in northwest France in the early morning hours as the sun rises. Through the foggy atmosphere, the viewer notes the reflection of the rising sun on the water. Since this style of painting was unknown, there was no established vocabulary for viewers to describe it. The word *impression- ism* was first used by art critic Louis Leroy on April 25, 1874, in the French newspaper *Charivari* to describe Monet's painting.

Impressionist painters created new techniques, such as the use of short brushstrokes, unblended colors, and vague forms. Because they relied on the use of short brushstrokes to form tiny patches of color, the human eye rather than the artist's palette was responsible for mixing color. This use of "fragmentation" resulted in paintings that lacked clear, detailed lines. The result is that form is difficult to see when viewed closely but becomes clear and recognizable from a distance.

Debussy scholar Oscar Thompson wrote that the goal of Monet and other impressionist painters, such as Renoir and Pissarro, was to "suggest rather than to depict; to mirror not the object but the emotional reaction to an object; to interpret a fugitive impression rather than to seize upon and fix the permanent reality" (Thompson 1937, 21). The style characteristics of

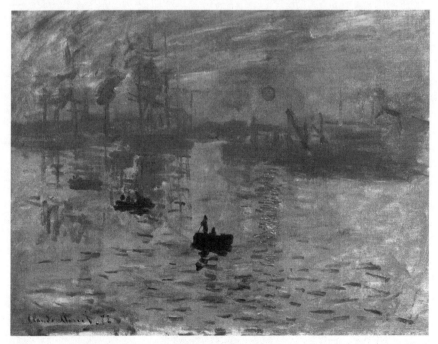

Figure 11.1. Claude Monet, *Impression, Sunrise,* 1872.

impressionistic paintings are certainly evident in many works, including Monet's *Impression, Sunrise*. When looking at this painting, the viewer is impacted by a sense of ambiguity, suggestion, and mood rather than the expression of feeling or narrative. With close analysis, this atmosphere, or "impressionistic style," was created through the careful and mindful combination of characteristic elements in painting.

Influence of Impressionism on Music

Although the term *impressionism* is one that comes from painting, there are some composers from the same time period whose music reflects similar ideas. The use of short brushstrokes in painting had a musical counterpart in the use of short bits of melody in music. Like the brushstrokes, these melodic fragments were integral to the overall structure of the music. The type of descriptive titles used for paintings were also used for some musical compositions. Even subjects, such as light and water, were used as titles of musical compositions. The purpose of looking across disciplines is not to use one to explain another but rather to explore the ways in which some of these new ideas and techniques were embraced in both art and music.

In music, the word *impressionism* suggests a musical composition in which descriptive impressions are created by evoking moods through rich and varied harmonies and tonal colors. Like its visual counterpart, so-called impressionistic music does not seek to express a feeling or tell a story but rather to evoke a mood or atmosphere with the help of suggestive titles and occasional reminiscences of dance rhythms, sounds imitating nature, and characteristic bits of melody. It relies on allusion and understatement.

Claude Debussy (1862–1918) was the composer most associated with impressionism in music. Like all categories of "-isms," such classifications help organize various styles and periods only to a point. Debussy once wrote, "I am trying to do 'something different'—in a way, realities—what the imbeciles call 'impressionism,' a term which is as poorly used as possible, particularly by art critics" (quoted in Schmitz 1966, 13). Whether this was a reaction to the negative use of the word to describe the new style of painting or a true rejection of this idea has been debated for decades. However, what is clear is that both composers and artists were doing "something different." They were breaking away from established expectations and making the way for the dramatic change that would follow in the twentieth century.

Debussy was influenced to a degree by many art forms, including symbolist poetry, as well as by art and music from the East, which he experienced at an international exhibition in Paris. In some of his music, one hears a certain

musical independence that was also being explored in painting. Although Debussy distanced himself from the term *impressionism*, he lived in the same time and place as visual artists, and many viewers and listeners have made connections between the two disciplines during this time period. Like artists of the time, Debussy had a disdain for established rules, and he strove to find a sense of freedom within broad structures. A sense of independence guided him as a composer. The similarities between impressionism in art and music are frequently overstated. However, it is interesting to look across the two disciplines in broad strokes and to focus on a couple of specific works that reflect similar ideas.

Like the brushstrokes of impressionistic painters, Debussy's melodies are frequently very short. They are often essentially brief motives of narrow range—like short brushstrokes of paint on canvas—freely combined to make a musical mosaic out of irregular, varied pieces. Debussy's *Prelude to the Afternoon of a Faune* (1894) is based on a poem by the symbolist poet Stéphane Mallarmé and calls for an orchestra of woodwinds, French horns, strings, percussion, and two harps. In this piece, Debussy highlighted various instruments in solo passages and created unusual timbres through unique combinations. A sense of allusion was achieved by orchestral fragmentation—series of brief but frequent solos, sometimes exploiting an instrument's unusual range—thus creating a broad palette of tone colors. Debussy wrote to a friend, "I am more and more convinced that music is not, in essence, a thing that can be cast into a traditional and fixed form. It is made up of colors and rhythms" (quoted in Fisk 1997, 207).

In addition to this approach to instrumentation, Debussy achieved coloristic effects through his use of harmony—nonfunctional harmony. Until the late nineteenth century, Western harmony was typically approached with the idea that every chord had a specific function—a tonic chord that provided a sense of aural "home" or a dominant chord that pulled the listener's ear in a new direction, for example. However, Debussy often approached harmony in a way described as nonfunctional. Sometimes chord structures that had been used to direct the ear in earlier classical music might be simply used as color—pure sound.

Paris International Expositions and Influence on Art and Music

Both artists and composers were introduced to Asian art and music in Paris in the nineteenth century. The Paris Exposition of 1867 was an enormous fair that featured products, food, and culture from around the world. This event created opportunities for nations to showcase their accomplishments

and traditions and to share them with other countries. It was here and also through reopened trade with Japan (1853) that European artists became familiar with Japanese prints. The word *Japonism* was even coined to describe the influence of Japanese art on the West. Common subjects used by Japanese artists included fish and birds, as well as seascapes and changing atmosphere created by wind and weather. Debussy drew upon this art in the way he chose titles for some of his music. This is reflected in his works, including *Estampes*, which includes movements called "Pagodes" and "Jardins sous la pluie" ("Gardens in the Rain"), as well as "Nuages" ("Clouds").

Debussy first heard music of the East at the Paris International Exposition in 1889. This exhibit marked the 100th anniversary of the French Revolution. Architectural triumphs, such as the Eiffel Tower, symbolized not just this event but came to symbolize the city of Paris itself. The music, art, and dance of "foreign lands" was showcased and introduced to Europe. Among the most popular musical events were performances by the gamelan from the Indonesian island of Java. The gamelan is a percussion ensemble comprised of instruments including chimes, gongs, and various types of drums. Debussy attended this exposition, and he was particularly struck by the sound of the gamelan. He later wrote to a friend, "Do you not remember the Javanese music able to express every nuance of meaning, even unmentionable shades, and which make our tonic and dominant seem like empty phantoms for the use of unwise infants?" (quoted in Machlis 1961).

As painters from this time were influenced by Asian art, Japanese prints in particular, Debussy often replaced traditional major and minor scales with whole-tone or pentatonic scales, which are found in music from Asia. Whole-tone scales are comprised only of whole steps; they lack half steps, which can function to pull the listener's ear in a specific direction in Western classical music. Because of the fact that half steps are absent, there are six notes in a whole-tone scale rather than eight. Pentatonic scales are based on five pitches rather than the eight pitches used in major and minor scales, and they correspond to the black keys on the piano keyboard. Basing harmony on these "new" scales helped create new pure sounds, which could create a sense of atmosphere. In addition to using these scales that were new to him, he also looked back. Debussy also used ancient church modes and frequently relied on pedal point, a sustained pitch creating a sense of anchor.

New Colors in Piano Music

Debussy was a prolific composer writing music for a broad range of instruments. Not only did he use orchestral instruments in new ways, but he also

created new effects for the piano. Among his many works for piano, his *Piano Preludes, Books I and II*" composed between 1910 and 1913 illustrate this. The piece *The Engulfed Cathedral* from the *Piano Preludes, Book I* exemplifies how he used harmony in a nonfunctional manner. In this piece, he used chord streams—parallel seventh and ninth chords that do not resolve according to the traditions of Western harmony but rather serve with the nonpulsating, irregular rhythms to create an image or atmosphere. As Monet's *Rouen Cathedral in Full Sunlight: Harmony in Blue and Gold* rises like a beacon from the landscape, Claude Debussy's piano prelude, "The Engulfed Cathedral" is thought to suggest the Breton legend of the Cathedral of the Ys rising from the ocean. The impressionistic contours of the cathedral arches can be sensed in the rise and fall of Debussy's dense chords moving in parallel motion. The musical depiction of the bells and the use of the church modes give an archaic quality to this music, which pays homage to the past but in a voice that is clearly of the turn of the twentieth century. Architect Mario Botta noted this spirit when he "equated the role of today's museum with religious temples of earlier times" (San Francisco Museum of Modern Art 1994, 13).

Listen to *Le cathedrale engloutie* (*The Engulfed Cathedral*, 1909–1910, Claude Debussy, http://www.youtube.com/watch?v=3sFTiYsVJ Gg.

Also from *Piano Preludes, Book I* are three pieces that suggest the theme of wind—*"Voiles," "Le Vent dans la Plaine,"* and *"Ce qu'a Vu le Vent d'Ouest,"* all three of which use both whole-tone and pentatonic scales. *"Voiles"* can be interpreted as either "sails" or "veils." Debussy's use of the whole-tone scale helps to give this piece a sense of mystery. The whole-tone scale is based only on whole steps. The lack of half steps found in major and minor scales that give the Western ear a sense of pull and direction are part of what helps to create a sense of ambiguity. This piece is composed in layers of sound—a repeated figure (ostinato), a sense of anchor (pedal point), and melodic line. Debussy also created new effects for the piano through the use of the damper pedal, which sustains tones; through greatly varied dynamic contrasts and effects; through extreme subtlety and nuance of "touch" from the hands of the pianist to the instrument; and through glissando-like figures.

Figure 11.2.　Claude Monet, *Rouen Cathedral Façade Sunset*, 1894.

Listen to *Voiles*, Claude Debussy, performed by Gaby Casadesus, http://www.youtube.com/watch?v=SKYfWwY6gTk.

In the piano prelude *Le Vent dans la Plaine* (*The Wind on the Plain*), musical phrases and structures are deliberately blurred and seemingly indistinct, although when "standing back," as one might do while viewing an impressionistic painting, a three-part, ternary form (ABA) is discernible. In contrast to the seeming stillness of *Voiles*, this prelude suggests a frenetic, whirling wind. Like *Voiles*, it is based on a combination of whole-tone and pentatonic scales but in reverse. The "A" sections are pentatonic, with a brief contrasting "B" section based on the whole-tone scale. The third prelude, with a title suggesting wind, *Ce Qu'a Vu le Vent d'Ouest* (*What the West Wind Saw*), offers a very different musical experience and depiction of wind—one of drama and the great power of nature. Debussy called for extreme contrasts of loud and soft in this piece, including bold chords and recurring crescendos and decrescendos on rising and falling scales.

Listen to *Wind on the Plain*, Claude Debussy, performed by Samson François, http://www.youtube.com/watch?v=xeGPpdH8WdA.

The Orchestral Palette

Like impressionistic painters, Debussy also used such subjects as water, clouds, and landscape in some of his pieces. Major works of Debussy that suggest water include the orchestral work *La Mer* (*The Sea*) and "*Reflets dans l'eau*" ("Reflections on the Water") from *Images pour piano* (1904–1905), which suggest water and reflection through sound. Like the subject of wind, this is, of course, implied. The listener cannot tell the piece suggests clouds or landscapes unless the composer tells us. This reminds us again of the use of metaphor across artistic disciplines. Rhythm is literal in music and metaphorical in visual art; color is literal in visual art and metaphorical in music.

Look at *Water Lilies*, Claude Monet, http://upload.wikimedia.org/wikipedia/commons/5/5d/Monet_Water_Lilies_1916.jpg.
Listen to *Images pour piano*—"*Reflets dans l'eau*," Claude Debussy, www.youtube.com/watch?v=mHCK8Djo2Eg.

Debussy's major orchestral work *La Mer* is subtitled *Trois esquisses symphoniques* (*Three Symphonic Sketches*). The composition is in three movements, each of which carries a descriptive title of the sea in various forms and in relation to light and wind. Movement 1, "De l'aube a midi sur la mer" ("From dawn to noon on the sea"), suggests the play of light as the hours of the day pass. Movement 2, "Jeux de vagues" ("Play of the waves"), echoes the movement of the sea. The final movement, "Dialogue du vent et de la mer" ("Dialogue of the wind on the sea"), suggests the interaction of the wind and the water. Each of these titles suggests a moment in time—a fleeting moment in the ever-moving and changing sea. Debussy wrote to his publisher Jacques Durand, "The sea has been very good to me. . . . She has shown me all her moods" (quoted in Brody 1987, 266).

It is interesting to note that Debussy requested to have an image of the famous wood block print *The Hollow of the Wave of Kanogawa* (often referred to simply as *The Wave*) by Japanese artist Hokusai as the cover image of the score of *La Mer*. Debussy drew upon visual influences from the East in this choice, which further reflected the influence of Japanese prints on the arts in Paris during this period of time.

Nocturnes of Debussy and Whistler

Parallels can also be found between the music of Debussy and other painters of the time, such as Matisse and Derain, as well as the American-born artist James McNeill Whistler (1834–1903), who worked in Paris and London. In the 1860s and '70s, Whistler often used musical terminology in naming his paintings. Common musical titles he used included *symphony*, *composition*, *harmony*, *arrangement*, and *nocturne*. For example, his *Symphony in White No. 1: The White Girl* (1862) was exhibited in Paris at the *Salon des Refusés* in 1863 along with such artists as Manet, Cézanne, and Pissarro. Works, such as *Symphony in Grey and Green: The Ocean* (1866–1867) and *Harmony in Grey and Green* (1873), followed. Whistler also painted evening scenes of water subjects, such as the Thames River in London and the lagoon in Venice.

Paintings from this time include *Nocturne: Blue and Silver—Chelsea* (1871), *Nocturne in Black and Gold: The Falling Rocket* (c. 1874), and *Nocturne: Blue and Gold—Old Battersea Bridge* (1872–1877). These paintings are thought by some to have been an inspiration to Debussy in his musical composition *Three Nocturnes* (1897–1899). Whistler explored the range of a single visual color in these works. For example, in *Nocturne: Blue and Gold—Old Battersea Bridge* (1872–1877), he explored gradations of the color blue.

Similarly, Debussy often exploited the possibilities of a musical instrument creating new tone colors within a single instrument. Whistler believed that music was the most abstract of all the arts. Indeed, this is why he often used broad musical terms to name his paintings. He said, "Music is the poetry of sound, [as] painting is the poetry of sight" (quoted in Brody 1987, 127).

The use of musical terms as titles took the focus away from the literal subject or narrative, and it helped move from nineteenth-century realism to a style developed in American art in the late nineteenth and early twentieth century referred to as tonalism. The subject of works in this style was often landscapes. Paintings of this style were characterized by a strong sense of atmosphere and mood, which was created by the use of soft, neutral hues.

Whistler believed in "art for art's sake." In his "Ten o'Clock" lecture, he said,

> Nature contains the elements, in colour and form, of all pictures, as the keyboard contains the notes of all music. But the artist is born to pick, and choose, and group with science, these elements, that the result may be beautiful—as the musician gathers his notes, and forms his chords, until he brings forth from chaos glorious harmony. To say to the painter, that Nature is to be taken as she is, is to say to the player, that he may sit on the piano. That nature is always right, is an assertion, artistically, as untrue, as it is one whose truth is universally taken for granted. Nature is very rarely right, to such an extent even, that it might almost be said that Nature is usually wrong: that is to say, the condition of things that shall bring about the perfection of harmony worthy a picture is rare, and not common at all. (quoted in Weinberg 2000)

As Whistler moved away from naturalistic painting, Debussy experimented with the translation of emotional and atmospheric impressions into music with his three-movement orchestral work *Nocturnes* ("*Nuages*," "*Fetes*," and "*Sirenes*"), which he composed between 1887 and 1899. The title is thought by some to have been suggested by the series of paintings of the same name by Whistler, whose work the composer admired. Debussy said, "The title, *Nocturnes*, is to be interpreted in a general and, more specifically, in a decorative sense. Therefore, it is meant to designate . . . all the various impressions and the special effect of light that the work suggests" (quoted in Cox 1975, 19).

Whistler explored gradations in the color blue in his *Nocturne: Blue and Gold—Old Battersea Bridge*. Debussy described his musical compositions *Nocturnes* as an experiment in the various arrangements that can be made with a single color—like the study of gray in painting. Of the first movement,

"*Nuages*" ("Clouds'), the composer wrote that "it renders the unchanging aspect of the sky and the slow, solemn motion of the clouds" (quoted in Cox 1975, 20).

Look at *Nocturne: Blue and Gold—Old Battersea Bridge*, 1872–1877, James Whistler, http://www.ibiblio.org/wm/paint/auth/whistler/i/cremorne-lights.jpg.

Listen to *Nocturnes*—"*Nuages*," Claude Debussy, www.youtube.com/watch?v=fljlEf9iCCM.

Collaboration

Debussy was involved with many major artists across disciplines during his lifetime. For example, Sergei Diaghilev, a major force in the arts scene in Paris in the early twentieth century and impresario of the famed *Ballets Russes* (Russian Ballets), provided the impetus for Debussy's orchestral work *Jeux*, which is characterized by a sense of musical flexibility and perpetual change. The listener hears orchestral sounds, melodic fragments, and rhythms in various combinations, yet they never appear twice in the same form.

The great Russian dancer Nijinsky choreographed this ballet, drawing inspiration from paintings by Gauguin. It seems natural to suggest possible influences of the visual arts on this music because Debussy's creative process involved thinking about music metaphorically at times. He frequently used descriptions and allusions that reflect other art forms. For example, with regard to *Jeux*, the composer wrote, "I'm thinking of that orchestral coloring which seems to be lit from behind" (quoted in Cox 1975). How does a composer "light" an orchestra? While painters of the same time experimented visually with new ideas pertaining to light and shadow, Debussy worked with this idea through sound—through his choice of instruments, the way he combined them, and their relative loudness or softness. He composed *Jeux* for a large orchestra, but because the instruments never play at one time, the musical textures are clear and direct, suggestive of chamber music.

Listen to *Jeux*, Claude Debussy, www.youtube.com/watch?v=kmD6jYW1_pc.

Debussy was often influenced by and inspired by the world of arts and culture around him. From literary ideas of symbolist poets to paintings by contemporary artists to the sounds of music from faraway lands, Debussy absorbed these ideas. In some of Debussy's original manuscript scores, he even used literal visual color to suggest orchestration and timbre. In both painting and music, these new sounds and images did not represent a complete break with tradition, but they represented bold advances in the way music was composed and paintings made. The result of the characteristic use of key elements was most certainly shaped by social, cultural, and intellectual developments of its time.

CHAPTER TWELVE

~

Cubism in Art and Music

The term *cubism* refers to a movement in art that began in Paris in the early twentieth century. Art historians acknowledge Picasso's *Les Demoiselles d'Avignon* (1906–1907) as a pivotal work that led the way to this style—one that would become a major force in modern art. Picasso's painting is thought to show the influence of African art, which he would have seen on exhibit in Paris; Iberian art, which is what he was studying at that time; and the strong figures of the Fauves, Matisse in particular. However, art historians also point to the works of Cézanne as those to have had the strongest influence on this style of painting. Cézanne showed that nature could be broken down into geometric forms.

Broadly defined, cubism focuses on line and structure rather than on color. Cubist works of art, including painting, collage, and sculpture, are marked by the reduction and fragmentation of forms as well as the use of multiple planes and perspectives. Essentially everyday objects used as subjects were broken up and then reassembled, creating abstract forms. Common subjects included still lifes, human figures, and letters or stencils.

Look at *Les Demoiselles d'Avignon*, 1907, Pablo Picasso, http://upload. wikimedia.org/wikipedia/en/4/4c/Les_Demoiselles_d%27Avignon. jpg.

Analytic Cubism

As a style in art, cubism is broken down into categories of analytic cubism (1909–1911), which was an early form beginning with early works by Pablo Picasso (1881–1973) and Georges Braque (1882–1963), and synthetic cubism (1912–1914), which was a later development. Picasso and Braque met in 1907, and they worked very closely together from 1908 to 1914. They painted together and shared thoughts about each other's paintings. Picasso said, "When we invented cubism, we had no intention of inventing cubism, but of simply expressing what was in us" (quoted in Gardner 1993, 163).

Analytic cubism is the phrase used to describe the work of these artists from 1910 to 1911. This early form of cubism involved a reduction of form into geometric shapes. Typically, these paintings involved a limited use of color—usually gray, blue, and ochre. Analytic cubism offered the viewer a universal vision by showing multiple perspectives of the subject. Instead of showing what something looked like, analytic cubism helped the viewer to understand it by showing all sides of it. It involved the reduction and analysis of key elements and then the rearrangement of them. Basic elements of an object were analyzed, and forms were flattened, taken apart, and pulled apart.

Synthetic Cubism

The years 1912 to 1913 marked a shift from analytic cubism to synthetic cubism. Synthetic cubism was more about construction than about analysis. The overarching objective in synthetic cubism was to reduce an object to its essential parts. The subject was then built up from preexisting objects. It marked a change from breaking down an object into essential elements as in analytic cubism to building them up through accumulation. Both Picasso and Braque experimented with incorporating such material as musical scores, objects, and letters into a painting. Collage became an important technique. Braque invented papier collé, which involved using wood-grained paper in the painting. This material became an integral part of the painting and at the same time clearly maintained the appearance of paper. Picasso also introduced collage into his work. Color was more bold, vibrant, and energetic. As the analytic approach broke objects down, the synthetic approach synthesized objects by building them up from various parts. This collage approach resulted in works that were of a modern, urban spirit.

The Music in the Art

Braque and Picasso, as well as other artists, such as Spanish-born painter Juan Gris (1887–1927) and French artist Amédée Ozenfant (1886–1966) frequently used musical motifs in their cubist works. Some of these artists even used composers' names, such as *Bach* and *Mozart*, in the works themselves. Some of Braque's works that directly allude to a specific composer are *Homage to J.S. Bach* (1912), *Still Life BACH* (1912), and *Bach Aria* (1913). Picasso's works with musical titles include *Still Life on a Piano* (1910–1911), *Violin "Jolie Eva"* (1912), *Toreador Playing a Guitar* (1911), and *The Violin* (1912). Juan Gris also used musical motifs in such works as *The Violin* (1913) and *Still Life* (1917), as did Ozenfant in *Guitar and Bottles* (1920) and *Composition Purist* (1925).

Picasso's *Standing Female Nude* (1910), a charcoal drawing, is considered to be a pure example of analytic cubism by many art historians. The work is characterized by shifting planes created by repeated lines and arcs, which create a vertical sense of visual rhythm. Perhaps the lines and arcs inherent in the structure of musical instruments, such as the violin, cello, and guitar, were what prompted artists of this style to use musical motifs so frequently. The lines of the strings and keyboards and the curves of the F-holes and of the string instruments themselves offered artists opportunity for breaking these subjects apart and reconstructing them into abstract forms through the use of multiple planes and perspectives. That, coupled with the sense of repetition and layering of repeated lines and shapes, created a sort of visual polyphony reminiscent of Baroque-era composers, such as J. S. Bach.

Look at *Standing Female Nude*, 1910, Pablo Picasso, http://www.metmuseum.org/toah/images/hb/hb_49.70.34.jpg.

Many works by both Braque and Picasso from this period use musical instruments, such as the violin, piano, and guitar, as subjects. While many of their works in painting and collage featured objects common in still-life works, such as jugs, candlesticks, and so on, it is interesting to note the large number of works that include musical subjects. Braque had studied music, but Picasso had little contact with serious classical music. Later, between 1917 and 1924, however, Picasso would work closely with many artists, including musicians, when he designed curtains for ballets, including Stravinsky's *Pulcinella* (1920).

Regardless of their personal interest in or experience with music, Braque and Picasso were interested in the shapes of these instruments. Viewers can still recognize the musical subjects, but they are broken down into small fragments and put back together again. In doing so, the viewer is drawn into the process of making music—the tactile nature of touching the strings of a violin or the keys of a piano to create sound, the multiple lines of musical polyphony, and the nature of all of this existing in time. Braque wrote, "At that period I often painted musical instruments. Firstly, I had a lot of them around me, and secondly, their form and volume fit into the realm of still life I had in mind. I was already on the path toward a tangible, or as I prefer to say, graspable space, and the musical instrument as object had the peculiarity that a touch was capable of bringing it to life" (quoted in Maur 1999, 62).

The multiple layers of lines, angles, and geometric shapes in Braque's *Homage to J. S. Bach* (1912; see figure 12.1) are akin to the layers of lines

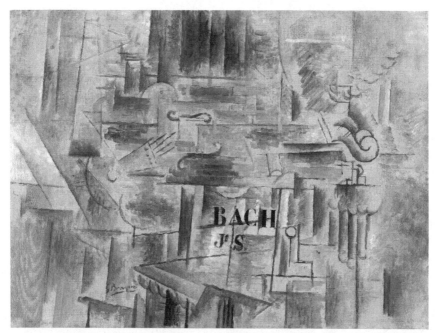

Figure 12.1. Georges Braque, *Homage to J. S. Bach*, Winter 1911–1912, oil on canvas, 21¼ × 28¾ in. (54 × 73 cm). The Sidney and Harriet Janis Collection, acquired through the Nelson A. Rockefeller Bequest Fund and the Richard S. Zeisler Bequest (both by exchange) and anonymous promised gift, 2008. The Museum of Modern Art, New York, NY. © 2014 Artists Rights Society, New York, NY/ADAGP, Paris. Digital Image © The Museum of Modern Art/Licensed by SCALA/Art Resource.

composed in the brilliant counterpoint of the polyphonic music for which Bach is remembered. The suggestion of a string instrument is apparent with lines that suggest strings. Vertical lines perhaps suggest keys on a harpsichord or early keyboard instrument. The repetition of lines, shapes, and angles creates a sense of vibration and, in doing so, highlights the temporal nature of music. In essence, the element of time in music is made visible to the eye.

The multiple perspectives created suggest both the distinctive sense of a busy contrapuntal texture as a listener would hear as well as the technical challenges a performer would encounter in a fugue by Bach. Braque even stenciled the composer's name on the painting as if to make the connection clear. The concepts of time and texture are made visible in this work.

Listen to *Prelude and Fugue in C Minor*, BWV 847, J. S. Bach, performed by Anthony Newman, http://www.youtube.com/watch?v=gY w7UgO2usI.

The term *polyphony* to describe this art was used by art dealer Daniel-Henry Kahnweiler in his 1920 book *The Way of Cubism*. In fact, he included a chapter called "Polyphony," in which he alluded to the work of Juan Gris, saying, "Gris's works recall . . . the grandiose musical architecture of Johann Sebastian Bach" (quoted in Maur 1999, 65). He also noted, "When I use the term 'polyphony' to describe the structure of Gris's work of this period, I am convinced it means more than a catchword. Anyone who looks at his 'architectures' . . . can easily recognize independent voices.' Thus Gris's method can doubtless be termed 'contrapuntal'" (quoted in Maur 1999, 67). These independent lines still function together, both horizontally as well as vertically, and together they create the larger structure.

Look at *Still Life*, 1917, Juan Gris, http://www.museumsyndicate.com/ images/2/14167.jpg.

The French painter Amédée Ozenfant also developed an architectural approach to cubism that was a reaction to earlier forms of cubism. By 1918, he believed that cubism had become too confusing and abstract, and he created

paintings that became representative of a style called purism. Like the guiding structure of a fugue by Bach, Ozenfant focused on balance of color, line, and form in his work. His goal was to paint using a more controlled approach, which resulted in works that have a strong sense of order and control. Some of his paintings used similar subjects as in earlier cubist works, including still-life paintings with vases and guitars. With the clean lines of their distinctive silhouettes, these subjects lent themselves to the artist's focus on proportion, balance, and line.

Influence of Cubism on Composers

Cubism, like impressionism, expressionism, and minimalism, is a term that was first used in the world of art. As with many such labels, "experiments" in cubism migrated to contemporaries in other artistic fields, such as literature (Gertrude Stein) and music. Although cubism did not define a period or even the work of a specific composer, there were some composers of that time who played with the idea of cubism in their musical compositions, even if just in a few works. Russian-born Igor Stravinsky (1882–1971) and Frenchman Darius Milhaud (1892–1974) were two such composers.

Igor Stravinsky

Stravinsky had a long career in which he contributed to many of the major musical developments of the twentieth century. He spent time in his native Russia, as well as in France, Switzerland, and the United States. Early in his career he composed three ballets that were commissioned by impresario Sergei Diaghilev of the Ballets Russes (Russian Ballet): The Firebird (1910), Petrouchka (1911), and The Rite of Spring (1913). As a part of Diaghilev's creative team, Stravinsky went from composing alone to working with some of the most avant-garde creative people of the time. During his life Diaghilev would work with some of the most celebrated names in the arts, including painters Picasso, Braque, Matisse, and Miró; composers Debussy, Ravel, and Prokofiev; and dancers and choreographers Nijinsky, Fokine, and Balanchine. Composing for these ballets marked a turning point in the career of the young Stravinsky.

In the years 1910 to 1913, Stravinsky composed music for three very different ballets. The Firebird is based on a fairy tale, and it reflects tradition and remains connected to a nineteenth-century approach to orchestration and narrative. The ballet Petrouchka opens in a bustling carnival atmosphere and tells the story of a puppet who comes to life. Unlike The Firebird, Petrouchka reflects an innovative approach that suggests collage in some respects. The

life of the puppet is shown through frames in his life, which are pieced together to convey the story, not unlike the collage approach that was being used by Picasso and Braque in the visual art of synthetic cubism during the same period of time. Similarly, Stravinsky drew upon musical material from folksong and combined that with new material characterized by brief melodic figures, polytonality, new meters, syncopation, and complex rhythmic patterns. *The Rite of Spring* embraced an even bolder step into the modern era with its use of harsh dissonances, irregular and changing meters, angular motifs, and constantly shifting rhythms, not to mention the story about a pagan ritual.

Stravinsky's enormous body of work includes compositions that represent many different styles. These include pieces that are considered to be neoclassical or sometimes referred to as modernist classicism. His work *Pulcinella*, for example, drew upon some elements of eighteen-century music. Stravinsky believed that it was through this nod to the past that he could compose his "serial" compositions later in his career. Like so many composers of the twentieth century, he also encountered jazz. It is in a couple of his jazz-influenced works that the listener also finds music that suggests ideas and approaches used in cubist art.

Ragtime

Stravinsky was acquainted with jazz mainly through sheet music. Three of the composer's pieces that reflect his experiments with jazz are *Ragtime* (1918), which was composed for eleven instruments, including winds, strings, percussion, and a Hungarian cymbalon; *Piano Rag Music* (1919) for piano solo; and later *Ebony Concerto* (1945) for solo clarinet and jazz orchestra, which was a nod to jazz big band and was premiered in 1945 by Woody Herman's band.

In his autobiography, Stravinsky reflected upon his interest in jazz and its influence on his *Ragtime*, writing,

> Its dimensions are modest, but it is indicative of the passion I felt at the time for jazz, which burst into life so suddenly when the war ended. At my request, a whole pile of this music was sent to me, enchanting me by its truly popular appeal, its freshness, and the novel rhythm which so distinctly revealed its Negro origin. These impressions suggested the idea of creating a composite portrait of this new dance music, giving the creation the importance of a concert piece, as, in the past, composers of their period had done for the minuet, the waltz, the mazurka, etc. So I composed my *Ragtime* for eleven instruments. (Stravinsky 1962, 77–78)

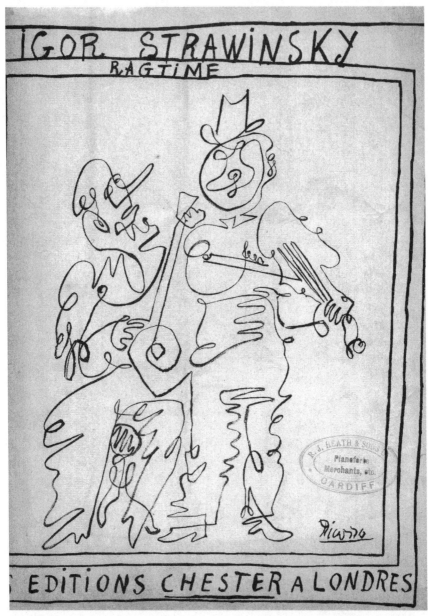

Figure 12.2. Pictorial music cover by Pablo Picasso for Igor Stravinsky's *Ragtime*, published in 1922 by J. & W. Chester Ltd., 11 Great Marlborough Street, London W 1. © 2014 Estate of Pablo Picasso/Artists Rights Society, New York, NY. Photo Credit: Amoret Tanner Collection/The Art Archive at Art Resource, New York, NY.

It is interesting to note that Picasso, whom the composer first met in 1917, designed the cover page for his piano arrangement of *Ragtime* (see figure 12.2). Picasso's drawing features a banjo player and a violinist, both of which would have been very prominent in American dance orchestras of the time. In his instrumental version of *Ragtime*, Stravinsky did not write for a banjo but rather a cymbalon, which added a tonal color similar to a banjo.

Listen to *Ragtime* for eleven instruments, Stravinsky, http://youtu.be/ QLwqVJ-owtg.

Piano Rag Music

The work of Stravinsky that best exemplifies musical cubism is his piano piece *Piano Rag Music*. He wrote this piece, which is influenced by American ragtime music, while he was living in France. Like the visual cubist works noted, this musical composition is essentially "assembled" from fragments of Russian-inspired melodies from his homeland and ostinati based on short repeated figures. The seemingly wild piece involves a fragmented approach to both rhythm and harmony. Stravinsky used "polyrhythms," many rhythmic figures used simultaneously, giving a sense of multiple layers of sound as in visual artists' use of multiple planes and perspectives. The composer also used "bitonality," which involves the use of two tonal centers or key areas at the same time. Not only does this create dissonance, but it also adds to the sense of layers. Stravinsky also included changing and irregular meters, as well as accents in unexpected places. The result is a piece of music that takes the listener on a wild ride in sound.

Listen to *Piano Rag Music*, 1934, Stravinsky, http://www.youtube.com/ watch?v=N1Eb56-9Z5c.

Stravinsky also recalled the tactile and percussive elements of this piece. In his autobiography, he wrote,

> I returned to Morges (June 1919), and finished a piano piece I had begun some time before with Artur Rubenstein and his strong, agile, clever fingers in mind. I dedicated this *Piano Rag Music* to him. I was inspired by the same

ideas, and my aim was the same, as in *Ragtime* (1918), but in this case I stressed the percussion possibilities of the piano. What fascinated me most of all in the work was that the different rhythmic episodes were dictated by the fingers themselves. My own fingers seemed to enjoy it so much that I began to practice the piece . . . simply for my personal satisfaction. Fingers are not to be despised: they are great inspirers, and, in contact with a musical instrument, often give birth to subconscious ideas which might otherwise never come to life. (Stravinsky 1962, 82)

Stravinsky was inspired by the power of touch and sheer virtuosity of the performer, as Braque and Picasso were of the lines and curves of musical instruments performers play. As in the paintings of Braque and Picasso from their analytical cubist period, where the subjects are discernible yet fragmented, Stravinsky's piece is suggestive of its homage to ragtime yet miles away from its early form as it ventured into the abstract realm.

Darius Milhaud
Another composer who hinted at cubist concepts in some of his music was the French composer Darius Milhaud. He was a prolific composer whose enormous body of work is hard to categorize. Like Stravinsky, he wrote some ballet music, most notably *La Creation du Monde*—a ballet in six scenes— which is scored for a small orchestra with a solo saxophone, which was traditionally a jazz instrument. He composed this jazz-influenced piece just a year after his 1922 visit to the United States, where he heard live jazz in Harlem. This piece is significant as it attempted to combine the new language of jazz with the traditions of classical concert music.

The 1920s was a fertile decade for the composer, one in which he also wrote six "little" symphonies for small combinations of instruments. As Braque and Picasso use a limited range of color in their analytical cubist works of the early twentieth century, Milhaud used small ensembles comprised of a limited range of musical instruments—tonal color. He rebelled against the complex formal structures and huge orchestras of Strauss and Wagner with his six little symphonies, all of which are spare in instrumentation and concise in form and length. Essentially, they are miniature symphonies. *Symphonie* no. 4 (1922) was composed for just ten string instruments— four violins, two violas, two celli, and two basses. It features homogenous tonal coloring, angular melodic contours, highly imitative passages, and busy Baroque-like figuration juxtaposed against other blocks of sound. Musical details dissolve into overlapping planes of sound.

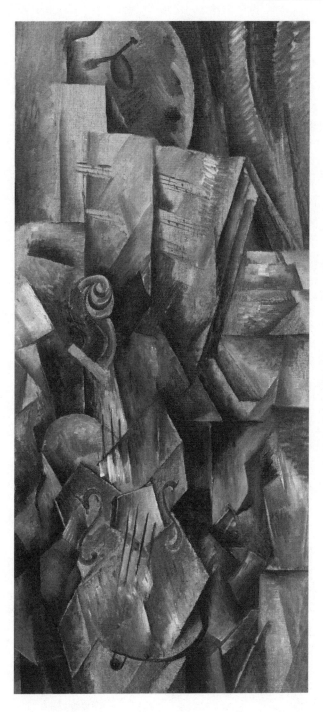

Figure 12.3. Georges Braque, *Violin and Palette*, September 1, 1909, oil on canvas. $36^{1}/_{8} \times 16^{7}/_{8}$ in. (91.7 × 42.8 cm). The Solomon R. Guggenheim Museum, New York, NY. © 2014 Artists Rights Society, New York, NY/ ADAGP, Paris. Photo Credit: The Solomon R. Guggenheim Foundation/Art Resource, New York, NY.

Listen to *Petite Symphonie* no. 4, Darius Milhaud, http://www.youtube. com/watch?v=Lmd775hAVFw.

Similarly Braque's painting *Violin and Palette* (1909; see figure 12.3) features classical forms and an underlying geometric order. It reflects an absence of detail—like musical ideas that are introduced but not developed. The reductive nature of both these musical and visual works, the focus on horizontal planes, and the juxtaposition of the old and the new in both art and music suggest the desire for experimentation and discovery.

The essence of modern art and modern music is the belief in the possibility of change. This involved not only experimenting with such elements as color, texture, and structure but also acknowledging classical forms. The painters and composers discussed in this chapter certainly did that. In doing so they created a visual and musical repertoire that reflected the spirit of modernism in the early twentieth century.

CHAPTER THIRTEEN

~

Georgia O'Keeffe and American Modernist Composers

The Spirit of a New Century

Several artists and composers have been referred to as "pioneers of American modernism." Georgia O'Keeffe (1887–1986), for example, was fascinated with the southwestern United States and its "wonderful emptiness." Her paintings reflect an awareness of and response to her environment. Similarly, Roy Harris (1898–1979), the prolific American composer of the twentieth century, along with his contemporary Aaron Copland (1900–1990), composed music with a distinctive American character that drew upon folklore and folk song, as well as such musical styles as jazz—music that was uniquely "American." For example, passages in Harris's *Symphony no. 3* are characterized by slow-moving, almost motionless harmonies, which suggest open, expansive landscapes like those painted by O'Keefe. Contrasting sections of this work feature highly rhythmic passages, which share the energy of the urban landscape, also of interest to O'Keeffe and some of her contemporaries, such as Joseph Stella (1877–1946) and John Marin (1870–1953).

Look at *Purple Hills Ghost Ranch*, 1934, Georgia O'Keeffe, http://www.onlandscape.co.uk/wp-content/uploads/2012/04/Purple-Hills-Ghost-Ranch-1934.jpg.
Listen to *Symphony no. 3*, 1939, Roy Harris, http://youtu.be/UQIT-v54rsVc.

Like American composers of the same generation, Georgia O'Keeffe was born during an era of great urban expansion and industrialization. Many important buildings were erected, bridges built, and major projects undertaken. The Brooklyn Bridge, for example, was completed in 1883 and was to become a symbol of a modern American city and would inspire artists across disciplines, including Walt Whitman, John Marin, Hart Crane, Joseph Stella, and Georgia O'Keeffe, to name a few. This was also a time of burgeoning experimentation in all of the arts in the United States. In fact, those in O'Keeffe's circle were at the pulse of such experimentation. For example, Stieglitz's issues of *Camera Work* addressed experiments in modernism in all of the arts.

O'Keeffe and Music

O'Keeffe was also interested in the power of music as a profound means of expression. She said, "Singing has always seemed to me the most perfect means of expression. . . . Since I cannot sing, I paint" (quoted in Hoffman 1997, 59). She studied the violin and often made use of musical vocabulary in her work. O'Keeffe noted an experience in New York that triggered her imagination with regard to music. She wrote,

> I never took one of Bement's classes at Columbia University, but one day walking down the hall I heard music from his classroom. Being curious I opened the door and went in. A low-toned record was being played and the students were asked to make a drawing from what they heard. So I sat down and made a drawing, too. Then he played a very different kind of record—a sort of high soprano piece—for another quick drawing. This gave me an idea that I was very interested to follow later—the idea that music could be translated into something for the eye. (O'Keeffe 1976, 14)

O'Keeffe created some paintings that suggest music in their titles and even evoke the essence of sound; these include *Music—Pink and Blue I* (1919) and *Blue and Green Music* (1921).

Look at *Blue and Green Music*, 1919–1921, Georgia O'Keeffe, http://upload.wikimedia.org/wikipedia/commons/2/26/Blue-green.jpg.

Blue and Green Music is one of many works in which O'Keeffe uses a V-like shape to create a powerful and dominant rhythmic structure. This suggests openness and space, not unlike slow-moving passages in Harris's *Symphony no. 3*. Art historian and O'Keeffe scholar Katherine Hoffman and others note that the flame-like image suggests sound waves or musical vibrations. The boldly rhythmic V shape is like a physical contraction that finally releases into space. O'Keeffe herself reflected on this shape in reference to her work *Red Hills and Sky* (1945). She wrote,

> A little way out beyond my kitchen window at the Ranch is a V shape in the red hills. I passed the V many times—sometimes stopping to look as it spoke to me quietly. I one day carried my canvas out and made a drawing of it. The shapes of the drawing were so simple that it scarcely seemed worthwhile to bother with it any further. But I did a painting—just the arms of two red hills reaching out to the sky and holding it. (O'Keeffe 1976, 85)

It was, in part, that thirst for space that helped shape the United States.

O'Keeffe was greatly influenced by the art and writings of Russian artist Wassily Kandinsky. She read his book *Concerning the Spiritual in Art* and was fascinated by his ideas on the relationship between meaning and the use of color. In his book *Point and Line to Plane*, Kandinsky explained his theories in great detail. In his chapter "Line," he discussed the emergence of angles and planes from single lines. He developed his ideas on their association with color and their power to create a feeling of lyricism or drama. He wrote, "Angular lines originate from the pressure of two forces. . . . The simplest forms of angular lines consist of two parts, and are the result of two forces which have discontinued their action after a single thrust" (Kandinsky 1979, 68–69). This idea is expressed kinesthetically in Martha Graham's bold development of the "contraction"—a powerful thrust emanating from the physical core and releasing gradually. This resulted in a highly charged sense of drama in modern dance.

O'Keeffe and the Southwest

Like composers Aaron Copland and Roy Harris, O'Keeffe had a great fondness for the southwestern United States. She lived and worked in Santa Fe, New Mexico, for many years, drawing inspiration from the expansive landscape and from everyday life. The influence of literal sounds from the world around her are found in such works as *Red and Orange Streak* (1919) and *From the Plains I* (1919), both of which give the illusion of great space.

Vivid shapes, such as a bold Z in *Red and Orange Streak* (1919), help structure the painting, along with a sense of emptiness and void that are suggested in the very dark colors. Deeply in touch with the forces of nature, her paintings often suggest the ochres, reds, and browns of a desert landscape, as well as the intensity of color and shape in the sky and sun. O'Keeffe was greatly influenced by the sounds of everyday, such as a train whistle in the distance and the ever-present hum of nature.

Look at *Red and Orange Streak*, 1919, Georgia O'Keeffe, http://www.berk shirefinearts.com/uploadedImages/articles/1213_Dove-OKeeffe 210101.jpg.

Katherine Hoffman wrote, "The year 1919 brought further ambitious abstract paintings inspired by music or aural impressions. *Red and Orange Streak* recalls the dark emptiness of the Texas plains with a scarlet line of a new day." She continued "*From the Plains* (1919) one once again finds jagged arc forms above the purple and blue tones of a night sky. Reinforcing the concept of the song imagery was O'Keeffe's inscription on the back of a photograph of the work: *A Song*" (Hoffman 1997, 50).

Look at *From the Plains I*, 1919, Georgia O'Keeffe, http://uploads5. wikipaintings.org/images/georgia-o-keeffe/from-the-plains-ii.jpg.

These paintings are of the plains of sprawling Texas. The artist herself wrote about these works,

> *From the Plains I* and *Orange and Red Streak* were painted in New York months after I left that wide world. And years after, I painted it twice again. The cattle in the pens lowing for their calves day and night was a sound that has always haunted me. It had a regular rhythmic beat like the old Penitente songs, repeating the same rhythms over and over all through the day and night. It was loud and raw under the stars in that wide empty country. (O'Keeffe 1976, 3)

Roy Harris and America's Musical Landscape

Roy Harris was a musical contemporary of Georgia O'Keeffe. As her work sometimes alluded to music, his work often suggested landscape. Born in Oklahoma, his roots in rural America followed him throughout his life. Later in his life, he noted that he was moved by the sounds of nature and that this influenced his musical compositions. He was a prolific composer who wrote more than 200 compositions from orchestral music to music for choir, solo voice, piano, and various ensembles. He also spent many years of his life as an educator teaching at prestigious universities and conservatories.

One of his influential teachers in the United States was Arthur Farwell, who encouraged him to find inspiration for his own music in traditional American music, such as folk song and hymnody. Farwell was himself a composer determined to write music that was truly "American." He was interested in Native American music, and he often used melodies from this body of music in his own compositions, as in *Three Indian Songs*, op. 32 (1908), for example. He also used folk song in his music. His commitment to writing American music as something distinctive and apart from European concert music was reflected in the Wa-Wan Press, which he founded in 1901 to publish music by living American composers.

It should be no surprise, then, that Farwell also introduced Harris to the poetry of American Walt Whitman, whose words Harris would eventually set to music in such works as the cantata *Give Me the Splendid Silent Sun* (1955). During his life Harris frequently drew upon texts by other American poets, including Carl Sandberg, Emily Dickinson, Archibald MacLeisch, and Vachel Lindsay.

In addition to Arthur Farwell, Harris studied with the great pedagogue Nadia Boulanger in Paris for three years at the suggestion of friend and composer Aaron Copland. Like Copland, his music was built on European foundations of harmony and form but with a distinctive American voice. He was inspired by American music from folk songs to country dances to hymnody, and he used this music within traditional musical forms, as the symphony. His approach to orchestration was colorful, indeed, characterized by a broad palette of sound ranging from individual solo instruments to brilliant brass and large percussion sections.

Harris was deeply influenced by American landscape and particularly the diversity of regional and ethnic musical traditions. His music often alluded to American traditions or history with such titles as *American Creed* (for chorus and orchestra in two movements—"Free to Dream" and "Free to Build"), the symphonic overture *Johnny Comes Marching Home* (1934), *Kentucky Spring*

(1949), *Symphony no. 6* (1944, *Gettysburg Address*), and *Symphony no. 10* (1965, *Abraham Lincoln* Symphony). Of his many works for orchestra, his *Symphony no. 3* (1939) and *Symphony no. 4* (1940, *Folksong*) were the most successful.

Symphony no. 4, the *Folksong* Symphony, is actually more of a choral orchestral fantasia. It was first performed in 1940 at the American Spring Festival in Rochester, New York, with Howard Hanson conducting. Composed in seven movements, it was profoundly inspired by American folk song and folk dance traditions, including cowboy songs, ballads of the great frontier, spirituals, folk songs, country dances, and marches. Movement 1, "The Girl I Left behind Me," is a Civil War song marked by strong rhythms that suggest a march. The second movement, "Western Cowboy," quotes the songs "Oh Bury Me Not on the Lone Prairie" and "The Streets of Laredo." Movement 3, "Interlude: Dance Tunes for Strings and Percussion," is rhythmically charged with patterns suggesting an Irish jig and a hoedown, a traditional country dance. The fourth movement, "Mountaineer Long Song," is based on the southern ballad "He's Gone Away."

Folk dance influences are present once again in the following "Interlude: Dance Tunes for Full Orchestra"; this movement also quotes another melody, "Jump Up My Lady." The following movement, "Negro Fantasy," is based on two spirituals—"Little Boy Named David" and "De Trumpet Sounds It in My Soul." The final movement, "Johnny Comes Marching Home," is based on the well-known Civil War song that is infused with the joy of the homecoming. In this work, the melodic material is clearly stated and very accessible to the listener, yet it is frequently accompanied by asymmetrical rhythmic patterns.

Harris' *Symphony no. 3* in one movement was hailed by conductor and champion of modern American music Serge Koussevitsky as the "first great symphony by an American composer." Koussevitsky conducted the premier of this work with the Boston Symphony Orchestra. This bold, dramatic composition incorporates European traditions, such as the use of chant and polyphony, as well as American folk music and hymnody. Unlike *Symphony no. 4*, which gives programmatic titles to each movement, this one-movement symphony was composed in five connected sections, each noting a tempo indication and character ranging from tragic, lyric, pastoral, and dramatic. The resulting tension was created not by contrasting themes but rather by the slow and powerful growth and expansion of the work. Clearly the elements of time and space are at the core of this work, suggesting an open and sweeping landscape so much a part of America's western landscape.

Aaron Copland and His American Landscape

Aaron Copland, a probably more recognized name, was of the same generation of American composers including Roy Harris, Virgil Thompson, and Walter Piston. The young Copland grew up in Brooklyn, New York, where he heard the sounds of early jazz and American popular music. Like Harris, Copland studied composition in Paris with Nadia Boulanger. Having the benefit of an American upbringing combined with formal European study, he had the ability to create a uniquely "American" sound through his mastery and understanding of European harmony. He was able to create the essence of a modern American sound.

How does a composer create an "American" sound? One way is through the literal quotation of American folk song, as noted in several works by Roy Harris. Copland used this method in some of his early works, such as the ballets *Billy the Kid* (1938) and *Rodeo* (1942), but often his use of folk melodies involved not the literal quotation of them but rather the adaptation of them. His ballet *Billy the Kid* is set in the open prairie land of the United States. Copland suggested this sense of open land and the emptiness of the prairie through the use of open fifths, which sound "empty" to the listener due to the lack of a third, which would complete a triad (chord). In this work, Copland adapted traditional cowboy songs; he did not use them literally but rather created a new spin on a traditional folk song.

His later ballet work *Rodeo* tells a story of a cowgirl in the American west. French composer Darius Milhaud wrote,

> What strikes one immediately in Copland's work is the feeling of the soul of his own country: the wide open plains with their soft colourings, where the cowboy sings his nostalgic songs in which, even when the violin throbs and leaps to keep up with the pounding dance rhythms, there is always a tremendous sadness, an underlying distress, which nevertheless does not prevent them from conveying the sense of sturdy strength and sun-drenched movement. His ballet *Rodeo* gives perfect expressions to this truly national art. (quoted in Butterworth 1985, 93)

From *Rodeo*, Copland created the orchestral work *Four Dance Episodes*, which is comprised of four movements with the titles "Buckeroo Holiday," "Corral Nocturne," "Saturday Night Waltz," and "Hoedown." In the first of these, "Buckeroo Holiday," Copland drew upon folk tunes from the collection of songs *Our Singing Country*, incorporating syncopated rhythms and ragtime accompaniment of early jazz. In the movement "Saturday Night Waltz," violinists must play their instruments in a way that suggests the

fiddle. The rowdy and boisterous last movement "Hoedown" suggests the country dance and uses the melody "Bonyparte" from another collection of songs called *Traditional Music of American* by Ira Ford.

Listen to *Four Dance Episodes*—"Hoedown," Aaron Copland, http://www.youtube.com/watch?v=tC2Df9_AtLQ.

His later works *Fanfare for the Common Man* (1943) and *A Lincoln Portrait* (1944), which were composed during World War II, suggest national pride and honor. Copland even used quotations from letters and speeches by Abraham Lincoln in the narration of *A Lincoln Portrait*. The narration includes words about Lincoln as well as actual words spoken by him, including his famous words from the battlefield in Gettysburg, "that from these honored dead we take increased devotion to that cause for which they gave the last full measure of devotion: that we here highly resolve that these dead shall not have died in vain; that this nation, under God, shall have a new birth of freedom; and that government of the people, and for the people, shall not perish from the earth." Using the technique found in earlier works, Copland adapted the American folk song "Springfield Mountain" as thematic material and restated this melody almost as a hymn. This appears along with a catchy dotted rhythmic melodic figure seemingly hinting at Stephen Foster's song "The Camptown Races." These melodies were woven into the larger fabric of the piece, one that creates a sense of musical nobility and even fanfare.

Listen to *A Lincoln Portrait*, Aaron Copland, http://www.youtube.com/watch?v=NOWkI9CU_jw.

Copland's work *Appalachian Spring* (*Ballet for Martha*) was the product of collaboration between the composer and dancer-choreographer Martha Graham, who is considered to be the founder of modern dance. In 1945, this work won the Pulitzer Prize for music. As in earlier compositions, Copland relied less on the quotation of folk songs but rather suggested the essence of folk traditions in his use of harmony and rhythm.

While Copland was developing a musical vocabulary that had a distinctive American flavor, Martha Graham was revolutionizing dance to the

point where she came to be considered the founder of modern dance. She broke away from conventional ballet and created a new technique that was based on muscular contraction and release. This involved a sudden contraction from the center of the body that was followed by gradual release of tension though the body. This movement was jarring to audiences who had never seen anything like this before. Described as angular and dissonant, this movement was at the core of her dance. Graham said, "Life today is nervous, sharp, and zig-zag. . . . It is what I want for my dances" (quoted in Gardner 1993, 274). Like Graham, Copland utilized harmonies that were at times dissonant and melodic figures that were often sharp in contour. One can also recall the powerful V shape and Z shape in many of O'Keeffe's paintings—angular and full of tension released into the greater space (see O'Keeffe, *Blue and Green Music*, 1919 to 1921).

Copland's original title was *Ballet for Martha*. The title *Appalachian Spring* was offered by Martha Graham herself and was taken from a poem by Hart Crane called *The Dance*:

> O Appalachian Spring! I gained the ledge;
> Steep, inaccessible smile that eastward bends
> And northward reaches in that violet wedge
> Of Adirondacks!

The poem itself is not reflective of the ballet's story and was chosen by Graham after the score was finished. With regard to American dance, Martha Graham once said that one must "know the land—its exciting strange contrasts of bareness and fertility" (quoted in Gardner 1993, 285). In the score published by Boosey and Hawkes, the preface reads:

> a pioneer celebration in spring around a newly-built farmhouse in the Pennsylvania hills in the early part of the last century. The bride-to-be and the young farmer-husband enact the emotions, joyful and apprehensive, their new domestic partnership invites. An older neighbor suggests now and then the rocky confidence of experience. A revivalist and his followers remind the new householders of the strange and terrible aspects of human fate. At the end the couple are left quiet and strong in their new house.

Together Graham and Copland "tell the story" by expressing core values and spirit. Graham expressed the values of simplicity, humility, and faith through psychologically powerful movements. Copland used sparse textures, sudden harmonic shifts, angular phrases, and multi meters, which biographer Howard Pollack suggests recall the natural rhythms of American speech

rhythms (for example, the opening measures of *Appalachian Spring* are 4/4, 3/2, 3/4, and 5/4). Copland's music suggests folk traditions, but he only quoted one folk melody—the Shaker tune "Simple Gifts." Like Graham's choreography, the words to this tune suggest the essence of the story.

> 'Tis a gift to be simple, 'tis a gift to be free,
> 'Tis a gift to come down where we ought to be,
> And when we find ourselves in the place just right,
> 'Twill be in the valley of love and delight.
> When true simplicity is gain'd,
> To bow and to bend we shan't be asham'd,
> To turn, turn will be our delight
> 'Till by turning, turning we come round right.

Listen to "Simple Gifts," excerpt from *Appalachian Spring*, Aaron Copland, http://youtu.be/XiLTwtuBi-o.

Georgia O'Keeffe and the Urban Influence

Georgia O'Keeffe, like her contemporaries, such as Aaron Copland and George Gershwin, was also a product of a new American urban energy. Artists and composers were influenced by the visual power of new skyscrapers being built in major American cities, such as New York. As a New Yorker, Copland was a composer who grew up in an environment alive with the emergence of jazz and American popular music. Although Copland did not try to imitate such sounds literally in his music, he aimed for a uniquely American sound and spirit in his music. His was a strong musical voice of America—from the rural landscapes to the big cities.

Similarly O'Keeffe's work was not limited to subjects of landscape and nature. In fact, she spent time in New York City, and she created several paintings based on her experience there. Many of these paintings used new skyscrapers as subjects, with their massive and bold lines and shapes in play with the light of the sun and the moon. These include *New York with Moon* (1925), *The Shelton with Sunspots* (1926), *City Night* (1926), and *Radiator Building—Night, New York* (1927), to name a few. She noted, "I walked across 42nd Street many times at night when the black Radiator Building was new—so that had to be painted too" (O'Keeffe 1976, 20). *The Shelton*

with Sunspots (1926) was one of several paintings she did of New York sky-scrapers from 1926 to 1929. The perspective is from the ground looking up to the great urban expanse leading to the open sky. Buildings such as this were not just seen as architectural feats but were also symbolic of an optimistic nation on the cutting edge—a place where just about anything was possible.

Look at *The Shelton with Sunspots*, 1926, Georgia O'Keeffe, http://www.artic.edu/aic/collections/citi/images/standard/WebLarge/WebImg_000153/5215_1643843.jpg.

Common Ground—O'Keeffe and Joseph Stella

Italian-born painter Joseph Stella moved to New York City and became greatly inspired by this modern American city. He was part of a group of painters sometimes described as precisionists, who used industrial and architectural objects as subjects. Influenced by cubism, they often emphasized the geometric and angular aspects of modern architecture—the clean lines and bold shapes of modern buildings and bridges, as well as the sounds and vibrant energy these subjects implied—perpetual motion, neon lights, and traffic noise. Stella saw the Brooklyn Bridge as a powerful and ever-present symbol of the modern urban landscape—an altar piece of modernism as suggested by the Gothic arches leading to the New York City skyline and its infinite possibilities. In fact, this became a recurrent theme throughout his career. His most famous work is *The Brooklyn Bridge: Variation on an Old Theme*.

Look at *The Brooklyn Bridge: Variation on an Old Theme*, 1939, Joseph Stella, http://whitney.org/image_columns/0001/5802/42.15_stella_imageprimacy_compressed_600.jpg.

The Gothic arches of this great monument invited the viewer to look across the bridge to the skyscrapers and energy of this modern American city. The bridge suggested a passage from the old to the new—accessible yet distant. It became a link to the past and a passage to the present and the future.

One can see glimpses of the city at different times of day and night and can imagine the clash of sounds and the bustle of the city itself.

Stella wrote an essay called "Brooklyn Bridge: A Page of My Life." In this piece, he reflected upon the first time he stood on the bridge alone at night. He wrote, "I felt deeply moved, as if on the threshold of a new religion or in the presence of a new DIVINITY" (label text for Joseph Stella, *American Landscape* (1929), from the exhibition "Selections from the Permanent Collection," Walker Art Center, Minneapolis, December 8, 1996 to April 4, 1999).

O'Keeffe's painting *Brooklyn Bridge* (1949; see figure 13.1) was one of the last paintings she made in New York City before she moved to New Mexico. This work suggests the power of the great city, however the clean lines and the invitation to look to the sky rather than to buildings suggest openness and space even in a busy urban area. The bold V composition is present here as it is in many of her landscape and nature paintings, giving a sense of strength, tension, and angular rhythm.

Poet Crane Hart (1899–1932), in whose work Martha Graham discovered the title *Appalachian Spring*, was also inspired by the Brooklyn Bridge, and he wrote a poem about it called "To Brooklyn Bridge." Like many of O'Keeffe's contemporaries, American artist John Marin was also intrigued by the ever-rising skyline of Manhattan and of the Brooklyn Bridge. He painted numerous New York landmarks, including the Woolworth Building and the Telephone Building, as well as the Brooklyn Bridge. His works highlighted the inherent geometry of the city's architecture—line and plane. However, his work was not limited to just images of the city. He conveyed the spirit of the city—the vibrant, bustling, swiftly growing urban landscape. Among his works in this spirit are *Lower Manhattan from the River, No. 1* (1921), *Related to Downtown New York, Movement No. 1* (1926), and *Broadway Night* (recto; 1929), all of which are in the Stieglitz Collection at the Metropolitan Museum Art in New York.

Like O'Keeffe, Stella, and Hart, Aaron Copland was not limited to landscape and folk traditions. His evocative piece *Quiet City* (1941) has the quality of an "ode" to New York City. It was originally composed as incidental music to a play by Irwin Shaw. Scored for solo trumpet, solo English horn, and strings, it is atmospheric and suggests a sense of spaciousness. Slow-moving harmonies suggest a sense of space and stillness amid the bustle of the city. Expressive ideas introduced by the solo instruments take on an emotional character. The music has been described as an aural fantasy in which the listener imagines the inner thoughts of a diverse population in a great city.

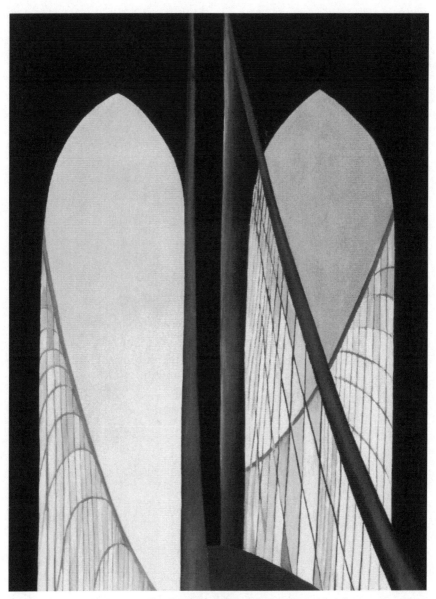

Figure 13.1. Georgia O'Keeffe, *Brooklyn Bridge*, 1948, oil on Masonite panel. © 2014 Georgia O'Keeffe Museum/Artists Rights Society, New York, NY. Brooklyn Museum of Art, New York, NY/The Bridgeman Art Library.

> Listen to *Quiet City*, Aaron Copland and the London Symphony, http://www.youtube.com/watch?v=tn5Ln8oZpfo.

Whether through the music of Harris and Copland or the art of O'Keeffe and Stella, these figures of the twentieth century captured the essence of a country that was quickly growing and full of optimism and pride. From the sounds and images of space and emptiness to the sounds of rapidly developing urban areas, these artists and composers honored the great pioneering spirit that was unique to the United States in the early twentieth century.

CHAPTER FOURTEEN

~

Diego Rivera and Carlos Chávez

Voices of Mexico in Art and Music

All art is a product of a time, a place, and a people. In the first decade of the twentieth century, Mexico was a nation of widespread poverty, growing slavery, and violence. The Mexican Revolution of 1910 against the tyranny of Porfirio Díaz was a horrific period in the history of this country. In a span of over a decade, more than one million Mexicans were killed. Artist Diego Rivera (1886–1957) was to become a voice of the people through his art, particularly his mural paintings. Shifra Goldman articulated Rivera's goals during the early decades of the twentieth century, writing,

> After the Mexican Revolution Rivera was concerned with two issues, and these determined his artistic themes: the need to offset the contempt with which the conquistadors had viewed the ancient Indian civilizations, and the need to offset the anti-*mestizo* and anti-Indian attitudes of the European-oriented ruling class during the *porfiriato* (the dictatorship of Porfirio Diaz). Mestizo and Indian peasants formed the basic fighting forces of the Revolution, and their economic needs were to be addressed on the political plane. The role of the arts was to restore understanding of and pride in the heritage and cultures that the concept of Spanish superiority had subverted. (Goldman 1994, 103)

In 1921, Álvaro Obregón, a reformist and lover of art, was elected president of Mexico, and this marked the beginning of a long period of reconstruction. Part of this rebuilding triggered a blossoming of the arts during the postrevolutionary period, which spanned from approximately 1920 to 1934. During these years of cultural renaissance, the arts became a vehicle for the

voice of the people—for all people, not just for the wealthy or for elite academics. The arts became relevant to everyone.

It is not surprising that artists who worked across artistic disciplines would address common interests and important contemporary issues of the greater society through their respective art forms. Two major figures in twentieth-century Mexican music were the composers Silvestre Revueltas (1899–1940), whose music was strongly rooted in folk music, and Carlos Chávez (1899–1978), whose compositions drew upon music of Mexican culture from various periods of history in some of his works but in a way that was clearly modern and in the voice of a twentieth-century composer. In addition to Diego Rivera, important visual artists of this time included José Clemente Orozco (1883–1949) and David Alfaro Siqueiros (1896–1974). These three visual artists were all important muralists, and boldly they worked on the front line of change, not only in the arts, but also in greater society. Together they challenged people to reconsider the place of art in society.

In 1940, the Museum of Modern Art in New York City featured a musical program led by Mexico's foremost composer and conductor Carlos Chávez in conjunction with an exhibit called "Twenty Centuries of Mexican Art." The inclusion of music was a necessary component of the museum's objective, which was to present a comprehensive view of the expressive forms that comprise Mexico's great cultural heritage. The works of both artist Diego Rivera and composer Carlos Chávez conveyed contemporary expressions of social, political, and historical elements in their respective art forms. They were friends, and they were part of a larger group of artists who gave voice to the revolution in their work.

Carlos Chávez

Carlos Chávez was born in Mexico City to Spanish-Indian ancestry. He was a prolific composer whose works include seven symphonies, four concerti, a cantata, an opera, five ballets, and many pieces for chamber groups. However, he was more than a composer. He was a conductor who founded and directed the *Orquesta Sinfónica de México* for twenty years and stood on the podium before many of the world's finest orchestras, conducting classical European repertoire and becoming a champion of Mexican music. Chávez was also a dedicated educator who served as the director of the National Music Conservatory in Mexico for several years. He was engaged in musical currents in Mexico and abroad, and he developed friendships with other important contemporary composers, such as Aaron Copland and Edgard Varèse. As an author, he wrote hundreds of articles as well as the book *Toward a*

New Music: Music and Electricity (1937), in which he addressed the impact of technology on music.

The music of Chávez is difficult to categorize in terms of a specific style because it evolved and changed throughout his life. He was constantly experimenting. He combined modern European compositional techniques with folk material. His music is original and creative—both contemporary and at times national. During his youth, Mexico was defining an independent and national culture. Chávez was greatly impacted by the social and political upheaval of his time. He, along with such artists as Diego Rivera, turned to pre-Columbian Indian culture for inspiration. By reaching that far back, they found what they understood to be an authentic Mexican spirit. Chávez studied the music and culture of Mexican Indians, native folk elements, and dance structures. He sometimes called for native instruments in his music.

Chávez wrote about the importance of knowing one's tradition. In an essay in *American Composers on American Music* (1933), he wrote, "The musicians of Mexico must know our tradition, for until such day as they do, our composers will not write Mexican music and they will go on saying that we have to continue in the European tradition and that the Mexican tradition does not exist" (quoted in Fisk 1997, 339). He organized the music of Mexico into three general eras, which he referred to as that of the aboriginal culture, the convergence of Indian and Spanish music (the *mestizaje*), and the nationalistic desires brought about by the revolution. He wrote about the *mestizaje* as including music of the city, which included concert music, dance music, and music written by professional and usually trained composers. The other category is music of the country, which included the song (*canción*), ballad (*corrido*), and sonnet (*son*) as well as dance music. These forms were integral parts of the culture.

The *corrido* (ballad), for example, was important on many levels. The *corrido* is a narrative song that is shared through the oral tradition. The professional *corrido* singers traveled from village to village, bringing news from outside. These musicians functioned as vehicles of communication; through their ballads they provided the means to communicate news from the outside and to share news from the inside to the outside world. The *corrido* singers also sang at fiestas and fairs, usually one or a few voices and perhaps a guitar. The *corrido* has been studied in depth and categorized according to subjects, including the romantic, tragic, descriptive, and didactic. The *corrido* singer was an important subject to such painters as Diego Rivera, who created a fresco of the *corrido* singer for the secretariat of public education in Mexico City.

An interest in and knowledge of musical traditions of one's country does not make a composer nationalistic. Certainly the music of Chávez is nearly

impossible to categorize because of his ever-changing style. However, he did believe in the importance of understanding one's traditions. His second symphony, *Sinfonía india* (1936), is a work in a single movement in which Chávez quoted actual Indian melodies. The work calls for native percussion instruments, such as rattles, cymbals, rasps, water gourds, and drums. In this piece, which is just under thirteen minutes in length, Chávez used a melody of the Huichol Indians of the state of Nayarit as the first theme. Melodies of the Yaqui Indians of the state of Sonora follow, as does a Seri melody. These melodies are narrow in range and are highly repetitive, bringing out a sense of primitivism; yet, this is clearly modern music. Chávez believed that there was an inherent sense of ancient sophistication in "primitive" music.

> Listen to *Sinfonía india* (Symphony no. 2), 1936, Carlos Chávez, http://www.youtube.com/watch?v=NElJfef1nZU.

Chávez did not always quote native material. He believed that a national character would emerge as a result of his voice in his own time and place. His chamber piece *Xochipilli Macuilxochitl* (1940) is a good of example of this. Although the work does not literally quote existing material, Chávez wrote that it was an "attempt to reconstruct—as far as possible—the music of ancient Mexicans." The title of this piece, *Xochipilli*, refers to the name of the Aztec god of music, games, love, and dance. The piece is subtitled *An Imagined Aztec Music*—imagined in that it is based in research of this ancient music and it calls for the use of native instruments. However, it does not quote original material. The instrumentation of this piece is four winds and six percussionists using native instruments whenever possible. These native instruments include Indian drums, such as the *huehuetl* (an upright drum) and the *teponaxtle* (a percussion instrument formed out of a cylindrical piece of hollowed-out wood). Additional percussion instruments include rattles, rasps, and so on. The work is highly repetitive, utilizing short melodies in a limited range and highly charged rhythmic patterns.

> Listen to *Xochipilli Macuilxochitl*, 1940, Carlos Chávez, http://www.youtube.com/watch?v=DXElDFYhW6A.
> Look at *Agrarian Leader Zapata*, 1931, Diego Rivera, http://macaulay.cuny.edu/eportfolios/konstantinsscrapbook/files/2010/12/CRI_151053.jpg.

Chávez said of this,

> I sought in this composition to penetrate the totality of Indian culture. It is, of course, an experiment. But the Aztec musical tradition was strong, complete and deeply rooted and even today the pure indigenous music is still sung in various remote places in Mexico. In great religious processions we may still hear Indians playing the "*huehuetle*, the "*Teponaxtle*" and their flutes. (quoted in New York Museum of Modern Art Archive 1940a)

Chávez had experienced religious fiestas of Indians, true pagan rites, as a child. He was deeply influenced by these memories. He reflected on these memories, saying, "Our whole being is moved by this music. In it we find ourselves. Its essence corresponds to our emotions. Its expressive qualities are related to our character and our unrest" (quoted in New York Museum of Modern Art Archive 1940b). Other works inspired by native music include the ballet *El Fuego Nuevo* (*The New Fire*) from 1921, which is based on Aztec culture and was commissioned by the government. It was composed for a large orchestra as well as native percussion instruments. His ballet music *Los Cuatro Soles* (*The Four Suns*) from 1926 also reflects both Indian and Spanish-Indian elements.

Chávez repeatedly expressed the connection of the musician (composer) to the nation through his music and his writings. He wrote in 1933,

> In the end we musicians must forge ourselves through work; we must make an art that is for all, not enclosed solely within the four walls of the concert hall. We must tend toward the more spectacular performances of music, theater and ballet such as the ancient Mexicans were accustomed to enact, such as Greece had, spectacles which epitomize, which forge into one, the soul and the national conscience. (quoted in Fisk 1997, 340)

Diego Rivera

Like Chávez, Rivera's art reflected history as well as social and political ideas in a style that was distinctively modern. Born in Guanajuato City, Guanajuato, he studied in Mexico City and later in Madrid and Paris. He spent a decade—from 1911 to 1920—studying in European art capitals, mostly Paris. While in Paris, he was influenced by the cubist style that was developing in the work of artists like Pablo Picasso and Georges Braque. In 1920 to 1921, he went to Italy, where he studied Renaissance fresco painting, which was to become the basis for his later work in mural painting. Rivera returned to Mexico in 1921 and became involved in mural projects that were sponsored

by the government. He, along with other artists, including José Clemente Orozco, David Alfaro Siqueiros, and Rufino Tamayo, used art as a form of political and social expression, particularly through mural paintings.

Rivera joined the Mexican Communist Party in 1922, the same year he helped to create the Revolutionary Union of Technical Workers, Painters, and Sculptors. This union was headed by artists Diego Rivera, Xavier Guerrero, and David Alfaro Siqueiros. Their signed manifesto praised Indians, workers, and soldiers. It condemned the excesses of the wealthy, and it rejected the elitism often associated with museums and galleries. These artists believed that art should be of use to the general public. They did not believe in traditional easel painting for private possession and decoration but rather supported public art as a voice of the current political and social situation.

Like Chávez, Rivera was very interested in pre-Columbian cultures. Among the subjects of the many murals he created during his life was history—its narrative, textures, and details. His concern with the social and political issues of the day and the spirit of revolution are evident in his murals beginning in the 1920s, years that ushered in periods of intense work for the artist. It was in the 1920s that Rivera began work on some of his most important mural projects in Mexico.

He also traveled, visiting Moscow in 1927 in honor of the tenth anniversary of the 1917 October Revolution. In 1929, he married artist Frida Kahlo, and in 1930, he went to the United States, where he would make many murals in San Francisco, Detroit, and New York City. His desire to paint murals was born in part out of the belief that art should be accessible to all people.

Mural Projects

In 1921, José Vasconcelos became the minister of education in Mexico. He commissioned artists to paint murals on public buildings in Mexico City. Through this commitment to Mexican mural painting, postrevolutionary ideals could be shared with the public through the language of art. Rivera's most famous murals of the 1920s in Mexico included those for the National Preparatory School (1922–1923); the National School of Agriculture, Chapingo (1925); and the Ministry of Education in Mexico City (1923–1928).

Rivera painted the mural *Creation* in 1922 to 1923 in the National Preparatory School. The work addressed themes of racial equality as well as unity between nature and humankind. Rivera also began work on the frescoes at the National School of Agriculture, Chapingo, in 1925. In this project he painted images that reflected his interest in pre-Columbian Indian religion and art, as well as socialist ideas.

In 1922 Rivera, along with his many assistants, began working on frescos that would cover the walls of the inner courtyards of the secretariat of public education. His murals portrayed images of Mexican history and culture with scenes of everyday life. In preparation for his murals at the Ministry of Education, Rivera wrote, "I roamed the country in search of material. It was my desire to reproduce the pure, basic images of my land. I wanted my paintings to reflect the social life of Mexico as I saw it, and through my vision of truth, to show the masses the outline of the future" (Rivera 1991, 79).

As Rivera worked on this project, he referred to two major areas of the building as the "Court of Labor" and the "Court of Fiestas." He reflected on this project, "I arranged my work as follows: on the ground floor of the Court of Labor, I painted frescoes of industrial and agricultural labor; on the mezzanine level, frescoes of scientific activities; and on the upper floor level, frescoes representing the arts—sculpture, dance, music, poetry, folk epic, and theatre." He continued,

> In the Court of Fiestas, I used a similar and also analogous scheme: on the ground level, frescoes of the great mass folk festivals; on the mezzanine level, frescoes of festivals of predominantly intellectual importance; and on the top floor, the Great Song frescoes based on the folk music of the people, music which expressed the people's will and revolutionary wishes from the time of the country's independence up to the revolution. (Rivera 1991, 79)

Like the *corrido*, which told stories and shared news through song, these murals told stories and shared history and culture through art. The 128 panels in the Ministry of Education in Mexico City told stories and conveyed the ideals of postrevolution Mexico (see figure 14.1).

Rivera worked on murals for the National Palace in Mexico City for more than two decades. He began working on these in 1929, and the project was completed in 1951. These murals depict more than 2,000 years of Mexican history and are called *Epic of the Mexican People in Their Struggle for Freedom and Independence*. In his autobiography, Rivera reflected on the murals in the National Palace,

> The murals before it had all set isolated figures and groups of figures against large and quiet backgrounds. In this mural, I borrowed the architectonic movement of the stairway itself and related it to the dynamic upward ascent of the Revolution. Each personage in the mural was dialectically connected with his neighbors, in accordance with his role in history. Nothing was solitary; nothing was irrelevant. My National Palace mural is the only plastic poem I know

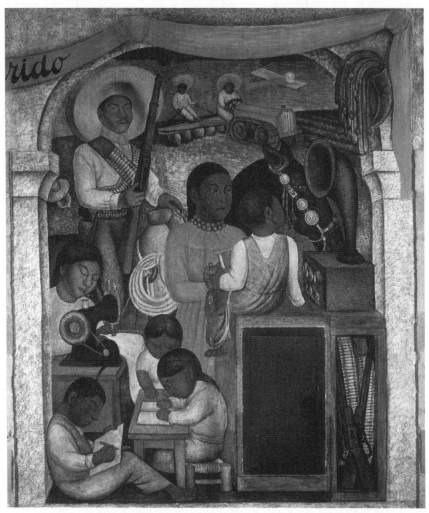

Figure 14.1. Diego Rivera, *Singing the Corrido* (*Fin del Corrido*), mural, 2.08 × 2.03 m; Court of Fiestas, *Corrido of the Agrarian Revolution*, West Wall, c. 1922–1928, Secretaria de Educacion Publica, Mexico City, D.F., Mexico. © 2014 Banco de México Diego Rivera Frida Kahlo Museums Trust, Mexico City, D.F., Mexico/Artists Rights Society, New York, NY. Photo Credit: Schalkwijk/Art Resource, New York, NY.

of which embodies the whole history of a people in its composition. (Rivera 1991, 100–101)

Rivera went to California in 1930 to paint murals at the San Francisco Stock Exchange and the California School of Fine Arts (now the San Francisco Art Institute). He continued on to Depression Era Detroit in 1932, where he started a two-year project—a mural called *Detroit Industry*. This depicted the worker and the machine. Just as Rivera celebrated the life of the farmer in Mexico, he painted images of the industrial workers he had observed at the Ford factories in Detroit. This was just one of many projects he carried out in the United States—projects that would create controversy, such as the *Man at the Crossroads* in New York City. This was commissioned by Nelson Rockefeller in the early 1930s and was to be placed in the lobby of the new Rockefeller Center. However, Rivera depicted an image of Lenin in the painting; it caused much controversy and was ultimately destroyed.

Although many of Rivera's murals were controversial for political reasons, his art and his use of techniques from Italian fresco painting had a huge impact on artists, particularly those in the San Francisco area. They had become familiar with his murals at the San Francisco Stock Exchange and at the California School of Fine Arts. In 1935, art patron Albert Bender commissioned Rivera to create a painting specifically for the San Francisco Museum of Modern Art. For this Rivera painted *The Flower Carrier* (1935), formerly known as *The Flower Vendor*. The style of fresco painting that he had studied in Italy is suggested in the artist's use of oil and tempera on gesso-covered Masonite panel. The painting makes a social statement about class struggle and human dignity.

Like Chávez, Rivera often used Indian subjects and recognized folk traditions in his art. Works, such as *Zandunga, Tehuantepec Dance* (c. 1935) and *Indian Woman* (1935), hold images of Indian people and traditions that are used as subjects. Rivera's painting *The Flower Carrier* (1935) is an image of a man carrying an enormous basket of flowers on his back with the help of a woman. The man, probably a peasant, is carrying these beautiful flowers, a symbol of luxury, to sell at the marketplace. Although the flowers are bright and full of striking color and texture, the man cannot see or enjoy them under the physical strain of carrying them. He is clearly burdened with the weight. He is struggling with his task, yet he is portrayed with great dignity. Symbolically the painting makes a statement in support of the physical laborer and struggling peasants. Rivera often used large figures in clear and simple forms with bold colors, which suggests an Aztec influence. Like his murals, this painting tells the story of one, which is surely the story of many.

Chávez also had a strong sense of art and music being *of* the people. He said, "Our whole being is moved by this music. In it we find ourselves. Its essence corresponds to our character and our unrest" (quoted in New York Museum of Modern Art Archive 1940a, 27). Like Rivera's *The Flower Carrier*, the musical composition *Three Pieces for Guitar*, no. 2 by Chávez reflects both simplicity and a profound sense of humanity. Composed for guitar solo, this movement is seemingly simple yet mysterious and difficult to comprehend. There is a feeling of loneliness as well as great beauty.

Look at *The Flower Carrier*, 1935, Diego Rivera, http://www.diegorivera.org/images/famous/flowercarrier.jpg.

Listen to *Three Pieces for Guitar*, no. 2, 1923, Carlos Chávez, http://youtu.be/GlGd86EeLqs.

Frida Kahlo, painter and wife of Rivera, made the following observation about him at the end of her life:

To Diego painting is everything. He prefers his work to anything else in the world. It is his vocation and his vacation in one. For as long as I have known him, he has spent most of his waking hours at painting: between twelve and eighteen hours a day. . . . He has only one great social concern: to raise the standard of living of the Mexican Indians, whom he loves so deeply. This love he has conveyed in painting after painting. (quoted in Rivera 1991, 188)

Rivera believed that the true artist was first and foremost a human being, one who had the ability to feel the struggles of humanity and to use his art as a voice of the people. Both Rivera and Chávez dedicated their lives to their art—art for all people. By drawing upon history and culture, as well as old styles and new, they were relentless in their work in creating powerful art and music that spoke to the people and issues of their time.

CHAPTER FIFTEEN

~

Minimalism in Art and Music

Overview

The term *minimalism* was first used by David Burlyuk in a 1929 catalog for an exhibit of paintings by John Graham at the Dudensing Gallery in New York City. In the introduction of the catalog, Burlyuk wrote, "Minimalism derives its name from the minimum of operating means." The term came into popular use in the art world in the 1960s, but it also carried into other fields, such as music, architecture, and literature. In art, the definition suggests the use of limited materials with a resulting style that can be characterized, in part, by the use of direct geometric shapes and figures and the frequent use of industrial materials. In music, a composer may use limited instrumentation and/or the number of performers required and may rely on techniques, such as repetition. Minimalism in both art and music is born out of an idea or concept rather than out of emotion, narrative, or social or historical context. The result can seem plain and somewhat impersonal. There is also a body of work that is referred to as "spiritual minimalism," in which the use of limited materials results in music of great emotional power.

Minimalism in Visual Art—Sol LeWitt

Sol LeWitt (1928–2007) was a draftsman, printmaker and sculptor who attended the Cartoonists and Illustrators School in New York City while in his twenties. In the mid-1950s, he worked for architect I. M. Pei for a period of time. He started to paint and also continued with graphic design. He quickly

abandoned painting in favor of abstract black-and-white reliefs. A few years later, in 1963, he started making table- and box-like constructions while continuing to make drawings on paper, wall drawings, and prints.

His work started with a concept or idea that he carefully planned out. He created a set of rules but did not know what the result would be until the work was complete. In 1967, LeWitt wrote, "The planning and decisions are made beforehand . . . and the execution is a perfunctory affair" (quoted in Wheeler 1991, 227); this resulted in art that was conceptual rather than emotional. His works stemmed from ideas that were often intuitive, at least at the beginning, but he also noted that "irrational thoughts should be followed absolutely and logically" (quoted in Wheeler 1991, 228).

LeWitt used limited materials, and he manipulated them systematically. When drawing, he use hard pencils, and in colored drawings and prints, he limited himself to four colors—red, yellow, blue, and black. Other colors were created from these four colors. He frequently based a work on simple geometric forms that he used repeatedly and in variation. His background as a draftsman was reflected in his work, which was approached as a system and often appears very architectural. His variations on order and form are seen in his grids and cubes (see figure 15.1).

In LeWitt's work *Wall Drawing 766*, the viewer observes a visual process of change evolving over space. The artist began with a limited number of angles, geometric forms, and colors. The work was born out of the artist's use of repetition and variation of shape, size, and color in creating a major work out of limited materials and a basic concept.

Look at *Wall Drawing 766*, 1994, Sol LeWitt, http://www.sfmoma.org/images/artwork/medium/2000.301_01_d03.jpg.

Minimalism in Music

Although the term *minimalism* is used in music, the term itself is borrowed from the world of art. It was explored in music, in part, as a reaction to such composers as John Cage and his use of indeterminacy and to the very strict serialism in the music of composers, such as Pierre Boulez and Karlheinz Stockhausen. Leading composers of minimalist music include Terry Riley and La Monte Young, followed by Steve Reich and Philip Glass. Arvo Pärt and John Tavener contributed to the repertoire through music that is some-

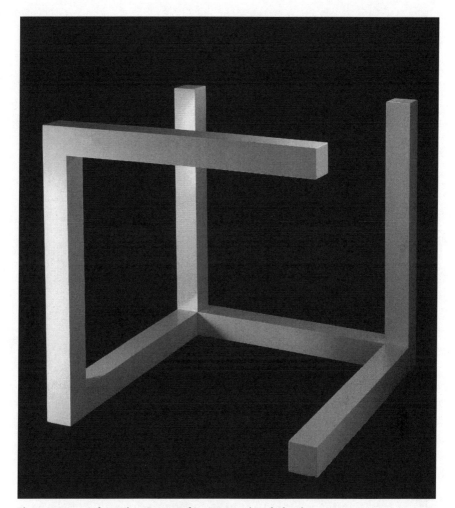

Figure 15.1. Sol LeWitt, *Open Cube*, 1968, painted aluminum, 105 × 105 × 105 cm.
Inv. Sammlung Marzona 0341. Nationalgalerie, Staatliche Museen, Berlin, Germany/
Photo: Peter Neumann/Art Resource, New York, NY. © 2014 The LeWitt Estate/Artists
Rights Society, New York, NY.

times referred to as spiritual minimalism. Through the intentional use of lim-
ited materials, subtleties in specific elements of music—melody, harmony, or
rhythm, for example—could be exploited.

Like visual artists, composers writing in a minimalist style used limited
means. The result was music that can be characterized by the use of short

fragments of typically tonal music, repetition, loops, and slow transforma-
tion—a new approach to time unfolding as process. The music can be heard
as static with seemingly little sense of direction. The first minimalist musical
work was Young's *Trio for Strings* (1958). This piece was marked by extremely
long-held chords, which created a sense of static and motionless harmony.
As a pioneer in the idea of minimalism in music, Young continued to explore
this concept in later works, such as *The Tortoise: His Dreams and Journeys*
(1964); the title itself suggests a whimsical sense of time. In this piece, sing-
ers and instrumentalists phase in and out, improvising over a drone, which
is played on a synthesizer.

Terry Riley

Composer Terry Riley (b. 1935) studied piano, music theory, and com-
position as an undergraduate and graduate student in California. He was
profoundly influenced by Pandit Pran Nath, a Kirana vocal master who was
Riley's teacher for decades. He went on to teach Indian classical music at
Mills College from 1971 to 1981, as well as at the California Institute of the
Arts, the Nairopa Institute, and the Christi Sabri School of Indian Classi-
cal Music in New Delhi—all in the 1990s. Riley also helped found the San
Francisco Tape Music Center. His works, such as *A Rainbow in Curved Air*
(1970) for keyboard, reflects Indian music in the improvisation over cycles
of rhythmic figures and modal scales.

Riley lived in Paris for almost two years. It was here that he collaborated
with director Ken Dewey, whom he had met while in San Francisco. Riley
produced music for Dewey's *The Gift* (1963), which was based on Miles
Davis's "So What." Riley took this jazz classic and then applied a "time-lag
accumulator" to it. This piece requires two tape recorders, which record and
play at the same time. This involved stretching the tape; the result was a
new sound characterized by rich and multilayered textures that developed
progressively over time, becoming more and more dense.

Listen to *The Gift*, Terry Riley, http://www.youtube.com/watch?
v=lMcmMhfYkNI.

Like Sol LeWitt, Riley's minimalist compositions were characterized by
the notion of strict order, simple systems, and variety within a system. In

music, these ideas were conveyed with pure tonal harmony, a steady pulse, and insistent repetitions of short patterns that, when combined, created a hypnotic effect. Riley's composition *In C* (1963) is one of the best known early examples of minimalism in music. It is based on simple material and a simple idea; however, it unfolds into something more complex. In this piece, the composer did not determine the instrumentation—he did not name what instruments will play. That is left to performing musicians. The piece consists of fifty-three brief melodic fragments in the key of C. Each player repeats each fragment any number of times and in any octave; each individual performer determines when to move on to the next fragment. Each musician in the ensemble plays each of the figures in order and in sync with a steady pulse. The work is based on repetition, but the performers make decisions on how it will be performed and how it will ultimately sound to the listener. Variety and texture are achieved within this strict ordering by the decision of each musician of when to move from one figure to another. The simple process of change evolving over time creates an effect that is trancelike. This was the first composition to bring musical minimalism into the mainstream.

Listen to *In C*, Terry Riley, http://www.youtube.com/watch?v=OjR4QYsa9nE.

Steve Reich

Steven Reich (b. 1936) studied philosophy at Cornell University and later studied musical composition at the Juilliard School of Music with William Bergsma and Vincent Persichetti. He also completed a master's degree in composition at Mills College with Lucio Berio. Like Riley, his interests in music went beyond the Western tradition. Reich wrote an important essay called "Music as a Gradual Process" (1968), in which he discussed their approach to musical composition.

Reich had performed with Riley in *In C*, and he had strong interests in African drumming and in the music of John Coltrane. Through listening to and performing music such as this, he developed an interest in what could be created with short repeated patterns and sustained harmonies. He composed *It's Gonna Rain* based on the idea of "phasing." This involved breaking up speech and rearranging it through the use of tape. Reich also explored this

idea of limits in his piece *Four Organs* (1970), which is based on a nine-note chord with principles of cycling and phasing applied to it.

Philip Glass's *Einstein on the Beach*

Like Steve Reich and Terry Riley, Philip Glass (b. 1937) studied the Western classical music tradition. He studied at the University of Chicago, at the Juilliard School of Music, and with the great pedagogue Nadia Boulanger in Paris. Also like Reich and Riley, Glass turned his back on it as he grew as a composer and embraced the music of the East. He developed a strong interest in Indian music. While in Paris in 1965, he worked with the great Indian musician Ravi Shankar and Alla Rakha, his table player. Glass was to spend many extended periods of time in India. He later reflected,

> In the twelve years since then [1965], these visits had continued regularly, approximately every third year. With each visit my interest in the culture and traditions of India deepened. Dance, theater and music in India are inseparable from religious traditions, so my interests, having started with the performing arts, began to broaden and included a wide range of cultural, historic and religious subjects. (Glass 1995, 90)

Glass was intrigued by the rhythmic organization of Indian music. He was so interested in this music and in his work with Shankar that he rejected many of the musical compositions that he had written to date, some of them already published. He considered them to be academic, and he believed that they lacked expressive qualities.

Indian music influenced musicians working in many styles in the 1960s. One of the great examples from the popular mainstream is the music of George Harrison and the Beatles in such songs as "Norwegian Wood" (1965), "Within You, Without You" (1967), and "The Inner Light" (1968). These songs reflect the influence of Eastern philosophy and the use of Eastern instruments, such as the sitar. Harrison studied sitar with Ravi Shankar. Indian influences can also be noted in songs like "Tomorrow Never Knows" (1966) and "Dear Prudence" (1968) in the use of tape loops and drones.

Among Glass's major works is a group of what he refers to as a trilogy of "portrait operas" on the lives and work of major figures—*Einstein on the Beach* (Albert Einstein; 1976), *Satyagraha* (the name of a book by Gandhi and the word used by him for his movement of nonviolent civil disobedience; 1980), and *Akhnaten* (the Egyptian pharaoh; 1984). The opera *Einstein on the Beach* debuted in Avignon, France, in 1976. This work broke conventions of traditional opera on multiple levels and in doing so redefined opera.

Glass collaborated with the avant-garde scene and staging designer Robert Wilson on this work. Glass first became familiar with Wilson's work in 1973 at the Brooklyn Academy of Music in an all-night performance of Wilson's *The Life and Times of Josef Stalin*. Glass described this as an "unending meditation in movement and images. . . . I loved it. I understood then, as I feel I have ever since, his sense of theatrical time, space and movement" (Glass 1995, 27). In describing the process of creating *Einstein on the Beach*, Glass wrote about how he and Wilson first determined the subject then worked out the structure and determined the company required.

Glass and Wilson considered other figures before deciding upon Albert Einstein as the subject. When describing their approach, the composer said,

> The portrait of Einstein that we would be constructing replaced the idea of plot, narrative, development, all the paraphernalia of conventional theater. Furthermore, we understood that this portrait of Einstein was a poetic vision. Facts and chronology could be included (and indeed were) in the sequence of movements, images, speaking and singing. Conveying that kind of information, though was certainly not the point of the work. (Glass 1995, 32)

Once Albert Einstein was chosen as the subject, Glass and Wilson created the structure of the opera and determined performing forces. The result was an opera that is four and a half hours long without intermissions, although those in attendance are encouraged to take breaks whenever they like. The four acts of the opera are separated by interludes, or "knee plays," which Glass described as the "joining function that humans' anatomical knees perform" (Glass 1995, 30). The instrumentation for *Einstein on the Beach* was built around that of the Philip Glass Ensemble—two electric organs, three woodwinds (doubling on flute, saxophone, and bass clarinet), one soprano, a sixteen-voice mixed chamber choir, and one violinist dressed as Einstein. Andre de Groat and Lucinda Childs created choreography for the abstract dance sequences.

This opera is nonnarrative; there is no sung text. Rather, the singers count out loud, singing numbers rather than words. They also use solfège syllables (do, re, mi, fa, sol, la, ti) juxtaposed with spoken texts that were written by Christopher Knowles, Samuel M. Johnson, and Lucinda Childs. Change takes place very slowly over time, thus creating an experience that has been described as hypnotic.

Glass described two of the techniques he used in this music—the additive process and the cyclic structure. He said,

> Additive process is one of those very simple ideas that can quickly lead to very complicated procedures. It can easily be explained: A musical grouping or mea-

sure of say, five notes is repeated several times, then is followed by a measure of six notes (also repeated), then seven, then eight, and so on. A simple figure can expand and then contract in many different ways, maintaining the same general melodic configuration but, because of the addition (or subtraction) of one note, it takes on a very different rhythmic shape. (Glass 1995, 58)

He continued by describing the cyclic structures, saying, "I have used rhythmic cycles (repeating fixed rhythmic patterns of specific lengths) to create extended structures in my music by superimposing two different rhythmic patterns of different lengths. Depending on the length of each pattern, they will eventually arrive together back at their starting points, making one complete cycle" (Glass 1995, 59). He pointed out that the result of combining these processes results in very complex structures.

In this opera, Glass also worked with the element of harmony. He wrote,

In *Another Look at Harmony*, written just before *Einstein* and an important thematic source for the opera, I turned to a new problem. What I was looking for was a way of combining harmonic progressions with the rhythmic structure I had been developing, to produce a new overall structure. This turned out to be a problem of such absorbing interest that it occupied me almost completely for the next ten years, and the results can be heard in all the music I wrote during that time. In *Einstein* the problem is approached in half a dozen different ways. (Glass 1995, 59)

It is not surprising that the American premiere of this opera attracted a nonconventional opera audience. The audience was challenged by this work in new ways. Glass said that the point of the opera was not "what it meant" but rather that it meant something to the audience who saw it. This leads to a fundamental requirement of this work, which is to encourage the audience to complete the piece through their own imaginations. This idea went beyond just *Einstein*, and it drew the audience into the work by leaving them room to make meaning based on what they saw and heard in combination with what they brought to the experience themselves. Wilson echoed this idea, saying that the audience did not have to understand anything, that it is OK to go and get lost in the experience of the performance.

Einstein on the Beach was performed at the Brooklyn Academy of Music in New York in 1984 and again in 2012. It was also the subject of a concurrent exhibit at the Morgan Library in New York City in 2012, with a room devoted to this work, including both sounds and images. It focused on the premiere performances in 1976. The exhibition space included the pages of Glass's autograph manuscript score, which were mounted on the wall, as

well as Wilson's storyboard comprised of 113 scene designs. There was also a film loop running in the exhibit room that featured clips of New York City rehearsals and of 1976 productions in Paris and Brussels. The Morgan Library also regularly showed the film *Einstein on the Beach: The Changing Image of Opera*, which details the Brooklyn Academy of Music production in 1984 through interviews with both Glass and Wilson about the nature of collaboration and creativity.

Listen to *Einstein on the Beach: The Changing Image of Opera*, Brooklyn Academy of Music with Philip Glass and Robert Wilson, http:// www.youtube.com/watch?v=vSu_SE7xWLg.

Spiritual Minimalism in the Music of Arvo Pärt

The term *minimalism* has also been applied to composers, such as Arvo Pärt, John Tavener, and Henryk Górecki, who are sometimes referred to as spiritual minimalists or mystic minimalists. Using sacred texts and drawing upon the tradition of Gregorian chant and choral music by such composers as Ockeghem (fifteenth century), they have developed new compositional techniques and in doing so have created works of great musical power and emotion.

Arvo Pärt (b. 1935) has composed music in many styles. He is influenced by many things, including plainchant and early polyphony of the medieval period. His music of the 1960s was largely serial and was considered to be radical. After 1976, he composed in a style that he referred to as "tintinnab- uli," which suggests the ringing of tiny bells. Pärt described this style, saying,

Tintinnabulation is an area I sometimes wander into when I am searching for answers—in my life, my music, my work. In my dark hours, I have the certain feeling that everything outside this one thing has no meaning. The complex and many-faceted only confuses me, and I must search for unity. What is it, this one thing, and how do I find my way to it? Traces of this perfect thing appear in many guises—and everything that is unimportant falls away. Tintin- nabulation is like this. . . . The three notes of a triad are like bells. And that is why I call it tintinnabulation. (quoted in Rodda)

The basic principle here is composing two simultaneous voices as one line— one voice moving stepwise from and to a central pitch.

His seven-minute-long choral work *Magnificat* (1989) is an example of this style of music. His approach to religion has given rise to humility in his artistic aims—music as a vehicle to reach for that which is unknowable. This work is based on the Latin text *Magnificat*—"My soul doth magnify the Lord: and my spirit hath rejoiced in God my Savior." It is composed for a cappella mixed choir—voices only, without instrumental accompaniment. It is chantlike in its absence of meter signature and bar line. In it, Pärt used very limited means. The piece is composed in angular lines of short motifs with drones and monotones that are disrupted by sharp dissonances. The use of open intervals gives a sense of space. Vocal lines move together rhythmically in a homophonic texture for the most part, and the use of lingering harmonies and silence create a sense of stillness. This piece, both introspective and direct, is an excellent example of tintinnabulation—rhythmically simple and slowly unfolding with an emphasis on the interval of a half step that, when prolonged, creates the sound of bells.

Listen to *Magnificat*, Arvo Pärt, Robert Shaw Festival Singers, http://www.youtube.com/watch?v=kVlGIrXGepc.

This piece brings to mind the long-considered question of the place of music in the Christian church. John Milsom, who wrote the liner notes for the CD *ikos*, named questions perhaps considered by composers writing sacred liturgical music—"Will his setting have pathos, drama, a surge of emotion, or should there instead be restraint and order, a liturgical decorum? Are the words to stand out as if declaimed by a great orator, or will they merely float on the surface of alluring music? Will the piece speak in the idiom of today, or will it echo the musical traditions of the Christian past?" (Milsom 1994). Pärt used a liturgical text and treated it with a fresh musical voice of today while paying homage to music of the past. In spite of, or perhaps because of, the way he used limited means, this piece is strikingly powerful in its stillness and calm.

The music of Arvo Pärt has sometimes been compared to white light—the white light that contains all colors. Through sparse means, and in a voice that is clearly of modern times, he creates music that transcends time and space. Pärt, along with artists and composers creating in a minimalist style, have shown through their work the infinite possibilities of using simple and limited means. In the hands of Arvo Pärt comes powerful music that evokes deeply personal and profound responses on the part of the listener.

Postlude

The choices of art and music highlighted in this book are presented with the objective of encouraging the viewer and listener to make his or her own connections. As noted, some of the connections are made as a way of addressing elements of style shared by art and music. In other cases, the connection between an artist and composer may be around a specific work and/or period of time or place. The links made should not be interpreted as generalizations of an artist's work. Artists, by virtue of being creative people, explore, experiment, discover, change, and evolve over a lifetime.

The objective here is not to use one art form to explain another. Each artistic discipline is part of a lineage and has processes that are unique to it. While the arts converse, the goal is not to use one at the service of another. It is also important to note that these are just a few connections that I chose to explore, representing different styles and different decades in the twentieth century. The connections here are of works in the mainstream. The art lives in museums, and the music is heard in halls and on recordings. However, many, many more connections are possible—other styles, cultures, audiences, periods of time.

My hope is that the connections offered here will be a mere starting place for the reader—a starting place for engagement with art and music. I encourage readers:

- to think,
- to feel,

- to be challenged,
- to sit with the challenge,
- to question,
- to wonder,
- to find joy,
- to experience "a ha" moments,
- to engage,
- to make meaning,
- to be open to learning and understanding,
- to be OK with not understanding,
- to know that sometimes there is no specific thing to understand or code to break,
- to ask questions,
- to find beauty,
- to find comfort,
- to bring your imagination,
- to participate, and
- to take time to do this!

Technology gives us unprecedented access to the arts. We can visit museums around the world on virtual tours and hear live performances streamed on our computers and phones. Technology gives us access to images of art and sounds of music through a quick flick of the finger on our favorite gadget. But technology also distracts us. It seems more and more difficult to be still and focus on one thing. Yet, that is what can allow us to engage fully with the arts. We must be still and really look. We must be still and really listen. Responses are powerful when they are shared with other people. They are also powerful when they are shared and considered across art forms. To respond is a way of saying that you belong—art matters to you, you matter to art.

While working on this book, I talked to my creative and energetic eight-year-old niece Emily about my project. As we were walking along the beach on a summer family vacation, I explained that I was writing a book about art and music. I asked her, "Do you think art and music are alike?" She instantly replied, "Yes." I said, "How do you think they're alike?" She quickly responded, "They're both active." Her tone suggested that this was *very* obvious! I said, "So they're both active when you *make* art and *make* music?" She said, "Yes, and also when you *look* at art and *listen* to music."

Glossary of Musical Terms

a cappella An Italian term used to describe music that is sung by one or more vocalists without instrumental accompaniment. Literally means "in the manner of a chapel."

atonal Refers to music that is void of a tonal center or key. The first atonal compositions were written around 1908.

bitonality The use of two key signatures at the same time.

blue note A term used in jazz and the blues to refer to a note that is played or sung slightly under pitch (a half step or less) in order to create expressive nuance.

brass Refers to a family of musical instruments including the trumpet, cornet, French horn, trombone, and tuba.

cacophony Refers to chaotic, dissonant, confused, and disjointed sounds.

call and response A phrase that refers to a musical pattern in which a phrase is sung first by a soloist or group and then repeated by a second soloist or group as if to comment on or respond to the first phrase.

chromatic scale A scale that moves by half step to include twelve notes; on a piano each pitch is equidistant from the other.

color (in music) Refers to the essence of sound created by a specific instrument, voice, or group of instruments. See also *timbre, tone color.*

consonance Musical sounds that are considered to be pleasing to the ear.

crescendo A musical term that tells the performer(s) to gradually get louder.

decrescendo A musical term that tells the performer(s) to gradually get softer.

dissonance Musical sounds that are not pleasing to the ear.

duple meter Organization of music into two beats per measure.

dynamics Refers to the relative loud or soft in music; *forte* (loud) versus *piano* (soft), for example.

fermata A symbol in musical notation that directs the performer(s) to hold a note or chord.

form Refers to the overarching organization or structure of a musical composition or movement.

glissando An Italian term (plural, *glissandi*) meaning to slide from one note to another or to glide through a group of consecutive notes.

improvisation Refers to music created spontaneously; for example, a melody created or varied over an existing chord progression.

instrumentation Refers to what specific instruments are used in a musical composition; piano and voice or strings, for example.

interval The space between two notes; a perfect fifth or a major third, for example.

key signature Denotes the tonal center of a musical composition; C major or g minor, for example.

leitmotif A musical phrase or idea that is heard in association with a specific character or idea. From German, meaning "leading motif."

meter The organization of music by placement of stresses that create pulse in music. This is notated with a time signature that indicates the number of beats per measure and what note value receives one beat. See also *time signature.*

nocturne In music, a term used to describe a composition that evokes evening or night.

ostinato	A musical phrase or motif (rhythmic and/or melodic) that is repeated in the same voice, often at the same pitch. Derived from the Italian, meaning "stubborn."
plainchant	Refers to chant sung during the liturgies of the early Western church. Characterized by a single unaccompanied melodic line (monophonic) with free rhythms guided by the texts.
polyphony	A term used in music (literally means "many sounds") to describe a texture in which two or more lines (voices) are sounding simultaneously yet independent from one another.
polytonality	The use of many tonalities (tonal centers) at the same time.
quadruple meter	The organization of music into four beats per measure; like a march. See also *meter*.
revue	A form of entertainment in which a show (including song, dance, short sketches) is built around an overarching theme or the work of a single composer.
riff	A short, repeated pattern in music. Like an ostinato. A brief series of chords in jazz.
rondo	An instrumental form in music that relies on the alternation between a recurring theme and contrasting material. Most rondos follow the pattern ABACA (A suggests the main theme) or ABACABA.
suite	A collection of dance movements; minuet, gavotte, waltz, for example.
syncopation	Refers to an accent in an unexpected place or on a traditionally unaccented beat.
timbre	Refers to the essence of sound in music created by a specific instrument, voice, or group of instruments. See also *color (in music), tone color.*
time signature	Comprised of two numbers and appears at the beginning of a musical composition; the top number indicates the number of beats per measure, and the bottom number indicates the type of note that receives one beat.
tone color	Refers to the essence of sound in music created by a specific instrument, voice, or group of instruments. See also *color (in music), timbre.*

tone poem

A musical composition in one continuous movement that is based on an extra musical idea, such as a story, a place, a painting, or an ideal.

triple meter

The organization of music into three beats per measure; like a waltz, for example.

twelve-bar blues

Refers to the number of bars (measures) used in blues songs. The twelve bars are played/sung over three phrases, creating the form A (four bars) + A (four bars) + B (four bars) = twelve bars and an AAB structure. This pattern is built on three chords: I (tonic in phrase 1), IV (subdominant in phrase 2), and V (dominant in phrase 3). This structure creates an anchor over which the singer tells a story with the words repeated in each of the A sections. The final B section is frequently a response to the first two phrases.

twelve-tone system

A system of musical composition begun by Arnold Schoenberg in which each of the twelve pitches of a chromatic scale is used in such a way that none is emphasized. Each note is essentially of the same importance, thereby avoiding a tonal center or key.

woodwinds

Refers to a family of musical instruments, such as the flute, piccolo, oboe, clarinet, and bassoon.

Works Cited

Accessed October 18, 2012, www.oxfordreference.com/view/10.1093/acref/9780195335798.001.0001/acref-97.

Bearden, Romare, and Charlene Hunter Gault. 1987. "Rhythm on Canvas." Discussion of Bearden's forty-year retrospective exhibition at the Bronx Museum of the Arts, New York, WNET/PBS, *The MacNeil/Lehrer Report*, June 26. Accessed October 17, 2012, http://www.metmuseum.org/metmedia/interactives.

Berman, Avis. 1980. "Romare Bearden: I Paint Out of the Tradition of the Blues." *ARTnews* 79 (December): 60–67.

Brody, Elaine. 1987. *Paris: The Musical Kaleidoscope 1870–1925*. New York: George Braziller.

Brown, Earle. 1962. *Novara*. New York: Edition Peters.

———. 2007. *Calder Piece*. New York: Edition Peters.

Butterworth, Neil. 1985. *The Music of Aaron Copland*. New York: Toccata Press, Universe Books.

Cage, John. 1951. "A Few Ideas about Music and Films." *Film Music Notes* 10 (January–February): 12.

———. 1985. *Silence*. Middletown, CT: Wesleyan University Press.

Calder, Alexander. 1966. *Calder: An Autobiography with Pictures*. With Jean Davidson. New York: Pantheon Books.

Cassidy, Donna M. 1988. "Arthur Dove's Music Paintings of the Jazz Age." *American Art Journal* 20 (1): 5–23.

———. 1997. *Painting the Musical City: Jazz and Cultural Identity in American Art, 1910–1940*. Washington, DC: Smithsonian Institution Press.

Copland, Aaron. 1940. *Quiet City*. New York: Boosey and Hawkes.

———. 1944. *Appalachian Spring*. New York: Boosey and Hawkes.

———. 1957. *What to Listen for in Music*. New York: McGraw-Hill.

Cox, David. 1975. *Debussy's Orchestral Music*. Seattle: University of Washington Press.

Da Costa Meyer, Esther, and Fred Wasserman, eds. 2003. *Schoenberg, Kandinsky, and the Blue Rider*. London: Scala.

Dave Brubeck Quartet. 1961. *Time Further Out: Miró Reflections*. Columbia Legacy, 1996. Liner notes from original recording by Dave Brubeck.

———. 1996. *Time Out*. Columbia/Legacy CD, 1997. Liner notes from original recording by Steve Race and notes by Dave Brubeck.

Dinerstein, Joel. 2003. *Swinging the Machine: Modernity, Technology and African American Culture between the World Wars*. Amherst: University of Massachusetts Press.

Duchting, Hajo. 1997. *Paul Klee Painting Music*. Munich: Prestel.

Earle Brown Foundation. 1954. "Time" notation used in "25 Pages" and "Music for Cello and Piano," by Earle Brown.

Feldman, Morton. 1985. *Essays*. Edited by W. Zimmerman. Kerpen, Germany: Beginner Press.

Fisk, Josiah, ed. 1997. *Composers on Music: Eight Centuries of Writings*. Consulting editor, Jeff Nichols. Boston: Northeastern University Press.

Gardner, Howard. 1993. *Creating Minds: An Anatomy of Creativity*. New York: Basic Books.

Glass, Philip. 1995. *Music by Philip Glass*. Edited by Robert T. Jones. New York: Da Capo Press.

Goldman, Shifra M. 1994. *Dimensions of the Americas: Art and Social Change in Latin America and the United States*. Chicago: University of Chicago Press.

Hahl-Koch, Jelena, ed. 1984. *Arnold Schoenberg-Wassily Kandinsky: Letters, Pictures and Documents*. Translated by John C. Crawford. London: Faber and Faber.

Harris-Kelley, Diedra. 2004. "Revisiting Romare Bearden's Art of Improvisation." In *Uptown Conversations: The New Jazz Studies*, edited by Robert G. O'Meally, Brent Hayes Edwards, and Farah Jasmine Griffin, 249–55. New York: Columbia University Press.

Heller, Steven. 2007. "Waxing Chromatic: An Interview with S. Neil Fujita." American Institute of Graphic Arts, September 18. Accessed August 27, 2012, http://www.aiga.org/waxing-chromatic-an-interview-with-s-neil-fujita.

Hills, Patricia. 1996. *Stuart Davis*. New York: Harry N. Abrams in association with the National Museum of American Art, Smithsonian Institution.

Hoffman, Katherine. 1997. *Georgia O'Keeffe: A Celebration of Music and Dance*. New York: George Braziller.

Hughes, Langston. 1995. *The Book of Rhythms*. New York: Oxford University Press.

Hutchins, Hapgood. 1913. "A Paris Painter." *New York Globe and Commercial Advertiser*, February 20, 12.

Jablonsky, Edward, and Lawrence D. Stewart. 1996. *The Gershwin Years: George and Ira*. New York: Da Capo Press.

James, Burnett. 1983. *Ravel: His Life and Times*. New York: Hippocrene Books.

Kandinsky, Wassily. 1977. *Concerning the Spiritual in Art*. New York: Dover Publications.

———. 979. *Point and Line to Plane*. Translated by Howard Dearstyne and Hilla Rebay. Edited by Hilla Rebay. New York: Dover Publications.

Klee, Felix. 1962. *Paul Klee*. New York: George Braziller.

Klee, Paul. 1964. *The Diaries of Paul Klee 1898–1918*. Edited by Felix Klee. Berkeley: University of California Press.

Kotz, Mary Lynn. 2004. *Rauschenberg/Art and Life*. New York: Harry N. Abrams.

Kuh, Katharine. 2000. *The Artist's Voice*. New York: Da Capo Press.

———. 2006. *My Love Affair with Modern Art*. Edited by Avis Berman. New York: Arcade Publishing.

Machlis, Joseph. 1961. *Introduction to Contemporary Music*. New York: W. W. Norton & Co.

Marter, Joan, ed. 2011. *The Grove Encyclopedia of American Art*. Oxford: Oxford University Press.

Matisse, Henri. 2001. *Henri Matisse Jazz*. Munich: Prestel Verlag.

Maur, Karin v. 1999. *The Sound of Painting*. Munich: Prestel Verlag.

Melberg, Jerald L., and Milton J. Block, eds. 1980. *Romare Bearden, 1970–1980: An Exhibition*. Essays by Albert Murray and Dore Ashton. Charlotte, NC: The Museum.

Messinger, Lisa Mintz, ed. 2011. *Stieglitz and His Artists: Matisse to O'Keeffe*. New York: The Metropolitan Museum of Art.

Milsom, John. 1994. Liner notes for *ikos—górecki, tavener, pärt*, Choir of King's College, Cambridge. EMI Records.

Morgan, Robert P. 1991. *Twentieth Century Music*. New York: W. W. Norton & Co.

Moszynska, Anna. 1990. *Abstract Art*. London: Thames and Hudson.

New York Museum of Modern Art Archive. 1940a. "From: Herbert Barrett Columbus 5-4640. Re: Mexican Music Program Aztec, Yaqui, Indian, Folk Ballad and Modern Mexican Music in Carlos Chávez Program for Museum of Modern Art." Press release, Concert combined with Museum of Modern Arts's exhibit "Twenty Centuries of Mexican Art," May 7.

———. 1940b. "Mexican Music: Notes by Herbert Weinstock for Concerts Arranged by Carlos Chávez as part of the exhibition 'Twenty Centuries of Mexican Art.' By Museum of Modern Art, Herbert Weinstock, Carlos Chávez. New York: W. E. Rudge's Sons, Museum of Modern Art, May.

O'Keeffe, Georgia. 1976. *Georgia O'Keeffe*. New York: Viking Press.

O'Meally, Robert. 2003. Liner notes for *Romare Bearden Revealed*, Branford Marsalis Quartet. Rounder Records CD.

Pritchett, James. 1993. *The Music of John Cage*. Cambridge: Cambridge University Press.

Rivera, Diego. 1991. *My Art, My Life: An Autobiography*. New York: Dover.

Rodda, Richard E. Liner notes for *Fratres, I Fiamminghi*, by Arvo Pärt, Orchestra of Flanders, Rudolf Werthen, Telarc CD-80387.

Rogers, M. Robert. 1935. "Jazz Influence on French Music." *The Musical Quarterly* 21, no. 1 (January): 53–68.

Rostand, Claude. 1967. *Le Figaro Litteraire*, August 21–27, n.p.

San Francisco Museum of Modern Art. 1994. *The Making of a Modern Museum*. San Francisco: Author.

Schiff, David. 1992. "In an Ugly Century, a Place for the 'Merely' Beautiful." *New York Times*, November 22.

———. 2004. "Conducted under Synaesthetic." *Times Literary Supplement*, March 12, 16–17.

Schmitz, E. Robert. 1966. *The Piano Works of Claude Debussy*. New York: Dover.

Schuller, Gunther. 2007. "Seven Studies on Themes of Paul Klee." Los Angeles Philharmonic, August. Accessed February 14, 2012, http://www.laphil.com/philpedia/music/seven-studies-on-themes-of-paul-klee-gunther-schuller.

Seroff, Victor I. 1953. *Maurice Ravel*. New York: Henry Holt and Company.

Soby, James Thrall. 1959. *Joan Miró*. New York: The Museum of Modern Art.

Spector, Nancy. "A Bavarian Don Giovanni." Guggenheim Museum. Accessed February 14, 2012.

Stravinsky, Igor. 1962. *An Autobiography*. New York: The Norton Library, W. W. Norton and Co.

Thompson, Oscar. 1937. *Debussy: Man and Artist*. New York: Dodd, Mead & Co.

Tick, Judith, ed. 2008. *Music in the USA: A Documentary Companion*. Oxford: Oxford University Press.

Tompkins, Calvin. 1977. "Profiles: Romare Bearden, Putting Something over Something Else." *New Yorker*, November 28, 53–77.

Ward, Ossian. 2006. "The Man Who Heard His Paintbox Hiss." *Telegraph UK*, June 10, n.p.

Weinberg, H. Barbara. 2000. "James McNeill Whistler (1834–1903)." Heilbrunn Timeline of Art History. Accessed September 14, 2012, http://www.metmuseum.org/toah/hd/whis/hd_whis.htm.

Weiss, Jeffrey, ed. 1998. *Mark Rothko*. New Haven, CT: Yale University Press.

Wheeler, Daniel. 1991. *Art since Mid-Century: 1945–Present*. New York: The Vendome Press.

Winterson, Jeanette. 1995. *Art Objects*. New York: Vintage International.

Wynton Marsalis and the Lincoln Center Jazz Orchestra. 1999. *Big Train*. Sony/Columbia CD.

Zilczer, Judith. 1984. "Synaesthesia and Popular Culture: Arthur Dove, George Gershwin, and the 'Rhapsody in Blue.'" *Art Journal* 44 (4): 361–66.

Works Consulted

Books

Apel, Willi. 1979. *Harvard Dictionary of Music*. Cambridge, MA: Harvard University Press.

Chávez, Carlos. 1975. *Toward a New Music: Music and Electricity*. New York: Da Capo Press.

Cheney, Sheldon. 1950. *The Story of Modern Art*. New York: Viking Press.

Cook, Nicholas, and Anthony Pople, eds. 2004. *The Cambridge History of Twentieth Century Music*. Cambridge: Cambridge University Press.

Copland, Aaron. 1952. *Music and Imagination*. Cambridge, MA: Harvard University Press.

Cross, Jonathan. 1998. *The Stravinsky Legacy*. Cambridge: Cambridge University Press.

Dabrowski, Magdalena. 2002. *Kandinsky: Compositions*. New York: Museum of Modern Art.

DuPont, Diane C., et al. 1985. *San Francisco Museum of Modern Art: The Painting and Sculpture Collection*. New York: Hudson Hills Press.

Fine, Ruth. 2003. *The Art of Romare Bearden*. Washington, DC: National Gallery of Art.

Goosen, E. C. 1959. *Stuart Davis*. New York: George Braziller.

Hamill, Pete. 1999. *Diego Rivera*. New York: Harry N. Abrams.

Hitchcock, H. Wiley. 1988. *Music in the United States*. Engelwood Cliffs, NJ: Prentice-Hall.

Hunter, Sam. 1974. *American Art of the 20th Century*. New York: Harry N. Abrams.

Kirchner, Melanie. 1988. *Arthur Dove: Watercolors and Pastels*. New York: George Braziller.

Lockspeiser, Edward. 1962. *Debussy: His Life and Mind*. London: Cassell.

Marnham, Patrick. 1998. *Dreaming with His Eyes Open: A Life of Diego Rivera*. New York: Knopf.

Mendelowitz, Daniel M. 1970. *A History of Modern Art*. New York: Holt, Rinehart, and Winston.

Nichols, Roger. 2011. *Ravel*. New Haven, CT: Yale University Press.

Penrose, Roland. 1985. *Miró*. London: Thames and Hudson.

Pollack, Howard. 1999. *Aaron Copland: The Life and Work of an Uncommon Man*. New York: Henry Holt & Co.

Roethel, Hans K. 1971. *The Blue Rider*. London: Praeger.

Rosen, Charles. 1975. *Arnold Schoenberg*. New York: Viking Press.

Ross, Alex. 2007. *The Rest Is Noise: Listening to the Twentieth Century*. New York: Farrar, Straus, and Giroux.

Salzman, Eric. 1974. *Twentieth-Century Music: An Introduction*. Engelwood Cliffs, NJ: Prentice-Hall.

Articles

Bagust, Sue. 2000. "Beyond Fission: Schoenberg, Kandinsky, the Blaue Reiter and the Russian Avant Garde." *Central Europe Review* 2, no. 16 (April 25): n.p. Accessed August 30, 2012, http://www.ce-review.org/00/16/bagust16.html.

Crawford, Richard. 1986. "Gershwin." In *The New Grove Dictionary of American Music*. Vol. 2, E–K, edited by H. Wiley Hitchcock and Stanley Sadie. London: Macmillan Press.

Dove, Arthur. ca. 1913. *Sentimental Music*. Heilbrunn Timeline of Art History. Accessed July 31, 2012, http://www.metmuseum.org/toah/works-of-art/49.70.77.

Feldman, Morton. 1971. "Rothko Chapel." Los Angeles Philharmonic. Accessed September 28, 2012, www.laphil.com/philpedia/music/rothko-chapel-morton-feldman.

"Henri Matisse: A Retrospective." 1992–1993. Announcement of Matisse retrospective at the Museum of Modern Art. Accessed August 14, 2012, http://www.moma.org/docs/press_archives/7059/releases/MOMA_1992_0067_55.pdf.

Isacoff, Stuart. 2009. "Inspired by Kandinsky." *Wall Street Journal*, September 23, n.p. Accessed August 30, 2012, http://online.wsj.com/news/articles/SB10001424054297020448830457442903230666812 44.

Johnson, Carl. 1986. "Whiteman." In *The New Grove Dictionary of American Music*. Vol. 4, R–Z, edited by H. Wiley Hitchcock and Stanley Sadie. London: Macmillan Press.

Kozinn, Allan. 1992. Review of recital by Jean-Yves Thibaudet (piano), 92d Street Y, 1495 Lexington Avenue, New York. *New York Times*, November 27, n.p. Accessed August 14, 2012, http://www.nytimes.com/1992/11/27/arts/review-music-thibaudet-plays-ravel-piano-works.html.

Manus, Susan. 1998. "What's Old Is New: Martha Graham Project Includes Archives, New Work." *Library of Congress Information Bulletin* 57, no. 6 (June). Accessed March 21, 2012, www.loc.gov/loc/lcib/9806/graham.html.

McBurney, Gerard. 2006. "Sound and Vision." *The Guardian*, June 23, n.p. Accessed August 30, 2012, http://www.theguardian.com/artanddesign/2006/jun/24/art.art.

"Music: The World of Paul Klee." 1960. *Time*, February 29, n.p. Accessed April 17, 2012, http://content.time.com/time/magazine/article/0,9171,873250,00.html.

"The Paris World Exhibition of 1889: A Cultural Awakening." 2007. The Enjoyment of Music. Accessed November 10, 2012, http://www.wwnorton.com/college/music/enj10/short/content/unit/persp_15.htm.

"*Red and Orange Streak*, 1919." n.d. Philadelphia Museum of Art. http://www.philamuseum.org/education/resources/73.html.

Ross, Alex. 2006. "American Sublime: Morton Feldman's Mysterious Musical Landscapes." *New Yorker*, June 19, n.p. Accessed August 8, 2012, http://www.newyorker.com/archive/2006/06/19/060619crat_atlarge.

"Roy Harris." 2012. *Encyclopædia Britannica*. Accessed March 21, 2012, http://www.britannica.com/EBchecked/topic/255935/Roy-Harris.

"Sonderausstellung: Schönberg, Kandinsky, Blauer Reiter und die Russische Avantgarde." 2000. Arnold Schönberg Center, March 9–May 28, http://www.schoenberg.at/index.php?option=com_content&view=article&id=351.

Wallach, Amei. 1981. "Catching Daily Life in Visual Jazz." *Newsday*, October 4, 17–18.

Websites

PBA Galleries: Auctioneers and Appraisers. n.d. http://www.pbagalleries.com. Accessed October 6, 2012, http://earlebrown.org/media/Earle%20Brown%20 open%20form%20general%20instructions.pdf.

Discography/Recordings

Minneapolis Symphony Orchestra. 2005. *Antal Dorati Conducts Stravinsky, Prokofiev, Gershwin, Copland, Schuller, etc.* Mercury Living Presence.

Media

"Romare Bearden: The Music in His Art, A Pictoral Odyssey." 2005. From the Jazz Jams Series (R. Bearden Foundation) in collaboration with the Center for Jazz Studies at Columbia University and Jazzmobile.

Index

About the Author

Brenda Lynne Leach is an accomplished musician and educator. She is a music professor who has taught at various institutions, including Harvard University. She has developed numerous courses and programs that emphasize interdisciplinary elements across the arts. Her approach has been greatly influenced by time living abroad in some of the world's great cities, including Paris and St. Petersburg, where she developed a passion for art. As a conductor and concert organist, she has performed at major venues in the United States, Europe, and Russia. Brenda Leach holds doctor of musical arts and master of music degrees from the Eastman School of Music, as well as a master of education in arts and education from Harvard University. She has created unique programs linking music and the visual arts for museums and orchestras in the United States and abroad. She lives in New York City and Pennsylvania.